San Anselmo Public Library
110 Tunstead Avenue
San Anselmo, CA 94960

LANDSCAPE PAINTING TECHNIQUES

D0131825

San Anselmo Public Library
110 Tunstead Avenue
San Anselmo, CA 94960

LANDSCAPE PAINTING TECHNIQUES

EDITED BY DAVID LEWIS

WATSON-GUPTILL PUBLICATIONS, NEW YORK

First published in 1984 in New York by Watson-Guptill Publications,
a division of Billboard Publications, Inc.,
1515 Broadway, New York, N.Y. 10036

Library of Congress Cataloging in Publication Data
Main entry under title:

Landscape painting techniques.

 Includes index.
 1. Landscape painting—Technique. I. Lewis, David,
1948-
ND1342.L3 1984 751.4 84-2400
ISBN 0-8230-2637-X (pbk.)

Distributed in the United Kingdom by Phaidon Press Ltd., Littlegate
House, St. Ebbe's St., Oxford

All rights reserved. No part of this publication may be
reproduced or used in any form or by any means—graphic,
electronic, or mechanical, including photocopying, recording,
taping, or information storage and retrieval systems—without
written permission of the publisher.

Manufactured in Hong Kong

3 4 5 6 7 8 9 / 97 96 95 94 93 92 91 90

There are many people who deserve thanks for helping me while I worked on this book, especially Susan Colgan and Jay Anning.

Without their help, creating *Landscape Painting Techniques* would have been impossible. With their help, it has not only been possible, but a pleasure.

David Lewis

Contents

Betty M. Wilson

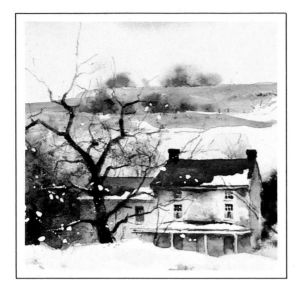

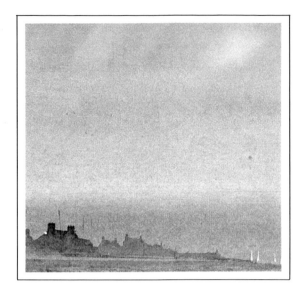

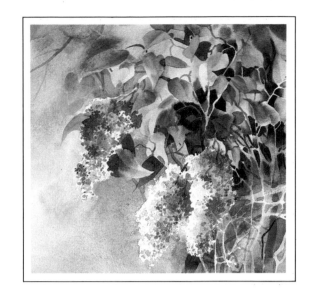

Introduction

Falling snow often inspires the artist, but capturing its effects can be confounding. Imagine snow falling through headlight beams as cars speed over the countryside, leaving piles of white on everything: roofs, limbs of trees, parked cars, fences, windowsills. Skiers create crisp tracks in the snow. People's booted feet leave blue hollows behind them. Snow weighs down the evergreens, making tunnels of forest paths.

Such overwhelming and spectacular whiteness can leave the aspiring painter at a loss; the prospect of managing white space is often intimidating. How have other artists dealt with weather, with snow? In the hope of finding how someone else has coped, one might flip through a good book of paintings for encouragement.

It is to this end that the editors of Watson-Guptill have addressed themselves in *Landscape Painting Techniques*. Instead of showing the work of just one painter, they have taken landscape painting demonstrations by many different artists and put them all in *one* book. How do a variety of artists approach the landscape that inspires them? Do they take photographs? Do they make sketches? What paints do they select? What brushes do they use?

Here the work of nine prominent contemporary artists has been culled through to select the best instances, the most instructive situations to help students. You will find approaches to landscape in all seasons and at varying times of day and in different climates.

Are you inspired and also confounded by an icy street, a misty seascape, or a stream's reflections beneath a gray sky? Thumb through this book and see what John Blockley did when confronted with a similar situation, or Charles Reid or Foster Caddell or Zoltan Szabo.

Do you ever find yourself daydreaming about a summer's garden, especially when the snow has melted and the days look gray and drab? You might be comforted or encouraged by another artist's attempt to capture fields of flowers he's seen over the years, not just one field.

Here nine artists explore skies, weather, trees, water, and flowers. Explore with them; see how they use both watercolors and oils.

As Wendon Blake has noted in the introductions to the two previous books in this series, *Oil Painting Techniques* and *Watercolor Painting Techniques*, having a book like this on your library shelf is like having an art school at your disposal, with a different professor in each room demonstrating his approach to a particular scene. The advantage is that they are all at work in *your* studio or work place. Here is a brief note on the artists whose works comprise this book:

John Blockley is a watercolor painter who lives in Great Britain. His book, *Country Landscapes in Watercolor*, has been one source here. Blockley is a master of the rural scene, an expert at evoking mood and finding texture, shapes, and colors in the landscape.

Foster Caddell, the oil painter, is a versatile landscape painter, adept at perceiving the difficulties inherent in students' work and at demonstrating how to transform common problems into useful lessons in landscape painting technique. Here the editors have selected sections from Caddell's book *Keys to Successful Landscape Painting*. He has also written *Keys to Successful Color*.

George Cherepov, the oil painter, is notable for his fresh approach to landscape. He usually blocks out his drawing on canvas and proceeds to cover up "the lines" as his painting emerges. Watch how he handles a stormy sky, a bright horizon—demonstrations that he created for *Complete Guide to Landscape Painting in Oil*, written by Wendon Blake.

Albert Handell's *Oil Painting Workshop* has been a rich source for this book. Handell's logical approach offers lessons in landscape and design. He works always from a loose underpainting in a transparent wash and builds to a more complex surface which invariably captures his subjects: the rhythm and movement of the woods or the austere light of noontime as it falls on the simple angles of a barn.

The editors have also dipped into *Capturing Nature in Watercolor* by **Philip Jamison**. Over Jamison's shoulder you can watch as he manages snow fields or develops a series of paintings from the same subject—a farm down the road from his house. You can also see how he works with flowers.

For water, especially lakes and high seas, you can look here to the work of watercolorist **John Pike**. He has an eye for simplifying and redesigning what he sees. He takes you step by step through painting a tropical storm as well as, in another demonstration, painting a lake near Kilarney in Ireland. If his views have particular appeal to you, take a look at *John Pike Paints Watercolors* for further study.

Charles Reid will advise you on breaking a landscape into values and the simple shapes these values make. He'll show you a parking lot and rooftops on Block Island, and he'll help you look at flowers, too, using a water lily as an example. Here the editors dipped into *Flower Painting in Oil* and *Painting What You Want to See*, two of his five books on landscape, figure drawing, still life, and flowers.

Paul Strisik works in oil. You can follow his steps as he paints a snow-capped mountain and a glistening stream in the Northwest. You might want to consult further his book with Charles Movalli on *The Art of Landscape Painting*.

For getting a close look at landscape—close-up views of trees and snow and streams and leaves and blossoms—look at the work of Zoltan Szabo, which always provides a valuable reference. Szabo's watercolor technique is masterful and his work, prolific. He'll show you how to get shadows right in snow and how to paint the curl of a wave. Two of his books have provided sections for this book: *Zoltan Szabo Paints Landscapes* and *Painting Nature's Hidden Treasures*. His other books that might be useful for further study are *Landscape Painting in Watercolor, Creative Watercolor Techniques*, and *Zoltan Szabo: Artist at Work*.

By now you know how useful this book can be to your work and you are probably eager to act on your inspirations. Take these artists with you, study them. Your work can't help but be enriched.

PAINTING LANDSCAPES IN WATERCOLOR AND OIL

How do different artists approach the outdoors? Here you can watch them work. You can see how they analyze a situation. You can see when they move trees to satisfy a composition. You can watch them move the colors across the skies, across the snow, a farmhouse, a mountain peak in the morning light.

Artists as facile as Philip Jamison show how a series of paintings in watercolor can develop from the same subject. Albert Handell uses oils to capture the movement of trees and the play of light and shadow on a red barn. Here you have the opportunity to observe painters who work in watercolor and oil: Foster Caddell, Paul Strisik, Philip Jamison, and Albert Handell. How do they create a sense of place? How do they use shadow? When do they depart from the literal? From their step-by-step approaches you can learn how to improve your own skills.

Painting a Snowbound Farmhouse

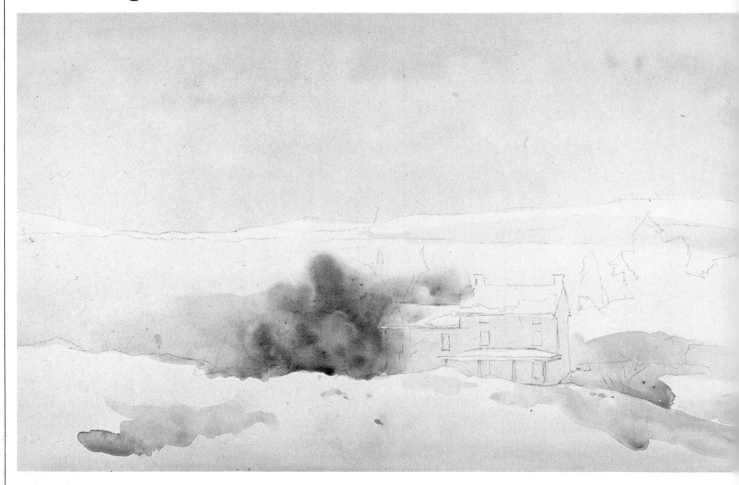

1. A two-hundred-year-old farmhouse, nestled in a valley near the artist's home, attracted his interest the first time he saw it many years ago. Since then he has done several paintings of it at various times of the year. In the winter, its red-painted tin roof stands out against the white blanket of snow that covers the hillside.

For this watercolor Philip Jamison chose a two-ply, 100-percent rag drawing paper with a medium-smooth surface, and stretched it on a board while damp. He wanted to paint the house from a distance in order to show its environment. His major concern was the division of the three main spaces in the composition: the sky, the very simple white foreground, and the center section, which contained practically all of the interest. After determining these shapes, he quickly painted the larger light areas. Using a 1-inch flat brush, he put a continuous wash over the sky, starting with a warm yellow ochre tint at the horizon and blending into a cooler mixture of Davy's gray and cobalt blue toward the top. He applied other light washes of Davy's gray to the house and the trees adjacent to it.

2. To indicate distant grasses adjacent to the sky area, Mr. Jamison selected various combinations of yellow ochre, raw umber, olive green, and burnt sienna in order to give the landscape a feeling of variety and color. Next he established his darkest value—the cluster of pine trees to the right of the house. Once this was done, it was easier to obtain the correct value relationships of succeeding washes by simply comparing them to this dark value. The pines were painted basically with olive green and ivory black, using a No. 12 sable brush. He was careful with the black: too much can easily kill the color of a painting. He applied a hint of wash to the house as he started considering its form.

3. Still working to establish the main values of the scene, he next put in a mixture of Indian red, alizarin, and Payne's gray for the strong red of the tin roof; then he painted the other roof with Payne's gray. He was careful to leave distinct patterns of snow on each roof. These became important elements of his design. To further define the form of the stuccoed house, he brushed a cool wash of Davy's gray onto the right side and under the porch. After dampening a small area of the paper with a 1-inch flat wash brush, he also dropped in some Davy's gray to suggest the trees on the distant hills. The tree area to the left of the house was similarly handled with Vandyke brown, to give it a bushlike quality. Against the dark pines he indicated another tree, painting the trunk and scratching out branches with a penknife.

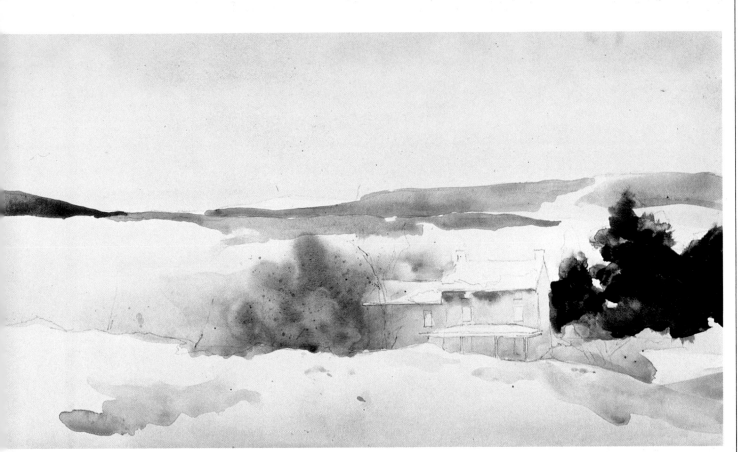

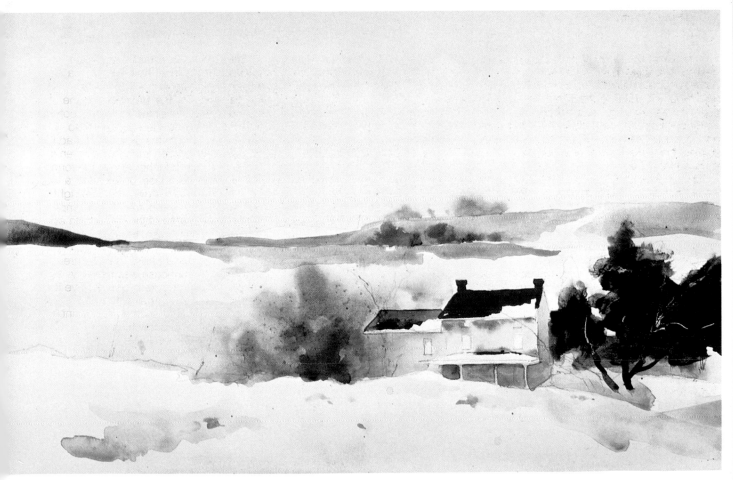

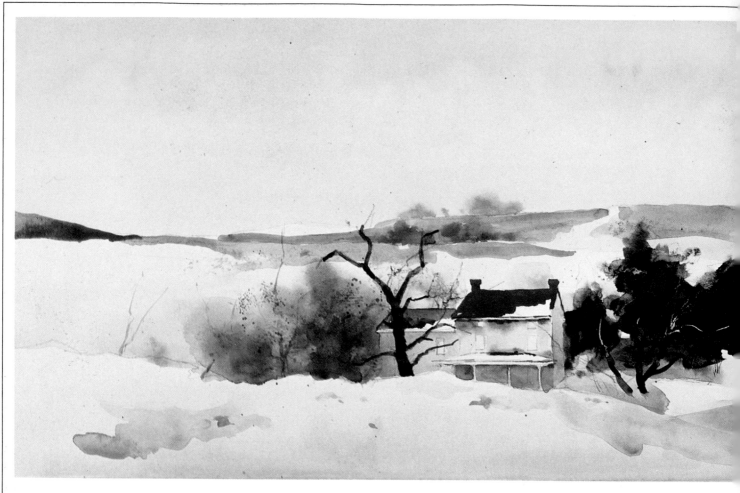

4. With tones of Davy's gray, Payne's gray, and Vandyke brown, Mr. Jamison painted the central tree in front of the house. This tree increased the feeling of depth in the watercolor and also added a stark, linear quality which contrasted with the rest of the painting.

Texture plays an important role in Jamison's work, and in most cases he builds it up in layers—some layers are painted wet-in-wet, some drybrushed, and still others are a combination of the two. He combined the two methods to further develop the distant hills and the trees to the left of the house. As the painting progressed, he continually worked over the entire paper, seldom finishing one area before proceeding to another. He added more form to the house by putting dark, warm tones of raw umber and raw sienna under the eave.

5. By this stage of the painting, all the main elements have been established and it is now simply a question of refinement. Mr. Jamison wanted to keep the sky area, which encompasses more than half the painting, very simple in concept but not overly empty. He added a single blend of Davy's gray and cerulean blue. Although it appears simple, he gave the shape and placement of this cloud more thought than any other single element in the painting. Small washes of Davy's gray were added to indicate the windows, and by adding thin layers of paint and creating texture, he further strengthened the central section of the painting.

6. During the final stage of this watercolor, as with most of Mr. Jamison's paintings, he spent more and more time planning than actually painting. After bringing the windows to what he felt was a "finished" state, he made many smaller refinements by adding various washes and textures. He also effected certain subtle changes by removing some areas with a wet sponge—a portion of the cool shadow in the left foreground, for example, and a small section of the dark pine trees. Then, after careful consideration, he added a spatter of opaque white to indicate falling snow. This is the only opaque watercolor used in the painting.

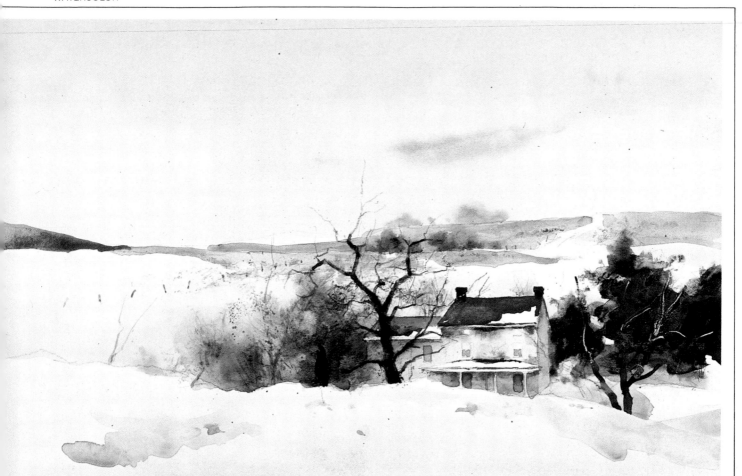

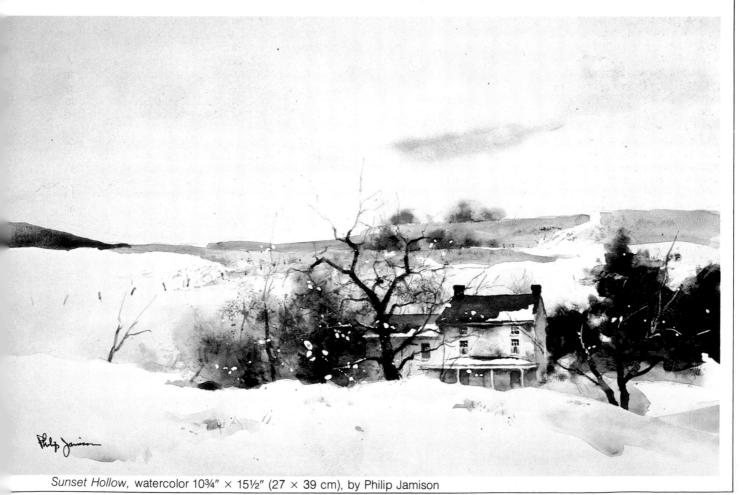

Sunset Hollow, watercolor 10¾″ × 15½″ (27 × 39 cm), by Philip Jamison

Developing a Series on the Same Subject

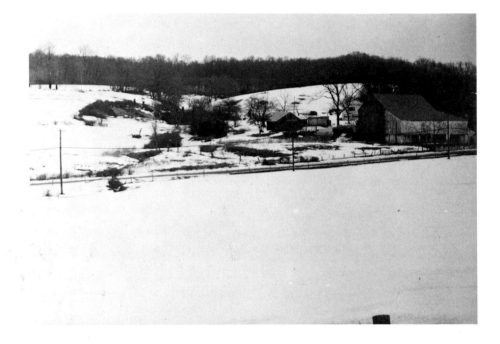

Occasionally, Mr. Jamison develops a series of paintings based on the same subject. It is not something he plans to do in advance; it just seems to evolve when his interest is aroused by a particular subject. Once he gets started, he often finds that it is difficult to stop because one idea, or even a change in a painting, will inspire another, almost like a chain reaction. At times he will repeat the same composition, hoping to improve it. When he has several watercolors in progress, he will constantly compare one painting in the series with another. Mr. Jamison finds this useful; a series gives him the opportunity to experiment and, at the same time, to study his subject in greater depth. The following five watercolors are part of a series he painted of a farm on Frank Road, near his home in West Chester, Pennsylvania.

The photograph above shows only one of the vantage points from which Mr. Jamison painted the following studies. Each painting varies greatly in its farm, outbuildings and in its surround-ing hills and trees.

For *Frank Road No. 1* Mr. Jamison chose a smooth four-ply drawing paper he likes to use when trying to get the "feel" of a subject. It has a rather hard surface, and the paint seems to float on top of the paper rather than become absorbed by it. Mr. Jamison finds that this is an advantage when he wishes to make changes because painted areas are so easily sponged out.

Initially, Mr. Jamison laid-in a warm gray-green underlay wash to tone down the sky area. After this dried, he brushed in the other large shapes quite directly, leaving both hard and soft edges. Because of the smoothness of the paper, most textures that he wanted had to be drybrushed over the washes later. In essence, this sketch consists of only two steps: applying the broad, wet washes first, and then adding drybrush detail over them. However, at a later date he did go back and change a few shapes to enhance the design. For example, he altered the pattern formed by the fields on the left.

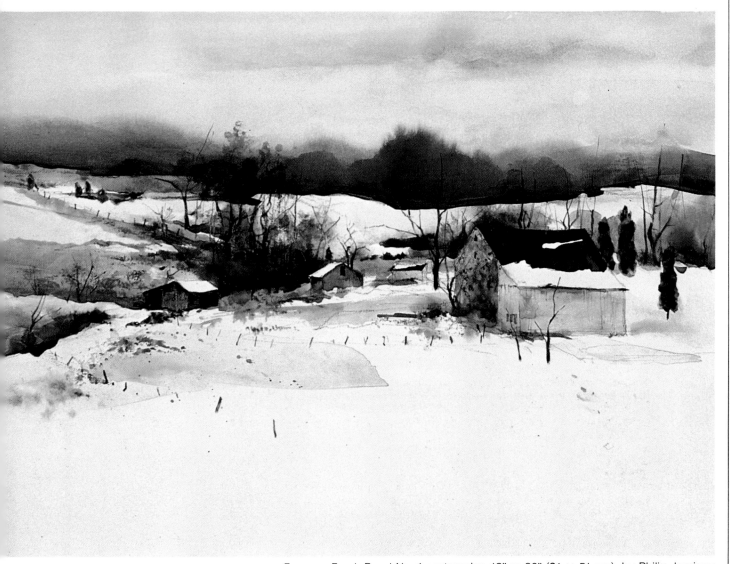

Farm on Frank Road No. 1, watercolor, 12″ × 20″ (31 × 51 cm), by Philip Jamison

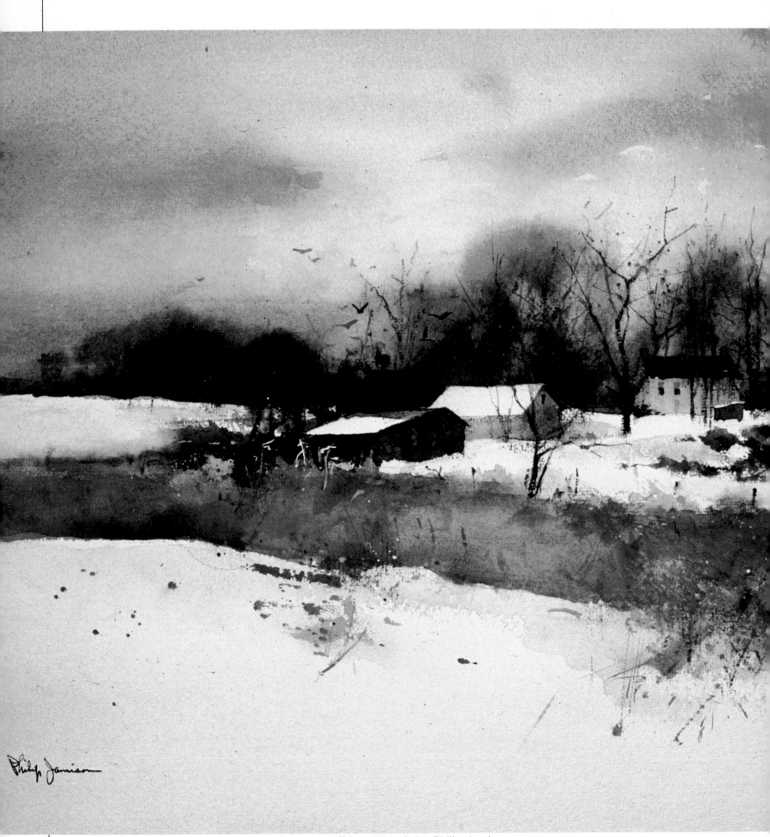

Farm on Frank Road No. 2, watercolor, 13″ × 19⅛″ (33 × 49 cm), by Philip Jamison

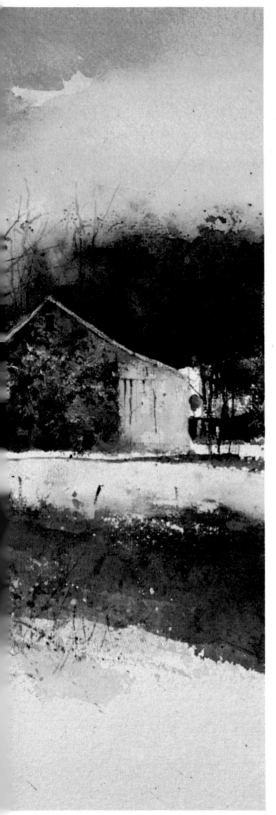

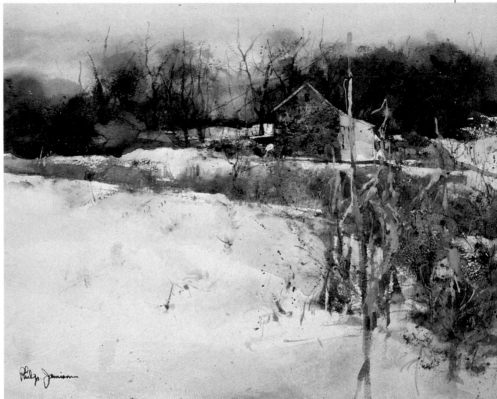

Farm on Frank Road No. 3, watercolor, 10″ × 13½″ (25 × 34 cm), by Philip Jamison

The artist stretched a piece of 140-pound semi-rough watercolor paper on a board to do *Frank Road No. 2,* a more sustained watercolor. As usual, he started by putting in a large, plain wash for the sky. After wetting the paper at the horizon line, he dropped in soft suggestions of trees using Davy's and Payne's grays. Next he applied the warm strip of grasses in an almost flat manner. Small washes were added next, to suggest the buildings and other areas of grass and brush. After Jamison defined all the large shapes, he went back and successively worked numerous layers of smaller washes into each area separately, in an attempt to create various textures. At the same time, he tried to keep the pattern simple. When the painting was almost finished, he added the cloud formations to enliven the sky.

Of the five paintings in the series, this one is the most faithful to the subject. But, while the main elements of the original scene are included, they have been simplified and strengthened to create a stronger design.

The unbalanced composition from this vantage point fascinated Mr. Jamison. In *Frank Road No. 3,* he wanted the large area of snow in the left foreground—fully one-third of the watercolor—to remain white. But if he wanted it to be consistent with the realistic quality of the painting, he could not just leave the paper blank. So he applied subtle washes of Davy's gray to suggest the receding plane of the snow and brushed in the merest hint of cornstalk stubs.

He felt the center of interest to be the stone barn, which is quite small on the paper. To reach the barn, the eye must travel past the large expanse of corn in the right foreground. Therefore he treated the cornfield as one mass, using layers of paint and always working to suggest the cornstalks and grass rather than portraying them in detail. As he progressed, he became very interested in textures; scarcely a space exists without many layers of paint. Mr. Jamison uses textures for their own sake, and to mold forms.

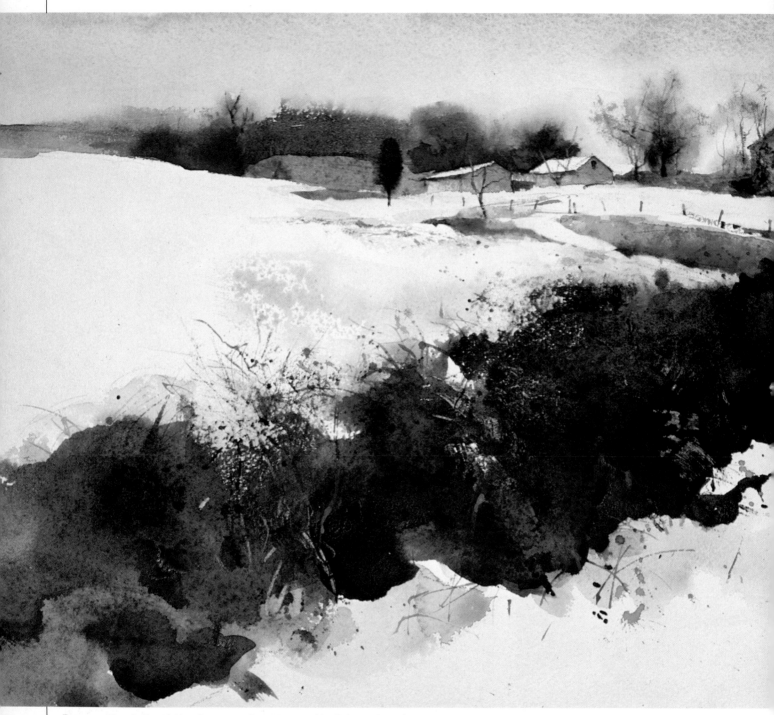

Farm on Frank Road No. 4, watercolor, 11″ × 18¾″ (28 × 48 cm), by Philip Jamison

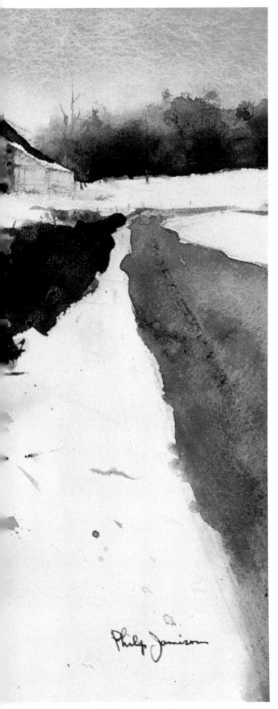

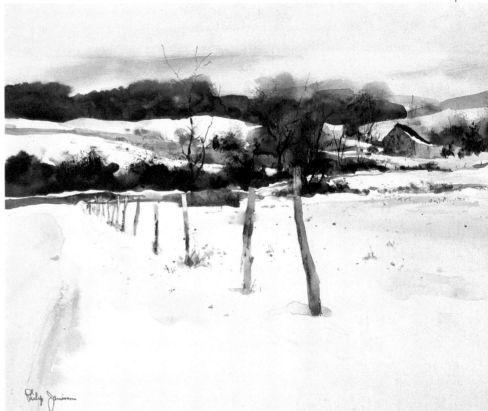

Farm on Frank Road No. 5, watercolor, 10¾″ × 13½″ (26 × 34 cm), by Philip Jamison

Mr. Jamison began *Frank Road No. 4* with an almost overpowering diagonal hedgerow of brownish brush, which forms an elongated triangle, one of many in the painting. Once the initial watercolor was "completed," he made a number of changes—not by adding anything, but by subtracting. The uppermost strip, including the sky and farm buildings, remains direct and fresh and almost as he originally painted it. The same holds true for all of the painted parts. However, all the white areas but one were originally grass or had suggestions of grass within them. The resulting busyness disturbed the artist, and so he began scrubbing out these sections with a natural sponge in order to simplify them. He achieved a chain of white shapes that balanced the darker triangles in a more dramatic way, lending strength to the composition.

One winter day as he drove down Frank Road, the artist's eye was drawn to a row of fenceposts. He was intrigued by the starkness of these vertical shafts standing in the soft blanket of snow. When he proceeded to paint *Frank Road No. 5,* Mr. Jamison also became aware of the way these foreground verticals contrasted with the background, which consisted almost entirely of horizontal elements. As in the first painting in this series, he used a four-ply drawing paper. Of the entire sequence, this is certainly the most directly painted: in most sections, the actual brushstrokes can easily be observed. To strengthen and simplify the composition, he altered the actual scene by "covering" a foreground road with snow, eliminating some extraneous detail and further emphasizing the horizontal shapes in the background.

Selecting a Value Scheme

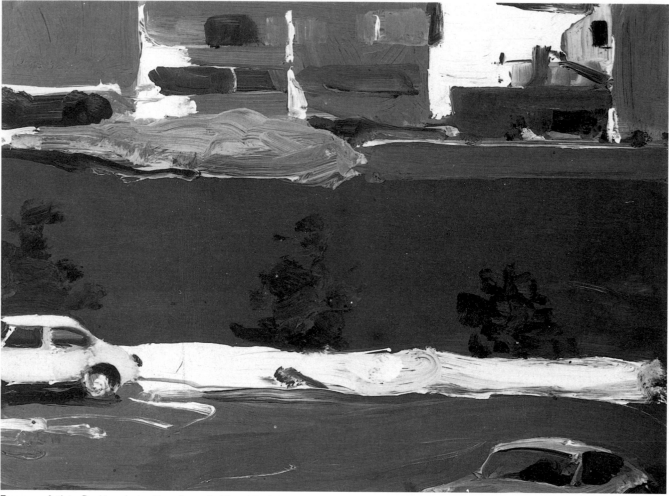

Famous Artists Parking Lot, oil on board, 9" × 12" (23 × 30 cm), by Charles Reid

In the eight sketches and paintings here and on the next three pages, artist Charles Reid has shown how to plan a basic value scheme. To make a strong statement, it is necessary to simplify one's values, although it may seem difficult to reduce a landscape to only two or three values. It is also hard to start thinking in terms of value shapes rather than specific objects because most people have been taught since childhood to make drawings look *real.* One must learn to ignore the objects and see the scene as a whole in order to paint. Shapes, good accurate shapes, are the key to realism, according to Mr. Reid. Notice how he has broken down the sketches for the four finished paintings here into broad shapes of two and three values.

This was already quite abstract as a painting, and so it is easy to see how Mr. Reid arrived at these value breakdowns. Notice how adding the darks strengthened the painting. Also notice how the sketch contains something of the essence of the final painting. (The subject of this painting is the parking lot of the Famous Artists School in Westport, Connecticut.)

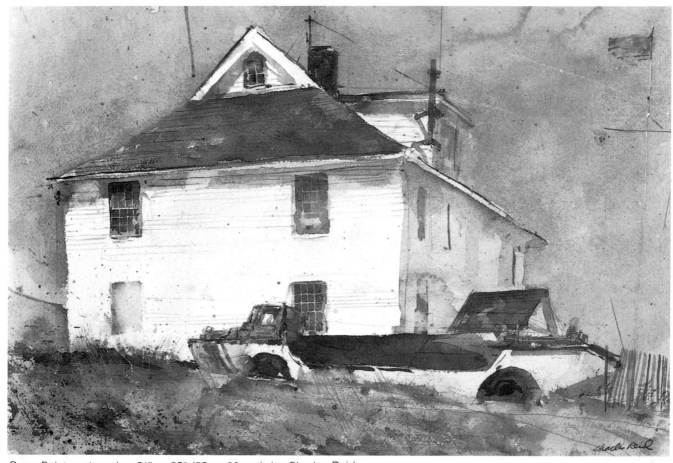

Race Point, watercolor, 21″ × 23″ (53 × 66 cm), by Charles Reid

Mr. Reid broke *Race Point* first into two values, then added a third value with some important darks: the chimney, left window, some small shapes in the grass, and darks in the boat in the middle distance.

The main point is that the first two or three value decisions made the picture. He could have added many small value changes after that, but they probably wouldn't improve the painting—in fact, they even might have hurt it.

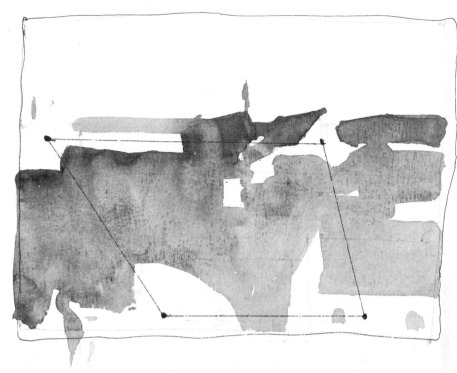

It wasn't really necessary to make an abstraction of this painting because it was already quite abstract. In fact, this little oil was originally done as a sketch for a proposed larger painting. Notice how all the darks are massed together and how the lights balance the darks. In color the definition is even clearer because, even though the values are close, there are warm and cool color changes.

This brings up another point the artist feels is important. He has often thought that if value changes are reduced and color changes are stressed instead, the result will be simpler and stronger paintings.

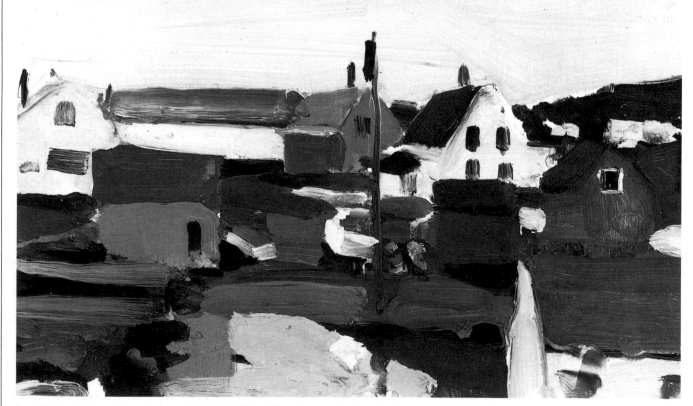

Port Clyde, Maine, oil on board, 9″ × 12″ (23 × 30 cm), by Charles Reid

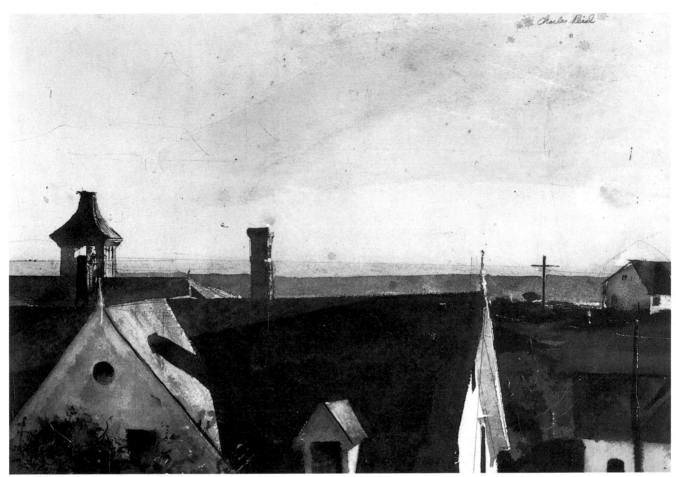

Block Island, R.I., watercolor, 21″ × 28″ (53 × 71 cm), by Charles Reid. Private collection

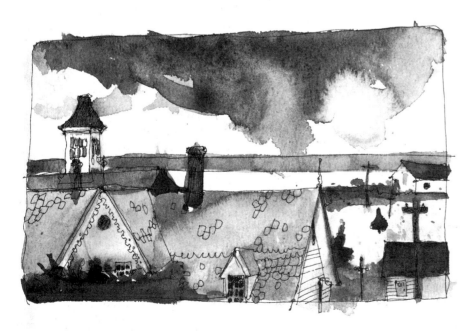

The composition of this painting of buildings on Block Island is different from the other examples. The light-and-dark breakdown was arranged not according to local values, but according to the way the light fell on these buildings and cast deep shadows. Because of these massed values, it is sometimes hard to see where one building or grassy area ends and another begins.

Mr. Reid has also included a sketch done in local values to show how the scene really looked. This also shows how different the composition looks when it is seen in terms of value rather than in terms of objects.

The important difference between the two interpretations is light. The painting was done in two sessions, under strong morning sunlight, whereas the sketch was based on imagining how the same scene would look under cloudy skies. Neither one would make a bad painting, but the point is that, even though the objects are in the same exact place, two interpretations of the same scene can be completely different.

Creating a Sense of Place

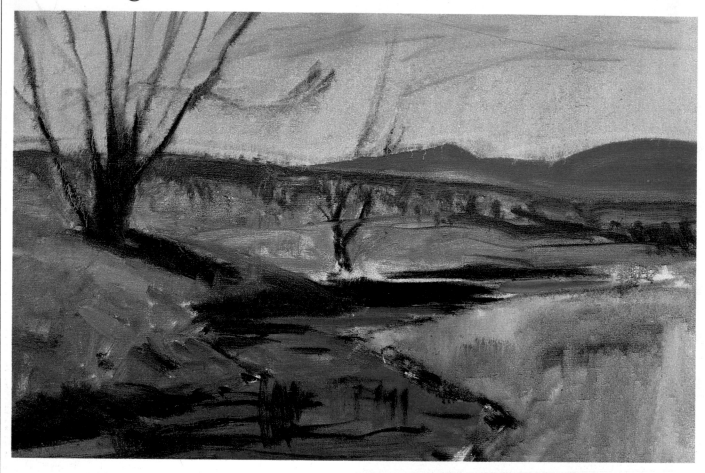

1. This is a typical stream in northern New Mexico; the ochrish colors of the grass and the earth predominate in autumn. Mr. Strisik walked for half a mile, searching for the right spot. Finally, he stopped here because of the large tree on the left, a strong dark among the otherwise similar tones of the landscape. The bridge also added interest. He decided to angle the stream to give it a more elegant contour and to enlarge the background mountain—its cool color would act as a foil to the warm earth tones. For the sky he used a wash of phthalo blue toned with yellow ochre. For the dark shadows he used a warm mixture of cadmium red medium and ivory black. Next he indicated the nearest part of the stream with ultramarine blue and a hint of alizarin crimson, and a few touches of orange to suggest the bottom of the stream. He painted the distant ridge of junipers with a dull gray-green mixture, and the background fields, yellow ochre dulled with a dab of cobalt blue.

2. Mr. Strisik wiped out a cloud or two with a rag, then began defining the background, buildings, and piñon trees. Next he drew the main tree, approximating the branches. He accentuated the bridge, brightened the rocks and put more paint onto the distant fields. Note that the darks under the edge of the bank—the area least affected by the sun—are the darkest parts of the picture.

3. He continued to work over all the canvas, adjusting values, shapes, and patterns. Slowly the painting came into focus. He developed the tree limbs and then painted the sky back into them, giving added definition. He also added light branches to the foreground tree to make some limbs come forward and to have others recede.

4. Back in the studio, Mr. Strisik completed the sky and worked on the anatomy of the trees, adding branches and small dead leaves. He completed the stream by adding some light greenish-blue reflections from the sky. He also lightened the distance in order to add atmosphere to the picture. He covered the far-off hills with a dull red earth (cadmium red medium and yellow ochre, grayed with a touch of cobalt blue). The fields became still warmer and yellower toward the foreground, but he kept the distant piñons a cool gray-green, suggesting their pattern instead of trying to describe each tree.

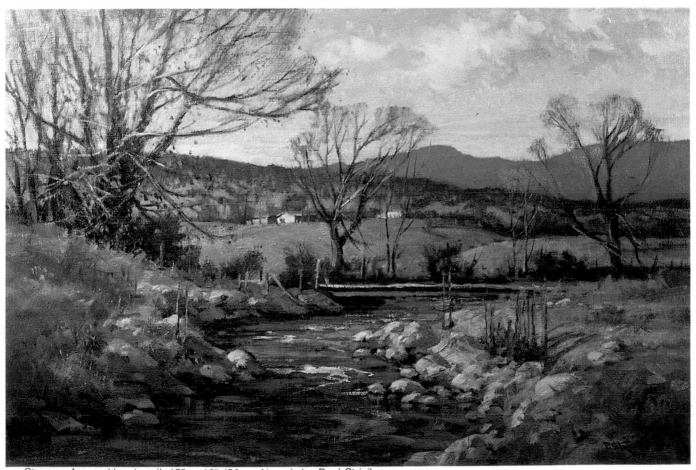

Stream, Arroyo Hondo, oil, 12″ × 16″ (30 × 41 cm), by Paul Strisik

Using Woodland Textures and Rhythms

1. Starting with a warm mixture of raw umber and Naples yellow, Mr. Handell lightly scrubbed in the trunk of the tree with a No. 6 round bristle brush. He worked thinly, using a combination of one part each damar varnish, linseed oil, and turpentine as his medium. Painting in the trunk gave him an immediate sense of the painting's design. To capture the rough texture of the trunk, Mr. Handell reworked the area. The opaque monochromatic underpainting was done with an assortment of round bristle brushes, using an opaque gray of raw umber and Naples yellow.

2. Mr. Handell brushed in the green background transparently for the most part with a No. 6 flat bristle brush and the medium he used in step 1. The yellow olive green, which was the overall tone of the foliage, was made up of cadmium green and yellow ochre. Using more color and less medium, he added more opaque touches. Then, mixing Maroger medium into his colors, he began to establish the variety of colors he saw in the trunk. The grays were made of black and white or by combining the three primaries, varying them with touches of ultramarine red, ultramarine blue, and Naples yellow. Smaller brushes, Nos. 2 and 4 round bristles, better expressed the rhythms. Although the tree and the foliage were not unified yet, Mr. Handell planned to float on a subtle green glaze later to bring the trunk and leaves together.

3. Starting in the middle of the painting where the green foliage was framed by the limbs and branches of the tree, Mr. Handell worked thinly with semi-opaque color, developing the foliage subtly and scumbling some of this green into the tree trunk so the two areas would become more united. At this point the underpainting was developed to a point

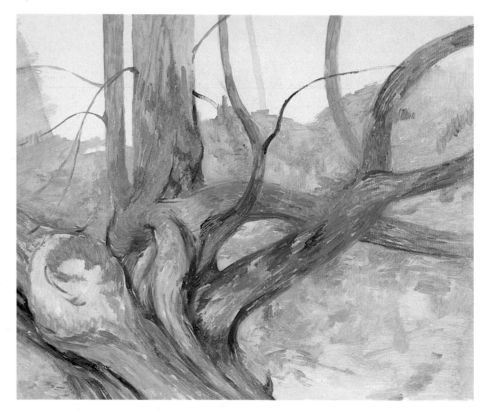

where it was ready for subtle unifying glazes. Since glazing must be done on a completely dry painting, Mr. Handell allowed the painting to dry for several days. Then the entire tree trunk and foliage were glazed with permanent green. He mixed the paint with Maroger medium—excellent for glazing—and scrubbed it on. In places he painted directly into the wet glaze to suggest leaves in the background, to establish some of the darker greens in the dense foliage under the extended limb, and to re-establish some of the darks in the trunk and branches. The glaze pulled the elements of the painting together.

4. Finishing the painting was only a matter of adding select details and textures. Mr. Handell added brushstrokes to capture the rhythm and movement of the foliage, using small brushes for details. He painted the sky with a light gray tone, the same value as the original color ground of the panel, and he gingerly painted in color variations of the bark—also with small brushes to capture texture and rhythm.

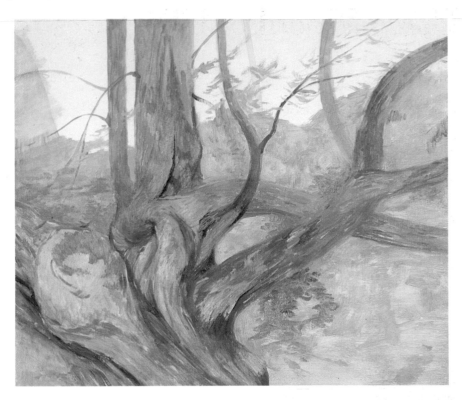

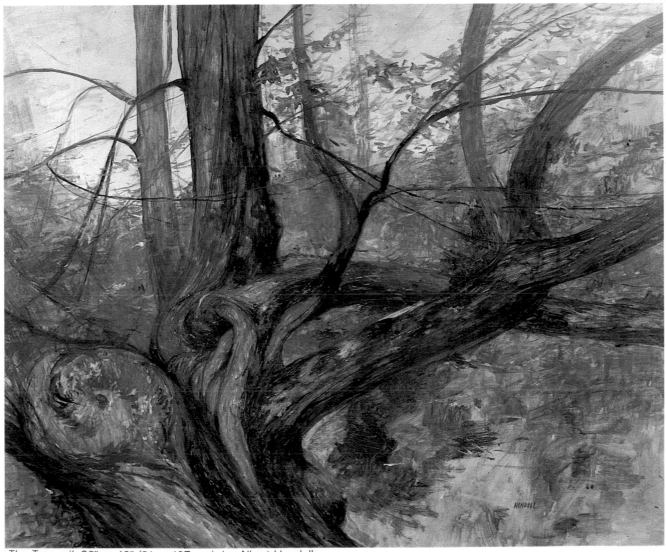

The Tree, oil, 36″ × 42″ (91 × 107 cm), by Albert Handell

Painting Structures in Bright Sun

1. *Sally's Red Barn* began with a loosely sketched-in pencil drawing. Mr. Handell then worked over this drawing lightly with turpentine and no color. This sealed in the drawing and also blended it a bit. He mixed cadmium red light into raw umber for the initial establishment of the rich, dark-reddish shadows of the barn. Then, mixing cerulean blue into raw umber and white, he applied a thin turpentine wash to establish shadows cast by the roof. These shadow areas created a sensation of sunlight immediately.

2. Using Maroger as his medium, Mr. Handell established the reds of the barn with cadmium red light mixed with a touch of raw sienna to decrease its intensity. He scrubbed in the colors transparently and semi-opaquely, covering all areas with a slow, controlled build-up of paint. The lower levels of the barn and the dormer were painted opaquely, as was the bluish cast shadow—cobalt blue—on the roof. The top half of the Dutch door to the right was painted opaquely while the bottom half was transparent. Mr. Handell left options open in this early stage as he felt his way around the picture.

3. A scrubbed-in feeling predominated while Handell planned and built slowly. He washed in the sunlit area of the foreground with a mixture of yellow ochre and raw umber diluted with turpentine as a base for the brilliant greens. For the shadow cast on the ground, he used a mixture of raw umber and some purple-gray tones. He then darkened the windows on the left and reinforced the line of the roof. To unify and harmonize the contrasting complementary colors, he put yellow ochre in the reds and in the tans of the foreground. He then began massing in the shadows of the roof using a combination of warm and cool grays of the same value. The light area of the roof was a mixture of Naples yellow, black, and white in a thin gray turpentine wash. He then started to indicate detail, such as the planks in the door.

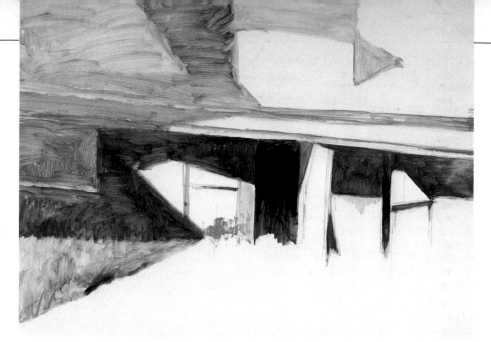

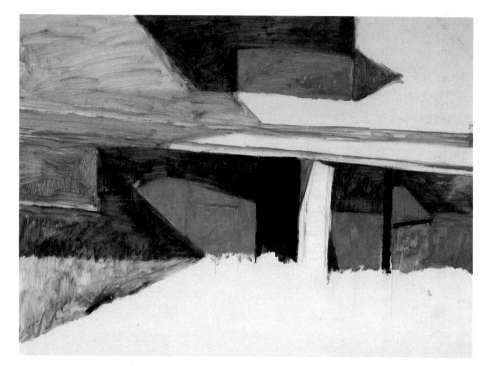

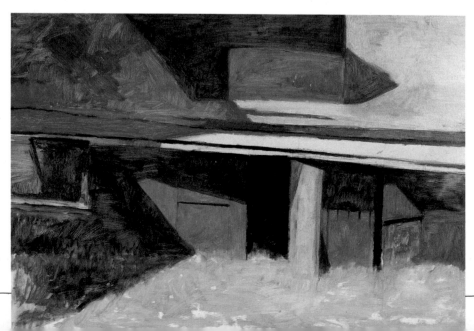

4. Next the lower roof and its upper ledge were established with opaque paint to emphasize the sunlight. The pink in the mixture harmonized the area with the surrounding reds. Mr. Handell mixed some permanent green with raw sienna to play down and integrate the siennas in the painting. As he painted in the ledge of the lower roof, he intensified the gray cast shadow on the door to tie up the textures of these shadow areas. He then worked over the entire picture, establishing areas opaquely with an eye to harmonizing the painting. The detail of the barn was added, as were darks in the windows. The shadow areas were re-established more opaquely throughout.

5. With clean palette and fresh paint, Mr. Handell contemplated the next step. In this final stage, he worked on every area of the painting and selected specific details to define. A bit of the green of the grass was mixed into the red barn—and conversely some of the barn color went into the green—to fuse and unite these two areas of complementary colors. He developed more variety in the greens, and incorporated subtle textures into both the light and shadow areas of the barn.

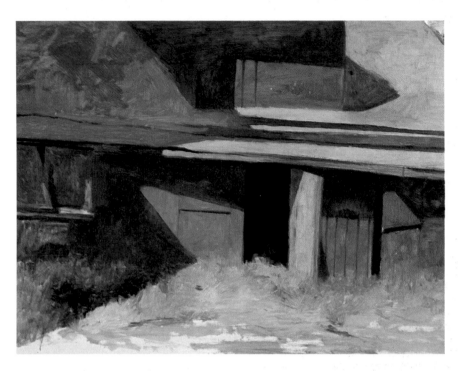

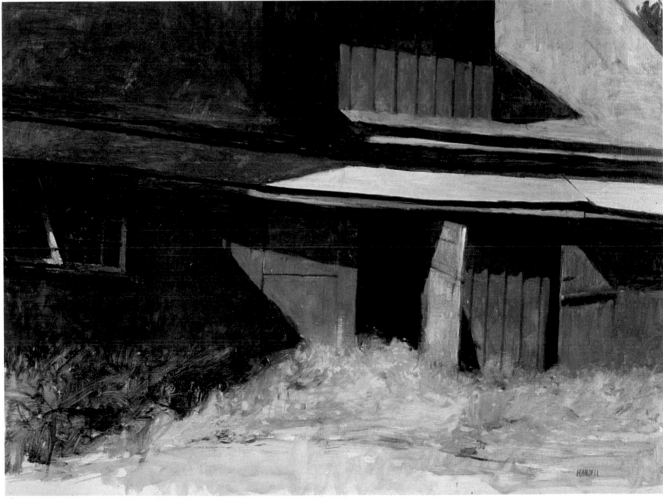

Sally's Red Barn, oil, 30" × 36" (76 × 91 cm), by Albert Handell

Capturing a Moment in Nature

1. To capture some of the elusiveness of the scene, Mr. Handell drew lightly on the panel with an IBM electronic scorer pencil No. 350. The responsivity of this soft graphite pencil allowed him to capture many nuances. He loosely sketched in the fallen tree, the sloping earth, and some of the surrounding branches and smaller trees, creating a sense of the elements that were to be part of the painting. With a clean No. 5 flat bristle brush, Mr. Handell floated turpentine over the entire panel drawing, washing it in with the rhythms and movements of the trees and the earth. This fixed the pencil drawing to the panel so that the washes that followed would go on cleanly.

2. Since he was painting a woods interior, he floated delicate greens over the entire painting, using lots of turpentine and letting it run. Then two important, basic elements of the painting were established: the drawing and placement, and a sense of pervading color, to which all colors thereafter would be keyed.

3. He then began building up the painting, still using turpentine as the medium but mixing a little less of it into his greens and browns to get darker tones. He allowed the thinly applied turpentine-saturated colors to run downward because he liked the spontaneous beauty these free-flowing runs added to the painting. Working outward from the center, keeping the wet watercolor effect, he established the denser buildup of the green foliage with mixtures of cadmium green light, permanent green, and sap green. For this he used a soft No. 4 red sable flat and Nos. 3 and 5 round bristles. Small strokes caught the "inner activity" of the scene for him.

4. Then, to intensify the entire painting, the artist worked on an angle from upper left to lower right, following the natural slant of the earth. The painting was then transformed from a loose wash into a painting with depth and dimension. The colors became richer and darker but were still luminous. Everything was there now, ready for completion, and Mr. Handell began to add suggestions of detail to the leaves and bark.

5. Right up to the end, he used turpentine washes with color. To lighten areas, he drew into the washes with a No. 4 flat red sable dipped in turpentine, then blotted out the area with a clean rag wrapped around his finger. (Sharpening edges for a crispness of detail can also be achieved through this method.) He used a bit of semi-opaque paint for variety and contrast on the left part of the fallen tree and for some of the green leaves that float over the tree. As particular details were emphasized, the underlying color wash created a unity and strength throughout the painting.

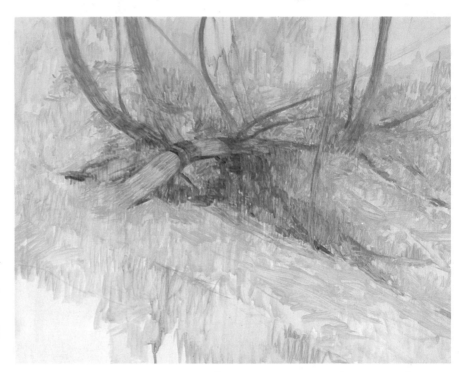

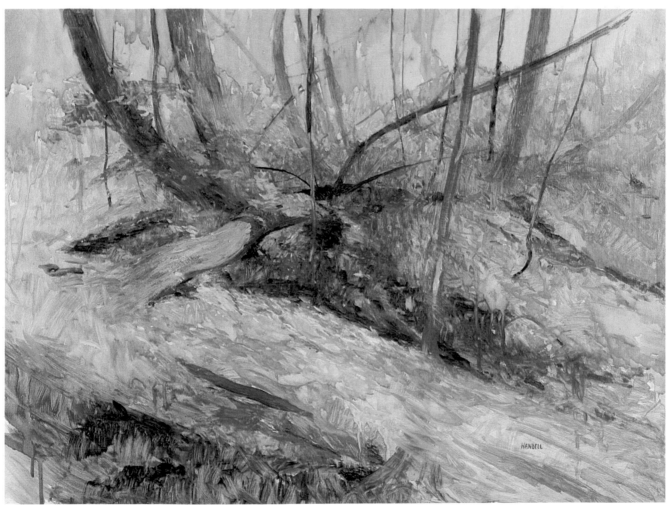

Woods Interior, oil, 24″ × 30″ (61 × 76 cm), by Albert Handell. Collection Bernard and Mary Paturel, The Bear Cafe, Bearsville, N.Y.

Painting a Wharf at Low Tide

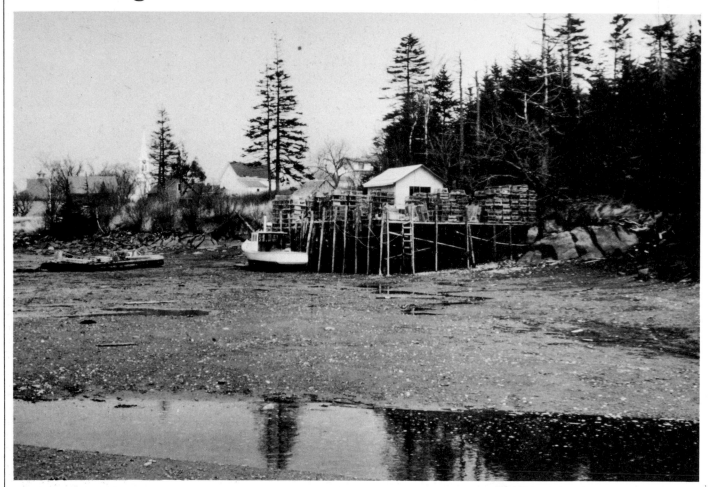

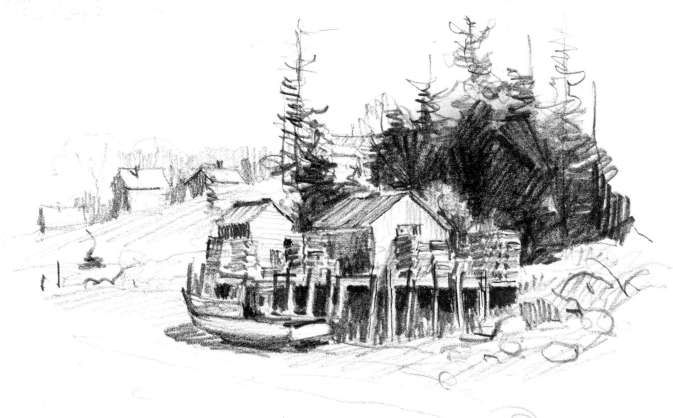

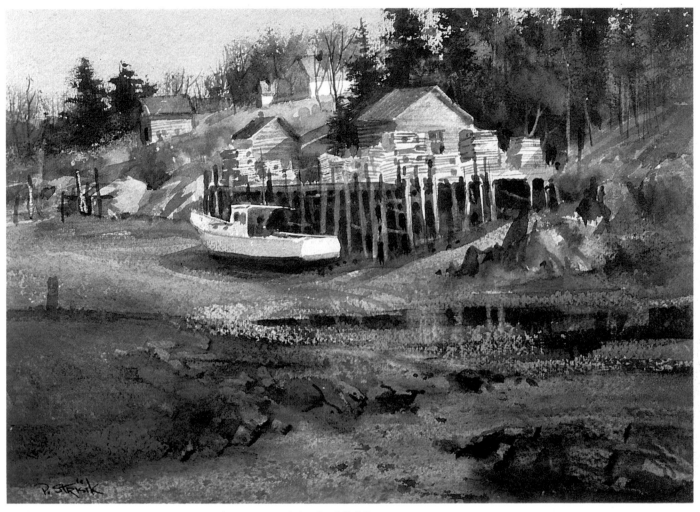

Clyde's Wharf, watercolor, 10″ × 14″ (25 × 36 cm), by Paul Strisik

When he first saw this area, Mr. Strisik was not very excited by it. He decided to draw, rather than paint, but by the time he'd finished his pencil sketch and worked out many of the compositional problems, he felt enthusiastic. He had become familiar with the place and had a better sense of its character.

In the painting, he gave a weathered tone to the newly built shack so that it would fit in better with the rustic subject matter. He used the mass of pine trees to set off the sunlit portion of the wharf. Since the factual appearance of these trees wasn't important, he did not try to copy them literally—what counts is their dark value against the light wharf—and so he made them into a decorative shape, eliminating tall pines that would have dwarfed and detracted from his center of interest. He also removed the distant church steeple; it was too arresting as a background element. Since the distant land mass slopes downward to the left, Mr. Strisik used dark pines at the far left to stop it from leading one's eyes out of the picture. The small poling on the left also functions as a stopping point. He gave the foreground water and mud a more dynamic design so it would lead the viewer into the painting.

Handling the Drama of a Hillside Scene

1. Mr. Strisik especially liked the diagonal of this hill—a welcome relief from the usual horizontal lines of a landscape. When he painted the first washes, he immediately established the silhouette of the land against the sky. Since he was particularly impressed by the rock outcropping, he emphasized it. He also planned to use the foreground rocks to lead the eye into the picture. For the brush he used a grayed reddish-violet, a mixture of cadmium red medium and ivory black. For the darks of the rocks, he used phthalo blue and burnt sienna, a color that gave a silvery, gray-green look to the shadows. These shadows harmonized with the greens in the grass which he painted with a very thin wash of phthalo blue and yellow ochre.

2. Next he added the suggestion of a distant mountain. The cool blue-violet mountain added vibrancy to the warm complementary greens of the foreground. He painted the gray clouds with burnt sienna, ultramarine blue, and white, applied in varying proportions and in a variety of different values. Yellow ochre and white formed the light portions of the clouds. Mr. Strisik decided that ultramarine blue was too warm to appear so low in the sky, so instead he used cobalt blue and white. The barn was painted a dull red and the sunlit parts of the rocks, a silvery gray-green mixture of cobalt blue, yellow ochre, and white. These rocks were a particularly attractive feature of the scene.

3. The artist made the foreground rocks large to pull that area forward and to give the picture depth. He painted the rocks on the hillside with strokes that reflected their geological character. In general they moved down the slope, following the lay of the land, but near the base of the hill, the downward movement was opposed by rocks angled in a contrary direction. The vertical trees also served as a counterpoint to the angular sweep of the hills. He painted the brush with cadmium red medium, ivory black, and white. For the grass he used phthalo blue, cadmium yellow, and yellow ochre. Once he had painted the sunlit tree trunks—with the same color used for the sunlit rocks—he had enough information to finish the painting in the studio.

4. In the end he decided to open up the sky near the horizon, using phthalo blue, white, and a touch of yellow ochre. This clean blue-green harmonized with the reds of the landscape. Some of the trees in front of the barn were removed to emphasize the silhouette. Richer grass tones were created with phthalo blue and cadmium yellow medium and were worked over the land in broken strokes. By lightening and warming, he suggested reflected light and increased the picture's luminosity. The darks in the foreground also gained strength.

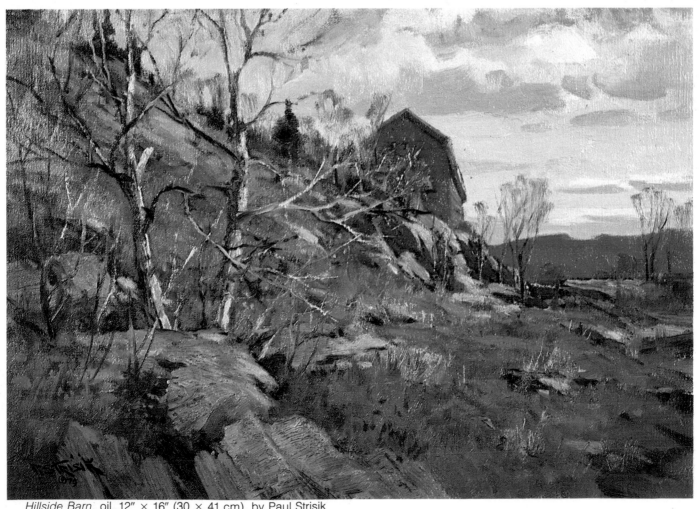

Hillside Barn, oil, 12″ × 16″ (30 × 41 cm), by Paul Strisik

Dealing with Strong Contrasts

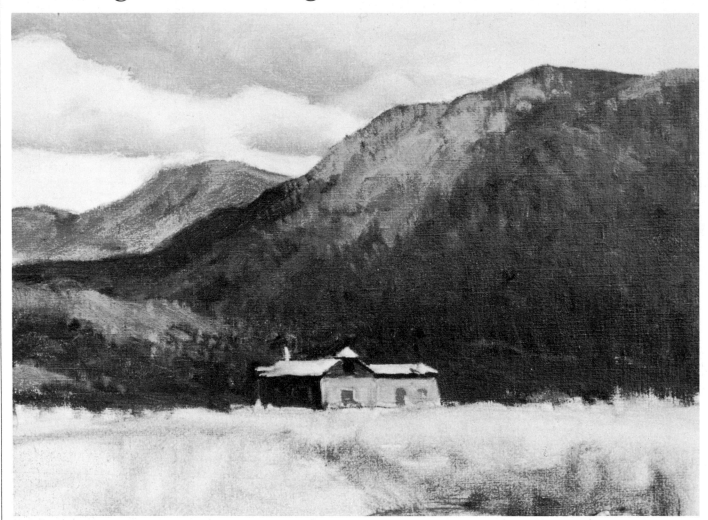

1. The artist was attracted by the strong contrast between the sunlit foreground and the shadowed mass of the distant mountain. The effect was heightened by the natural lightness of the aspens and the dried foreground grasses. In the first step Mr. Strisik covered his canvas and established both his basic colors and his darkest and lightest values. He did this by quickly distributing his main masses with washes of color. The sky changed rapidly and he painted the cloud shadows with white, ultramarine blue, and burnt sienna. For the sunny areas of the clouds, he used more white and some yellow ochre. He mixed ultramarine blue and ivory black for the mountain range, warming it with cadmium red medium where it received light in the distance. For the basic hue of the adobe farm he used burnt sienna, with white added in the light areas and ultramarine blue in the shadow. In the lightest portions of the foreground grass he put yellow ochre, and to the darker areas he added burnt sienna and ultramarine blue.

2. At this stage the artist wanted to suggest areas of light without disrupting the impressive mass of the mountain. In the distance he grayed the mountain with terra rose and white, which made a dull, cool red. He painted the sunlit area of the hill in the middle distance with chromium oxide green opaque, grayed slightly to make it stay back in space. He added a touch of phthalo blue, mixed with yellow ochre and white, to the sky near the horizon, suggesting clear mountain air. For the metal roof he used a high-key, silvery blue-green.

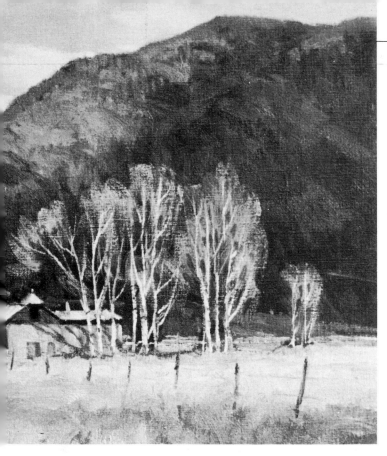

3. Next Mr. Strisik added the light trees, some overlapping the barn and others showing in the distance. He also varied their sizes. Since he wouldn't be painting every branch, he used a worn No. 2 filbert to paint the trunks and principal branches over the half-dry wash. For this he selected white with a touch of yellow ochre. Once he had the main branches drawn, he scumbled the same tone, darkened slightly with the mountain color, over the trees to suggest masses of small branches. He placed a few dots of mountain color among these branches, clarifying the drawing and suggesting open spots. Next he began to draw the building more accurately. He painted the foreground with yellow ochre and burnt sienna, occasionally adding gray-violet to suggest areas of shadow. Because he found the cloud shapes distracting, he flattened them. Next he added the western fence. Note how the posts are dark against the light grass and light against the dark mountain.

4. Back in the studio the artist decided to eliminate much of the light from the nearest hill. He did not want to lose the inky black feeling of the mountain mass, but he did put some light at the upper right in order not to have the shape too flat. He added shadow to the left side of the roof, thus concentrating his main lights at the right, near the trees. He raised the value of the foreground grass, bringing it nearer to the yellow-white appearance it had on the spot. Note that the brightest area is next to the trees, the center of interest. The shadows on the field were created with raw sienna and touches of cadmium red medium, ultramarine blue, and white. He used larger strokes to suggest the nearness of grasses and other materials.

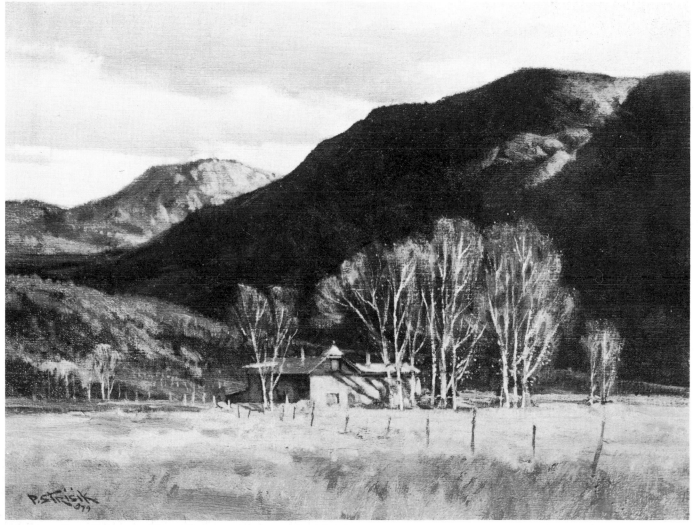

Arroyo Seco Farm, oil, 12″ × 16″ (30 × 41 cm), by Paul Strisik

Painting Mountains in Morning Light

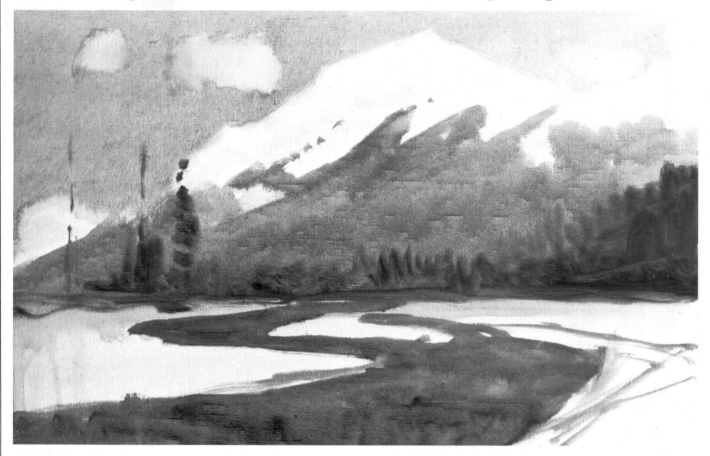

1. At this site, Mr. Strisik was impressed by the sparkling morning light of late October, just after a snowstorm, when the snow was still on the trees and the distant mountain. The water looked unbelievably rich and blue in color. He decided on a simple foreground as an entrance to the picture. He washed-in the sky with cobalt blue and a touch of yellow ochre, then wiped out clouds and the top edge of the snow-capped mountain with a rag. He indicated distant trees with a mixture of chromium oxide green opaque and ivory black. For the trees in the middle distance he used the same mixture, darkened, and added blue to the shadows. For the river he selected phthalo blue, tempered with raw sienna to keep the blue from looking too "raw." He added more ultramarine blue to the stream in the foreground, using orange here and there to suggest areas where the stream's bottom showed through.

2. Next he developed the mountain. For the trees on the mountainside he mixed chromium oxide green opaque, white and ivory black. The green became lighter in value and less intense in color as it moved away from the foreground. The shadows on the peak weren't very dark since the clouds hanging among the mountains acted as reflectors, bouncing light down into everything. To the snow on the mountaintop Mr. Strisik added a touch of cadmium orange for the cap. A hint of phthalo blue softened the shadow areas.

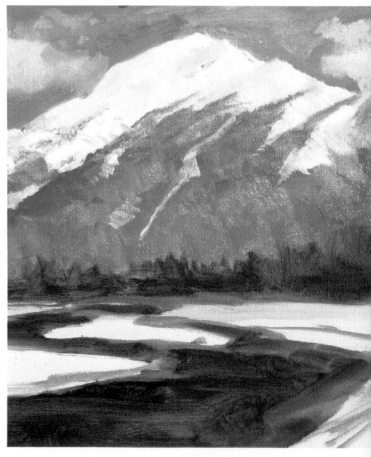

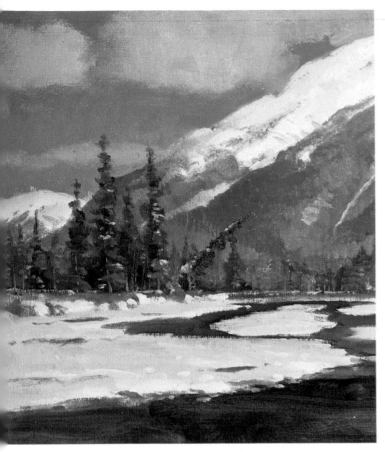

3. With more pigment on his brush, he strengthened the sky, grading it to a greenish blue at the horizon. He painted the clouds yellow ochre and white, muted with a bit of sky color, because, unlike the reflective surface of the snow, the clouds absorb light and appear less white. Distant trees were suggested with small vertical strokes. The trees in the middle distance were darkened with ultramarine blue and burnt sienna. He combined phthalo blue and orange for the areas in light and here and there the color was tempered with yellow. The trees here were nearest and therefore the most detailed. In the foreground, the horizontal areas of snow received less light than the more vertical planes. In the distance, a bit of ultramarine blue gave the snow a more atmospheric, violet character. The sunlit area of snow was painted white with yellow and became more orange as it receded.

4. In the studio, he modeled the clouds, making them pinker and duller nearer the horizon. He painted the distant water with simple horizontal strokes, using the same color applied to the lower part of the sky. In the near foreground, where the stream became more turbulent and active, he used richer colors: phthalo blue with burnt sienna and orange. A few random darks suggested the reflections of the background pines. He touched the sunlit rocks with yellow ochre and white and modified the distracting, fingerlike shapes of the masses of foliage near the mountain's peak.

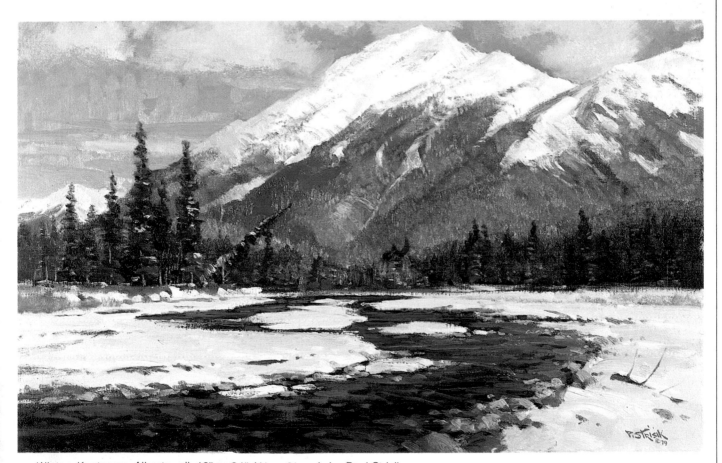

Winter, Kootenay, Alberta, oil, 16" × 24" (41 × 61 cm), by Paul Strisik

Using Decorative Patterns of Light

In the next eight pages Foster Caddell selected a series of paintings that present problems often confronted by students. His own approach to the same subjects offers solutions that are also discussed in the text.

The main improvement Mr. Caddell introduced here was the decorative use of shadows traversing the road and climbing the fence and house. In doing this one must always be aware of the source of light. The orange tree in the center was handled in a way that gave Mr. Caddell an excuse to play a decorative shadow pattern over the structure of the house as well. He demonstrated, too, that the play of light on the fence is much more interesting than showing each picket. The tree on the right is still large but here there is space to play colorful foliage around it. Moving it into the painting throws the road off-center, and its cast shadow on the foreground eliminates the harsh lines of the road.

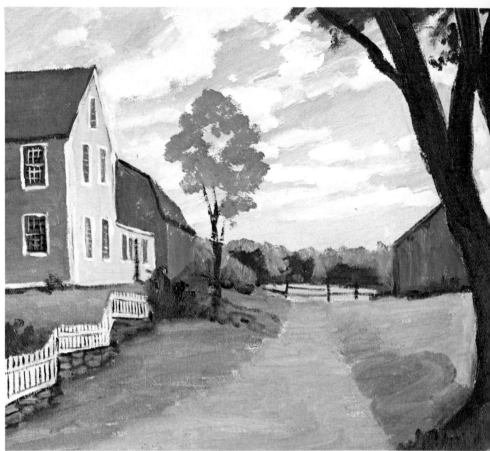

POOR

BETTER

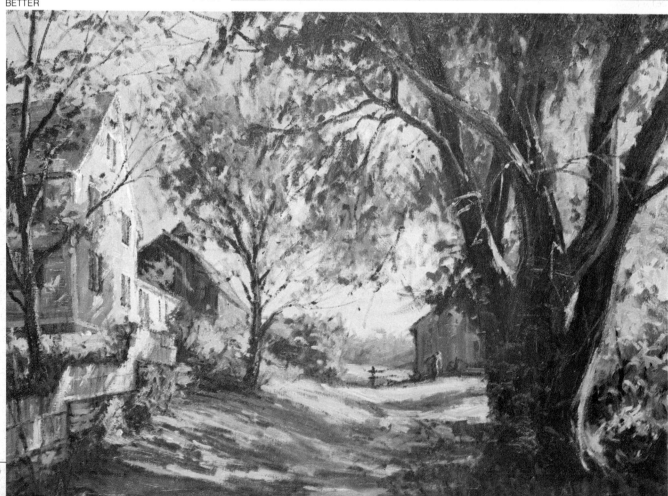

Sunshine and Shadows, oil, 24" × 30" (61 × 76 cm), by Foster Caddell. Collection Mr. and Mrs. Wilfred Jodoin

Creating Shadow to Enhance Design

Mr. Caddell always stresses that the pattern and design of lights and darks are as important as the design of the objects themselves. Two main points have been achieved by the use of shadow patterns in the painting below. The shadow patterns have broken up and tempered the unfortunate linear design of the road. The shadows also give the viewer a marvelous sense of form and texture in the areas they pass over. The horizontal pattern of the shadows over the road in the painting below is now a more dominant factor than the vertical design of the road itself. Notice how cleverly the shadow shapes are made larger in the foreground and diminish as they go back into the picture—a marvelous device to aid the illusion of depth. Note too how the feeling of form and contour to the land and grasses is greatly helped by the drawing line on the edges of the shadows. The hard-packed, concave shape of the wheel ruts and the vertical depth of the grasses and weeds come across mostly because of the diversified handling of the shadow pattern edges.

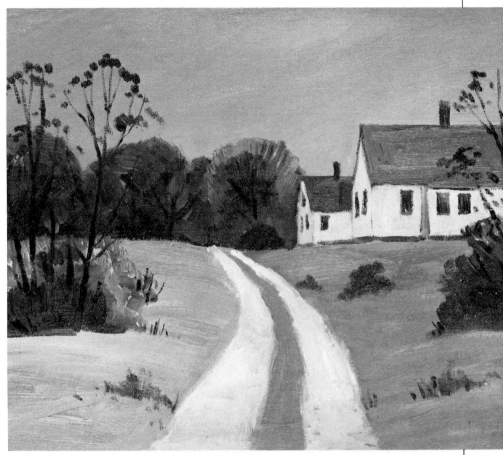

POOR

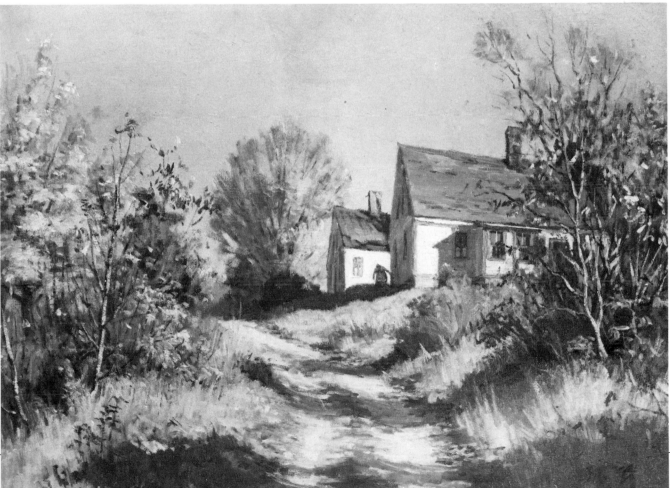

BETTER

Beach Dale Lane, oil, 24" × 30' (61 × 76 cm) by Foster Cacdell. Collection Mr. and Mrs. Emerson R. Naugle

Departing from the Literal

The rendition below has a harmony of warm tones that was achieved by painting a sky warmer than it actually appeared at first. The luminosity of a hot, sultry, Indian summer day then became evident. This effect was achieved by using high-keyed yellow, pink, and blue in an impressionistic manner with the warm tones dominating. Mr. Caddell made the sky harmonize with the warm autumn grasses and made the sky a pleasing complement to the cooler variations in the old, weathered boards. Notice, too, the colorful accent he provided with the old rusted lightning rod running along the ridge of the roof. The suggestion of color he added in the roof shingles and on the weathered boards up under the eaves rounded out the overall tonal harmony.

Notice how Mr. Caddell made the most of the sloping hill and how he adjusted the sizes of the trees for a less symmetrical solution. By shifting his vantage point, the cupola became off-center and allowed for a more interesting design. This shift also put a small portion of the barn in sunlight.

POOR

BETTER

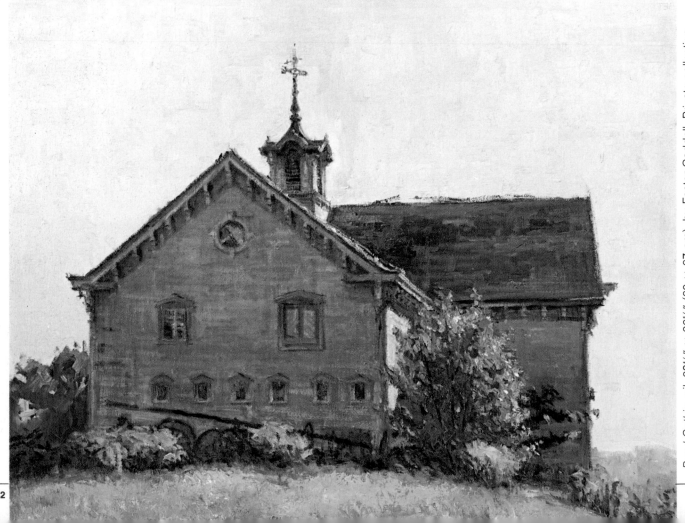

Rural Gothic, oil, 23½" × 26½" (60 × 67 cm), by Foster Caddell. Private collection

42

Evoking Moonlight

This painting contains the two ingredients missing in the painting at right: color and luminosity. Mr. Caddell has made the viewer sense where the light is coming from in the sky without it rivaling the foreground. Also, Mr. Caddell has not seen moonlight as stages of blue. He introduced color into the grasses and bushes. The light sides of the buildings were given more color as well, yet they remain restrained. He even painted the snow with soft variations of color. He also handled the water area with more color and detail. Mr. Caddell used luminosity in his overall concept. With more light present, he feels, one can "see" more colors.

Notice how Mr. Caddell painted the darks of the foreground tree on the right darker than the dark area under the barn directly behind it. This progressive lightening of darks takes place once again in the distant trees behind the barn, which are another step lighter. He has shown that the very same progression of values that takes place in the daytime should take place in moonlight.

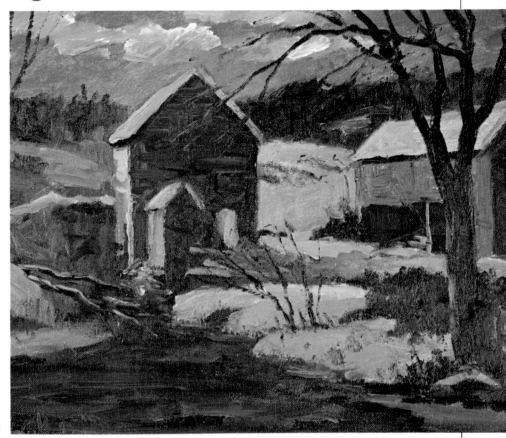

POOR

BETTER

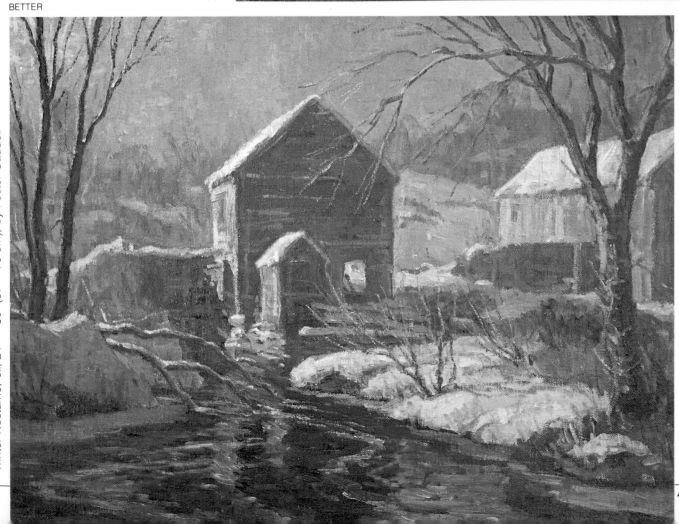

Winter Nocturne, oil, 24" × 30" (61 × 76 cm), by Foster Caddell

43

Achieving Luminosity in Shadows

Incorporating a range of values within the shadow areas of a painting, without destroying its solidity of design, is not easy. But if it is done correctly, as Mr. Caddell demonstrates in the work below, one can maintain brilliance in the lights and achieve luminosity in the shadows, avoiding the static quality of the painting at right. Notice how the luminosity in the work below is helped by strategically using very dark darks here and there, which make the general shadow areas look relatively lighter. A good example of this is the darks behind the tree trunk on the left. The foreground of the painting below has been given a rhythmical curve and flow which leads down the path to the center of interest. Allowing more area at the top of the painting, has enabled Mr. Caddell to expand the large elm farther over in the composition. The sky area has been helped with a subtle design of clouds. To balance the composition, Mr. Caddell introduced another tree on the right. Notice how it leans into the picture. The hills are now atmospheric in value and color, and the added tree helps push them back into the distance.

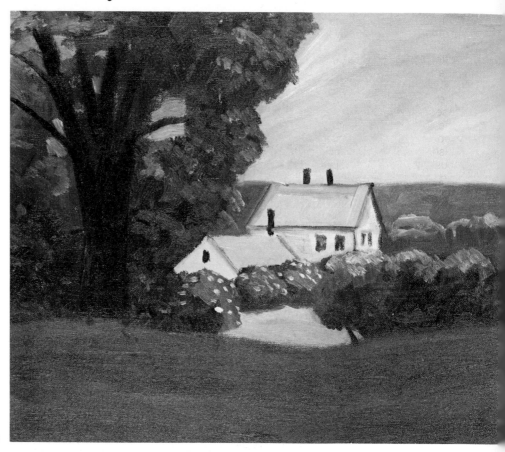

POOR

BETTER

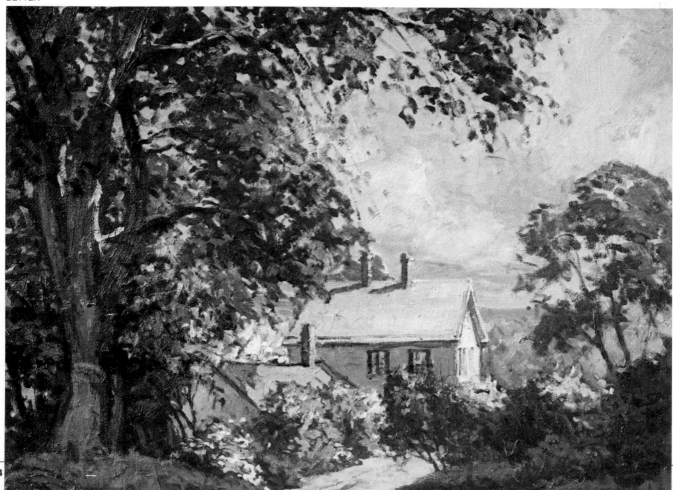

Lilac Time, oil, 24" × 30" (61 × 76 cm), by Foster Caddell. Collection Mr. and Mrs. Gary Roode

44

Perceiving Colors in White Clouds

Mr. Caddell painted the large, billowy cumulus clouds in his painting, below, without going to the highkeyed white so often employed. Notice how he painted the white farmhouse unrivaled by the sky full of clouds. Not only did he paint the clouds restrained in value, he also used colors in them. Notice, too, that the colors in the rest of the painting are repeated in the sky, but in a muted fashion. Mr. Caddell moved the sumac bushes so that the upper field would be smaller in size than the lower one, enhancing the effect of distance and creating a much better design. He also used a cast shadow over the center of the sumac to break up the pattern.

Mr. Caddell's elimination of the barrier effect allows the eye to travel quite easily into the painting. He gave the bushes themselves a greater feeling of detail. He also moved the remains of an old stone wall farther into the composition and threw this lower right-hand corner into shadow. A group of trees down the hill to the left was brought up into the picture, helping to balance the composition.

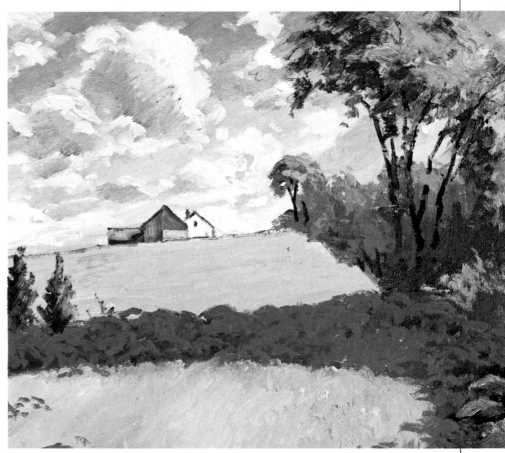

POOR

BETTER

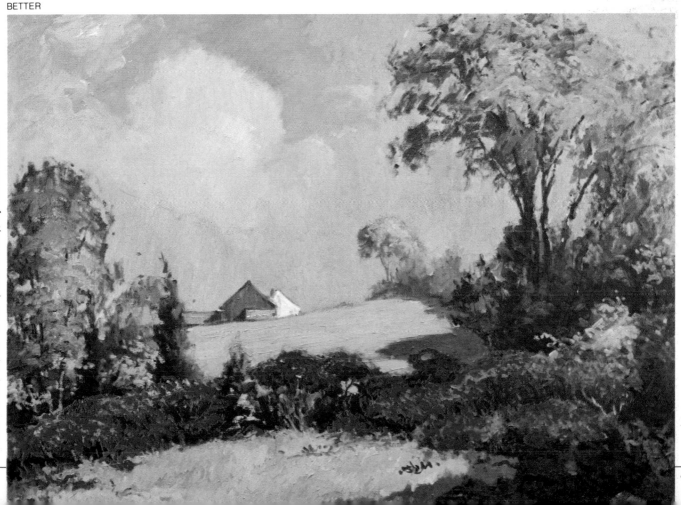

Gardner's Hill, oil, 30" × 36" (76 × 91 cm), by Foster Caddell

Keeping Shadow and Light Patterns Consistent

In the painting below one can readily see that the shadow and light patterns are consistent—the morning sun that hits the old house throws the tree shadows backward, not forward. Also note how Mr. Caddell has used these tree shadows in a decorative way. A painter can give a feeling of the terrain by the way shadows play over it—notice how they climb the bank on the right. Mr. Caddell has done several things that have improved the work below. He has brought forward the tree on the left and enlarged it, giving a definite progression in the trees as they go back into the painting. The road was improved in design and converted to dirt, a device Mr. Caddell often relies on to add charm to a scene. He stresses once again that the key to all design problems is diversification; avoid repetition. Keeping this in mind, he has painted the tree on the left with only a small amount of foliage showing. The next tree on the right has a different trunk design, and the foliage goes off the canvas in a lacy decorative way.

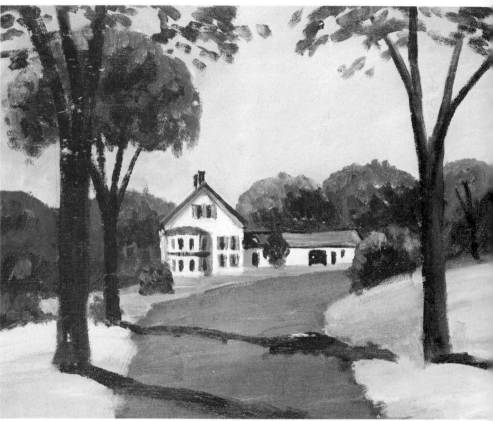

POOR

BETTER

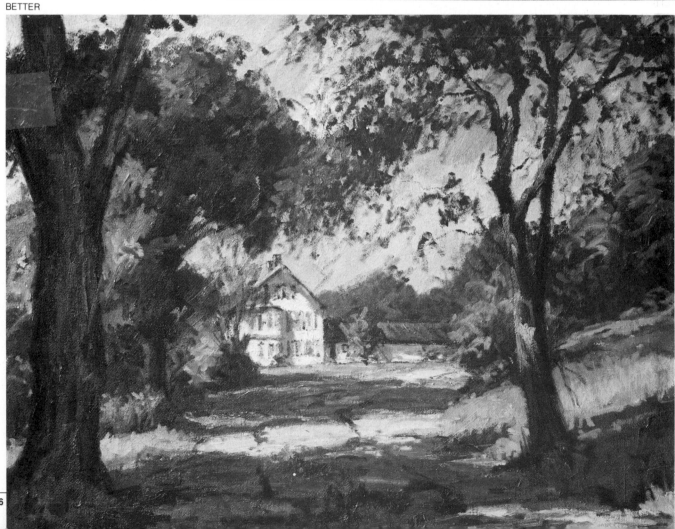

Regal Victorian, oil, 24" × 30" (61 × 76 cm) by Foster Caddell

46

Imagining Skies

This sky is purely out of Mr. Caddell's imagination. Skies, he feels, seldom happen exactly as one wants them to. The sky in the painting below is not only more dramatic than the sky actually was, but it also gives a darker value to play the trees against and a logical excuse to throw the distant hills into cloud shadows. Now the flaming trees have greater importance because they play against darks. There are other improvements in the composition below as well. Mr. Caddell has heightened the trees on the right and left to avoid any unfortunate alignments. By converting the road to dirt, he gave it charm and character to complement the old farm buildings. He added the shadow in the foreground to complement the strong geometric patterns of the building and to make the foreground more interesting. Notice not only the addition of a figure, but also see that he does not appear to have any legs. This tells the viewer that the land dips down as it goes around the bend.

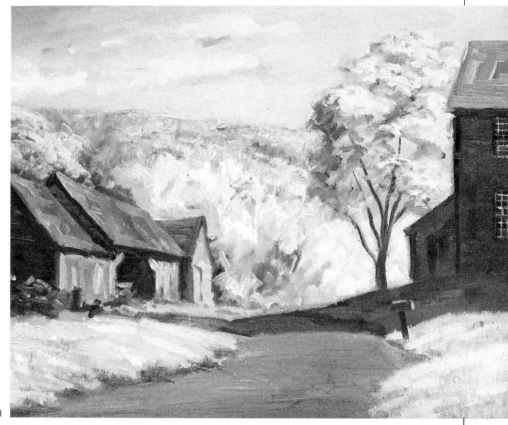

POOR

BETTER

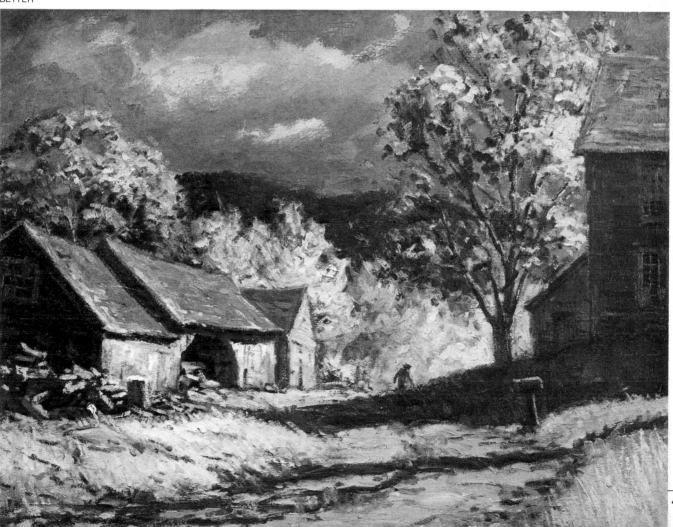

Autumn Splendor, oil, 20″ × 24″ (51 × 6ʳ cm), by Foster Caddell

Dealing with a Strong Directional Thrust

When a strong directional thrust threatens to sweep the viewer's eye out of a composition, one should put a "block" there to stop the exit and turn the eye back into the painting. Here Mr. Caddell created a block by introducing the tree at the right. Notice that the height of the tree is important also—it is not as tall as the birches in the left foreground, but it is taller than the pines farther back on the left. In the painting below, the water channel was more thoughtfully designed. The area of weeds in the lower right was also enlarged and developed with greater detail. The birches and bare peninsula were moved into the painting for a better design. By including the birches Mr. Caddell also kept the area of fir trees in the middleground. The distant plane was enlarged in size as well. Its main directional thrust now brings the viewer's eye back into the composition. The sky was made up, but Mr. Caddell feels it was the necessary touch to take this painting out of the realm of the ordinary.

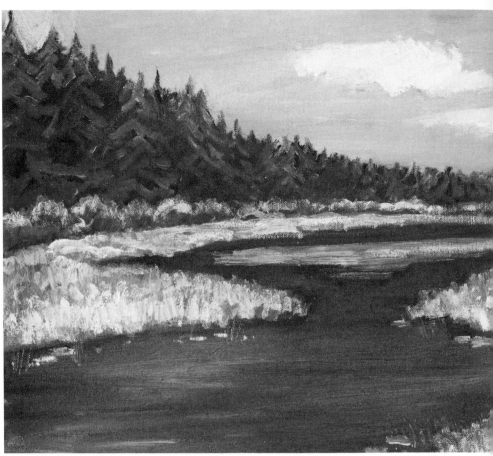

POOR

BETTER

Storm's End, oil, 24" × 30" (61 × 76 cm) by Foster Caddell

Finding Colors in Snow

Notice that there is not one spot in the painting below that is just white. Mr. Caddell painted this work on location, even though the temperature was 20 degrees. It was the only way for him to get the real feel of the place. Notice the artist's use of blues and purples in the foreground shadows and the yellows and pinks in the highlights. He also used vibrant color in the other elements of this snow scene: the bare trees were interpreted with color and painted so that one senses a distance beyond them. Compare this treatment to the solid statement "trees" at right. Even Mr. Caddell's ice has color: note a bit of yellow ochre in the gray. He caught, too, the winter sun's long shadow patterns extending out over the ice. Although the stream was actually frozen over, as in the demonstration at right, Mr. Caddell showed water in the channel—again creating more interest. The foreground grasses and bushes enabled him to introduce more color, which he repeated in the sky. But he played the clouds down so they would not rival the snow.

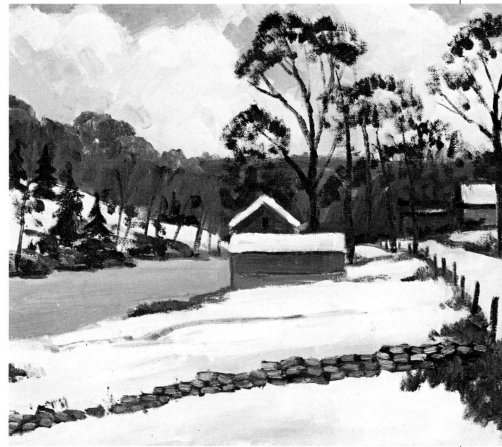

POOR

BETTER

Winter at Clark's Falls, oil, 16" × 20" (41 × 51 cm), by Foster Caddell

WEATHER

How do artists perceive changes in climate?
How do they translate the violence of storms
and rushing winds? How can you capture
the gentleness in a snowbank or soft rain?
Learn how John Pike catches the splendor of
a tropical hurricane and how Zoltan
Szabo creates the shadows in snow. Learn
how you can use a wash, wet paper, dry
paper, and a knife to depict rain falling over
a mountain range.

Subduing High Winds

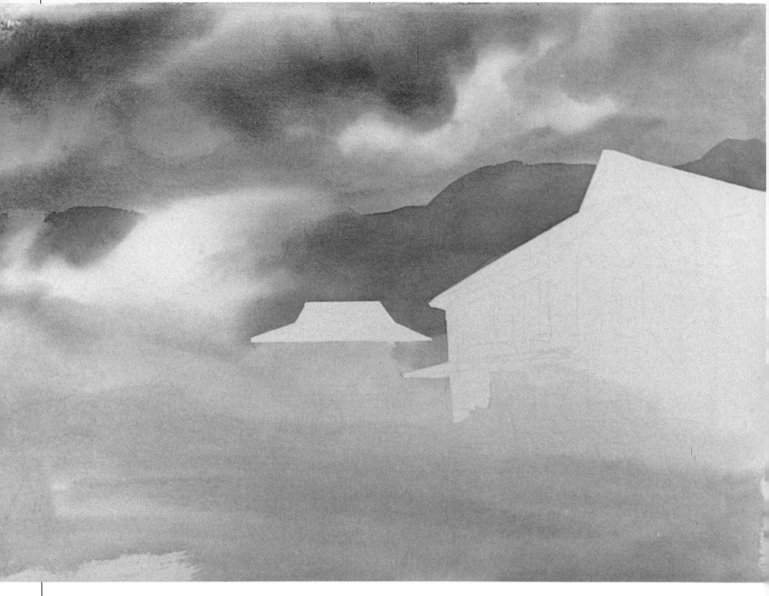

John Pike began with a sketch as a point of reference, although he relied heavily on his pictorial memory to capture this dramatic scene.

1. This first step was actually the result of three major moves. First Mr. Pike put masking tape over the roofs and the fronts of the buildings where they caught the last bit of sunlight. He wanted to be sure that those areas were protected from the color that he brushed over most of the sheet. Then he sponged the entire paper with clear water and began at once with the modeling of the heavy clouds, using ultramarine blue and burnt sienna. Mr. Pike left some gaps of clear paper for the lighted areas of the clouds and painted around the top of the dashing foam where the sun hit it. Then he went down and across the entire bottom with a blue-gray wash, putting the whole foreground in shadow. After the sheet dried, he put in a dark, sharp-edged mountain at the horizon, blurring the wash with some strikes of clear water where the mountain was hidden by the big splash of foam. When the whole sheet dried again, he peeled off the tape, revealing the pure white paper.

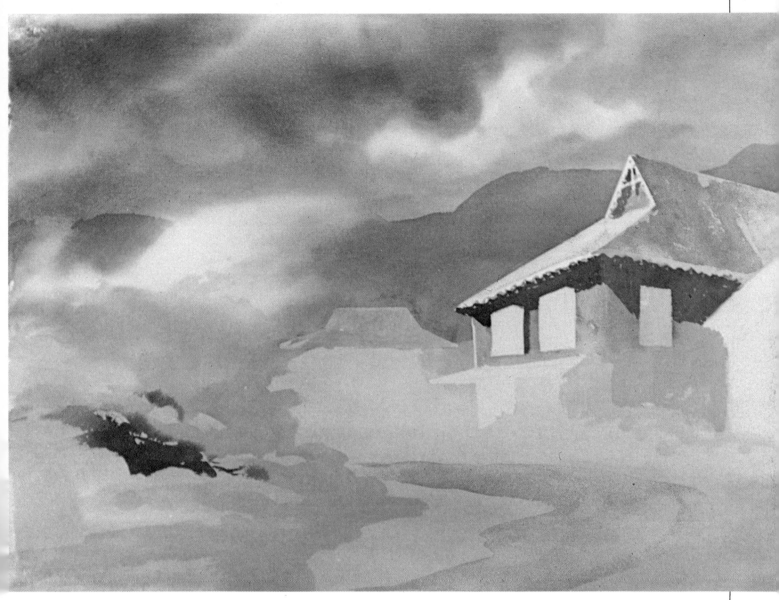

2. Here he was concerned mainly with getting down the underpainting color of the green building: phthalocyanine green and a little burnt sienna. He ran a warm tint of burnt sienna (muted with a little blue) over the tin roof and then down on the crescent of the beach. With a grayish mixture of ultramarine blue and a little burnt umber, he covered the distant tin roof and then carried this tone down over the surf, where he began to model the shapes of the flying, splashing water with broad, curving strokes. Into this wet tone he stroked the shape of a dark rock—burnt umber and a little ultramarine blue. Now it is evident why the artist protected the green house with tape: the walls are the brightest, clearest note in the painting.

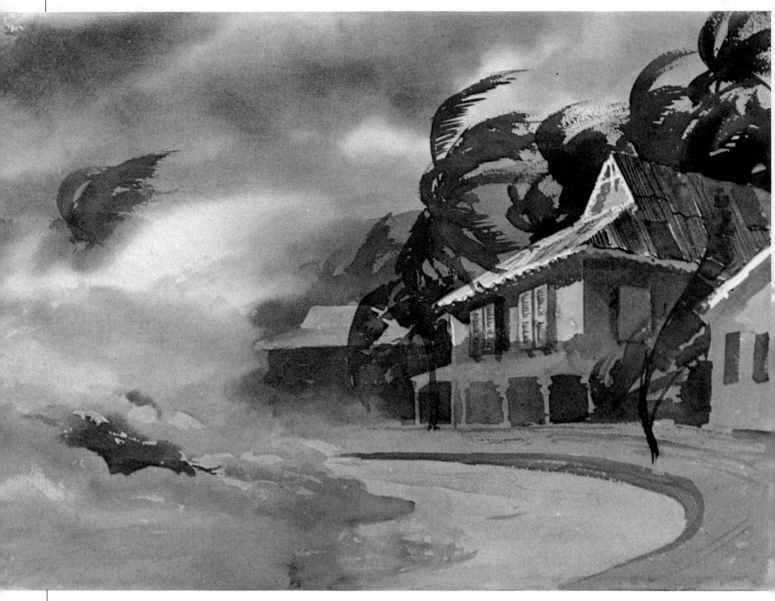

3. Mr. Pike began to hit some of the large, very dark areas here—the accents that make each value stay in its proper place. Most important were the big, dark palms, a rich mixture of phthalocyanine green and of burnt umber, painted with the rapid, curving strokes of a round brush. He planned the design of those very dark, wind-blown coconut palms very carefully, since they would appear stark against what now seems a much lighter sky. It's the dark palms that make the lighter sky go back in space. For composition, he needed some "palette grays" and the tip of a slender, round brush. He then darkened the near side of the building and put some darks under the arcade. He also darkened the face of the more distant building and added some details to the little pink building at the right. A curving shadow was placed along the sea wall and some reflections of sky color were dashed into the pool of water that's spilling on the beach.

High Winds, West Indies, watercolor, 22″ × 30″ (56 × 76 cm), by John Pike.
Collection Susan Bloomfield

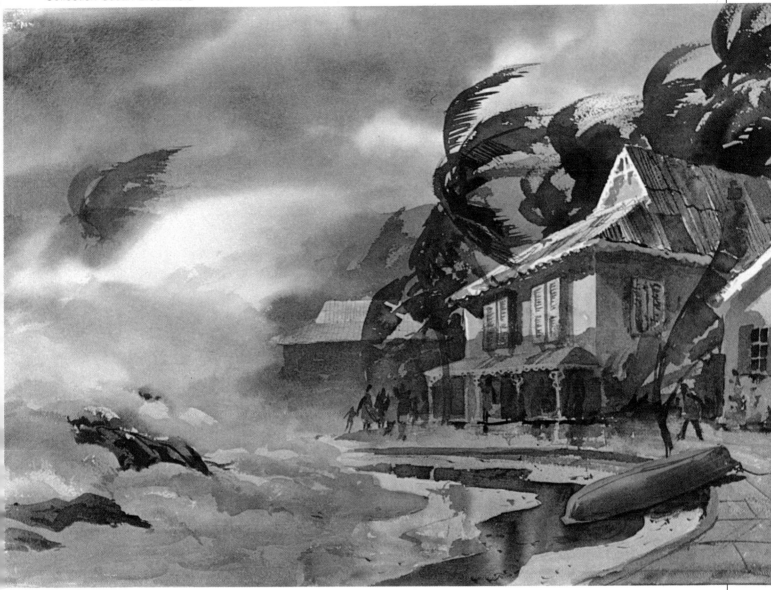

4. Here's the finished view of the watercolor. Mr. Pike added more dark rocks to the boiling surf—for compositional reasons once again. He also added some shadows to the forms of the foam and a dark strip of water to the beach, first painting a pale wash of burnt sienna and then dropping in the dark tones reflected by the buildings and trees above. The bottoms-up dugout was added in two flat washes, one covering the whole shape of the boat and the other just covering the shadow side. He added details such as the lines on the most distant tin roof and on the pavement to the right, plus the little, dark flecks on the beach. The reflections on the wet pavement were drybrushed with the side of a round brush, which makes a ragged, unpredictable stroke. Mr. Pike noted that he usually painted standing, but after finishing this one, he sat down. "Most of the painting was pulled from the mental filing system at the rear of my skull," he said; "and that makes my back very tired."

Snowy Roads

1. The artist chose a gray-toned canvas to suggest a shadowy undertone and to accentuate the bright strokes of the snow. The preliminary brush drawing concentrated on the road and the shadows that moved across the snow, since lines can't define the snow itself.

2. He painted the gradation of the sky from dark to light, since this light was to be reflected in the snow. He then defined the big dark to the right and began to paint the shadows which would contrast with the whiteness of the snow. He saved the lights for the final stage.

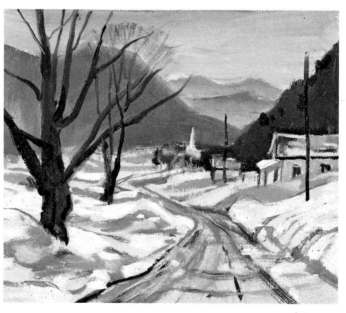

3. The artist next worked on the intricate pattern of shadows in the foreground, since the shadows would surround and define the lighter areas. The dark tree was blocked in to provide contrast too. He then suggested the first few lights on either side of the road.

4. The artist interwove strokes of shadow, thinly painted, with thick, decisive strokes of light. The essence of this snow picture is the shadows, which define the contours of the landscape and enclose the patches of light.

Reflections on Ice

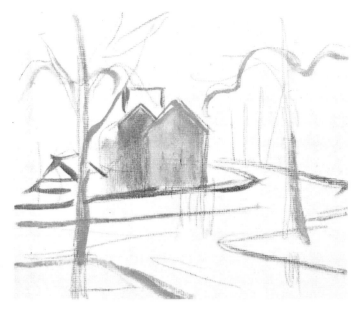

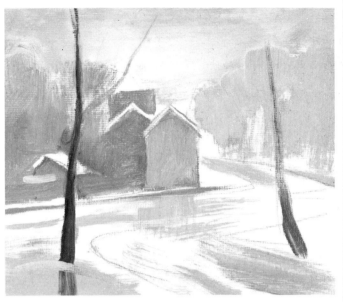

1. The rough brush drawing defined the shape of the sky—which provided the light reflected in the icy road—and the shape of the road itself. The artist then began to block in the shadowy houses, which would provide the dark note to accentuate the brilliance of the ice.

2. Here the artist concentrated on the surroundings of the icy road, not on the ice itself. He blocked in the pale sky, the dark houses and trees, and a few darks in the foreground, leaving the road as bare canvas except for a dark reflection in the center.

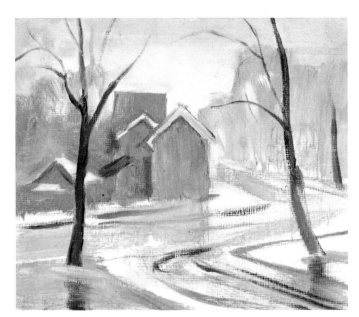

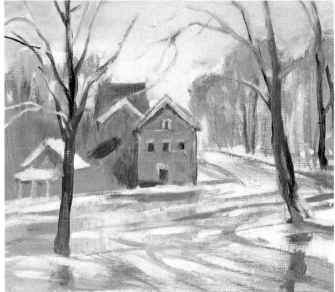

3. He continued to work on the darks and middletones, gradually covering every portion of the canvas, except for the reflected lights on the icy street. Next he concentrated on the darks reflected in the ice, but saved the light touches for the final stage—just as he did in the preceding demonstration.

4. In the last stage the artist, working mainly on the road, developed the complex pattern of the darks and middletones in thin color. Then he struck back into these tones with a few thickly painted lights. In painting ice, like snow, the essence of the picture is the pattern of the darks and middletones; the lights are final accents to be used sparingly.

Spiky Winter Grasses in Snow

Although a snow scene often involves a great deal of white and even unpainted space, much planning is involved to create the illusion of snow.

1. In this closeup the artist shows mainly negative space (bare snow) with just a few dark details placed against the whiteness. Mr. Szabo feels that every touch of the brush must be carefully planned and that whiteness must be preserved. First, he masked out the big fencepost. Then he painted the dark background with Antwerp blue, French ultramarine, and burnt sienna, leaving a pale, ghostly tone for the soft value of the drooping spruce. When this dark band dried, he wet the rest of the paper and brushed in an almost invisible, neutral wash of French ultramarine and burnt sienna, adding darker strokes of the same mixture for the shadows of the snowdrifts.

2. Mr. Szabo warmed the snow mixture with a bit more burnt sienna and modeled the humps of snow with lost and found edges. He used a bristle brush with a mixture of raw sienna, burnt sienna, and French ultramarine to drybrush the stiff, dead blades of grass and the patches of exposed dirt. While these shapes were still damp, he used his nail clipper to scratch in some texture. Notice how the loose drybrush strokes break up the solid darks, which are placed to lead the eye upward toward the fencepost.

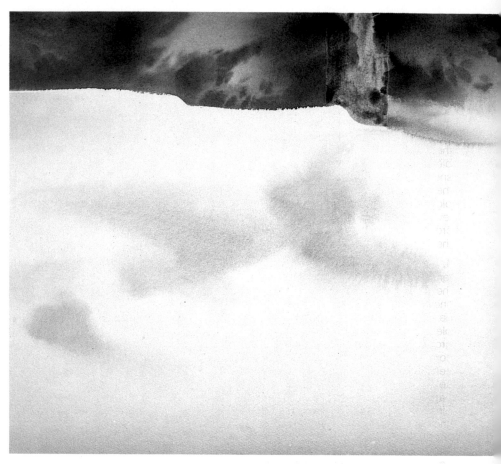

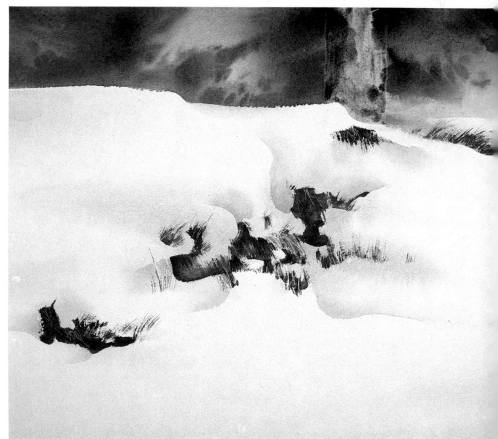

3. Mr. Szabo painted the post with burnt sienna and French ultramarine. The color was tacky, containing very little water, so he could knife out the wires wrapped around the post. Adding more touches of shadow to deepen the modeling of the snow, he painted the scattered stalks of dead grass among the darks and out in the snow. He strengthened the darks by glazing them with brown madder and Antwerp blue. Then he set to work on the pale, snowy spruce that's silhouetted against the dark background. He then wet and blotted out some light, leafy twigs. A few blades of grass were painted to cross the horizon line and thus blend the snow with the darker background.

4. Next, he painted more wires on the fencepost and added the dark lines of the barbed wire leading down into the snow. Where they tuck into the snow, he added shading to suggest the "dimples." Then he darkened the foreground a little more, particularly in the corners, to attract more attention to the center of interest and the birds. Finally, he painted the birds on slightly damp paper to soften their feathers. As the birds are far from the viewer, they don't show too much detail, but they must be accurate. Their value is important: the birds are dark enough to stand out against the bright snow, but not too dark.

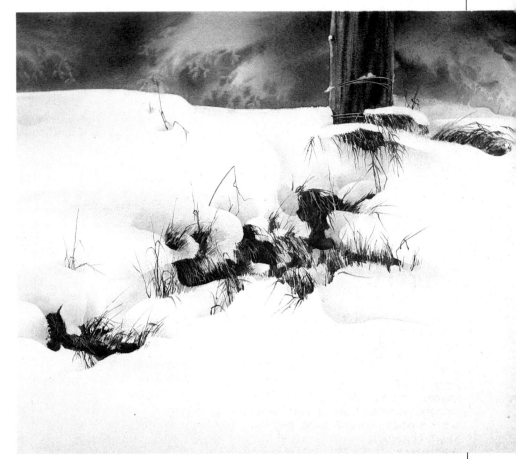

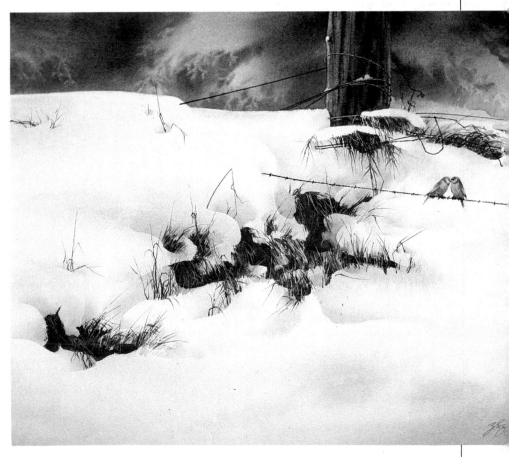

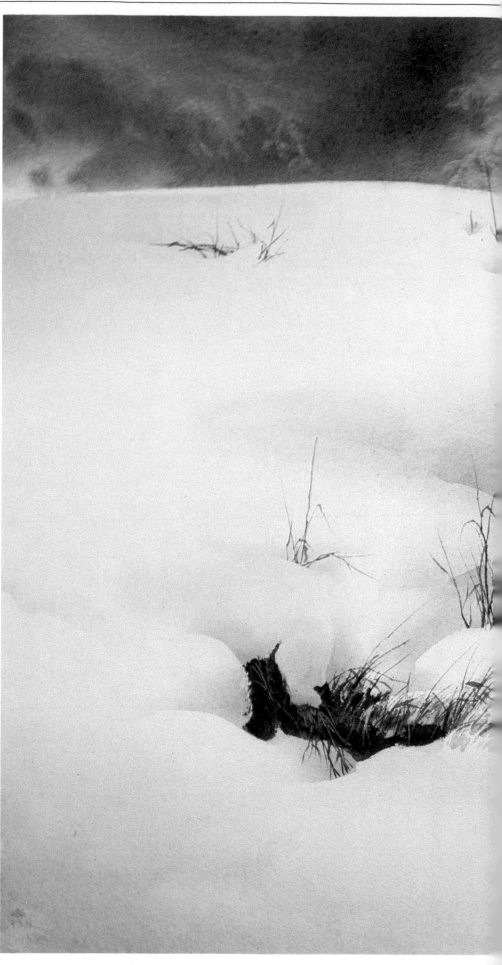

Photograph. (Top) The main purpose of the photo was to record the elements that gave the artist his idea: the general shape of the fencepost, the spruce limbs, the dark patch where the grasses come through the snow.

Pencil Sketch. (Above) The drawing comes closer to the final composition. But it is apparent that the snowy foreground is even bigger in the watercolor.

Finished Painting. The snow isn't shown as dead white, but as a collection of extremely soft values, with shadows only a bit darker than the lights. The negative shape of the snow provides a beautiful frame for the darks that lead the viewer's eye through the painting. Those darks weren't brushed in casually; they were designed so that each one would have its own distinct shape and texture. And the pattern of light and dark in the background was designed to frame the fencepost.

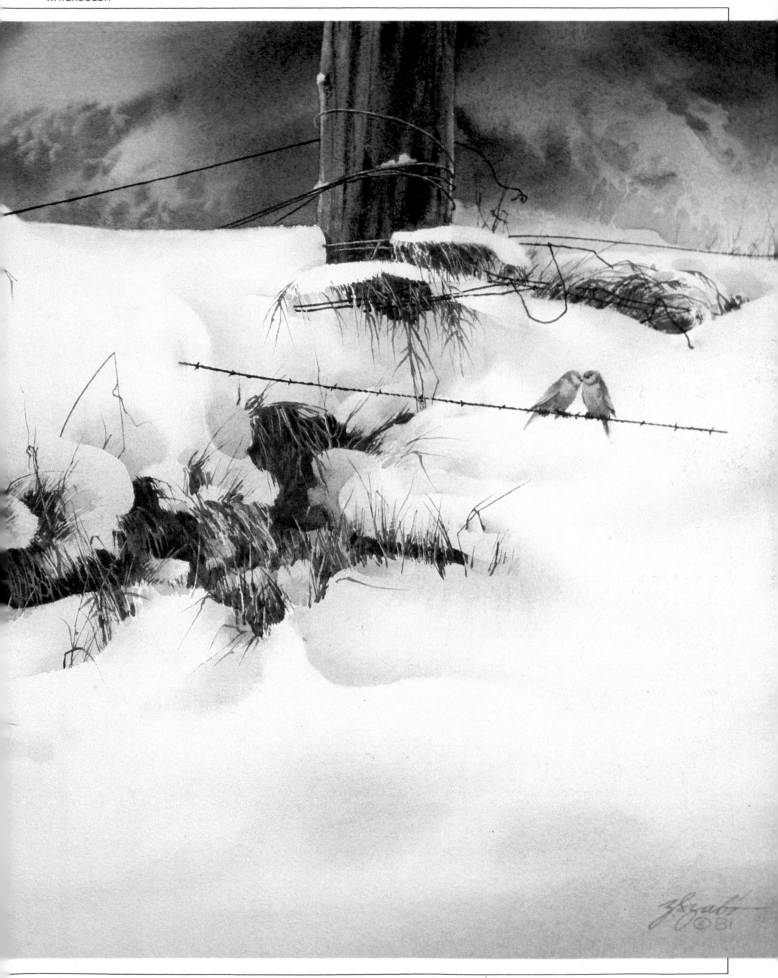

Mountain Rains

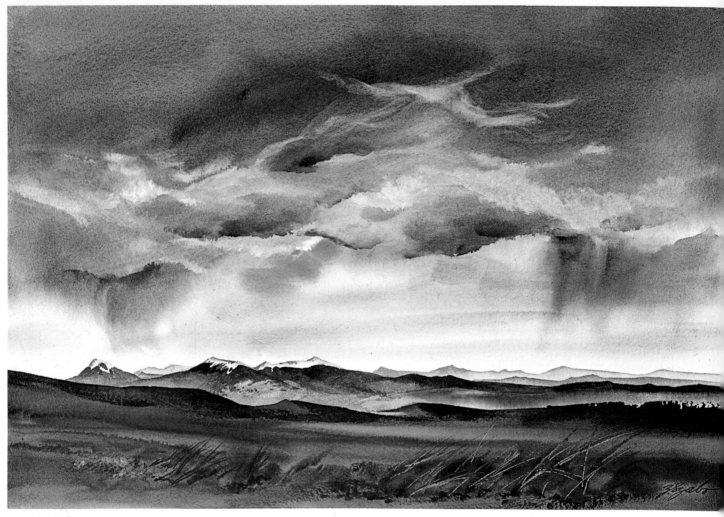

Colorado Drizzle, watercolor, 15″ × 22″ (38 × 56 cm), by Zoltan Szabo

Zoltan Szabo started this expansive landscape by painting the sky on very wet paper using burnt sienna, French ultramarine, and brown madder in the clouds, and Antwerp blue and raw sienna (in a light consistency) in the clear sky area. As this wash lost its shine, he lifted the light cloud edges with a clean, thirsty brush. For the rain, he rewet the already dry lower sky and brushed in the rain with downward strokes. He glazed the ground definition on dry paper, starting with the blue, distant peaks, then adding more and more value, color, and definition as he approached the foreground. He painted the subdued foreground with quick, rich, mingling washes of raw sienna, Antwerp blue, burnt sienna, and brown madder. He knifed out the light from this damp wash, brushed on the dark grass, and drybrushed a hint of coarse soil.

In this detail at right, showing a section of sky in the top center of the painting, the artist has blended the soft blue of the sky into the angry clouds. To exaggerate the rough clouds, Szabo used a separate wash of French ultramarine, burnt sienna, and brown madder. He then lifted the wet edges with a thirsty brush, added sharp darks to some spots after the first wash dried, and lost one edge of this brushstroke, blending it into the cloud masses. The feeling of distance created in this painting is enhanced by the treatment of the peaks and clouds. In the detail at right, taken from the lower left of the painting, the illusion that Mr. Szabo has created is easier to see. He has manipulated the warm and cool colors to great effect. Observe how he has layered glazes that move from dark to light values and from cool to warm. The cool blue sky looks farther away than the warm gray clouds. The blue peaks seem farther away than the strong, snow-covered, textured, and warmer green mountains. The strongly shaded closer slopes appear even nearer.

PALETTE
French Ultramarine
Antwerp Blue
Burnt Sienna
Raw Sienna
Brown Madder

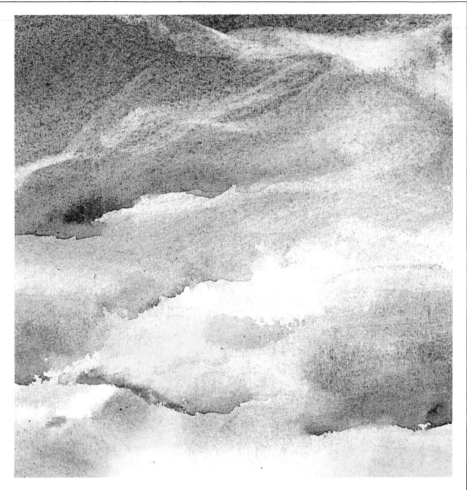

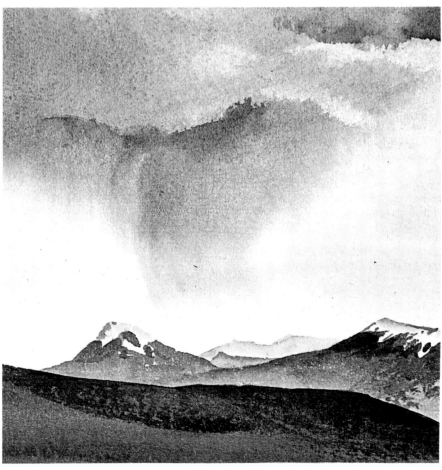

SKIES

Sometimes the sky in a landscape painting takes up what seems to be the entire canvas or paper. Watch the sky. See how the colors change at different times of the day; notice the shifting clouds, their puffy, tumbling forms or their silvery, streaky shapes. The landscape painter is always dealing directly or indirectly with the sky and the light that emanates from it. A coastal sky will affect the color of the sea. What does the sky look like at dawn in the mist? How are the different cloud formations rendered? Learn how artists make their decisions and choose their colors—whether they use oils or watercolors. What about cumulus clouds? How does a painter give drama to a gray day?

Handling Cloud Formations

Mr. Szabo painted around the *thunderhead* above, and lifted the blue clouds from the background after the Winsor blue had stained it. For shading he used a few sepia strokes. Below it he wiped off the rays of light and the rain and applied soft gray rain. With *fractocumulus clouds,* below left, he used a wet-in-wet application of Winsor blue, French ultramarine, and Antwerp blue and left out some white clouds. When dry he blot-lifted the broken clouds with tissue. Using a simpler approach to the same condition, below center, Mr. Szabo painted between the clouds with French ultramarine, Antwerp blue, and raw sienna. For *backlit clouds* he used a flat brush, then wiped off the wisps with a thirsty bristle brush and tissue. The centers are a warm gray wet-blended on the edges.

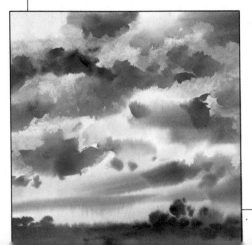
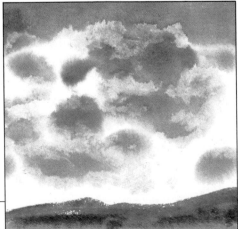

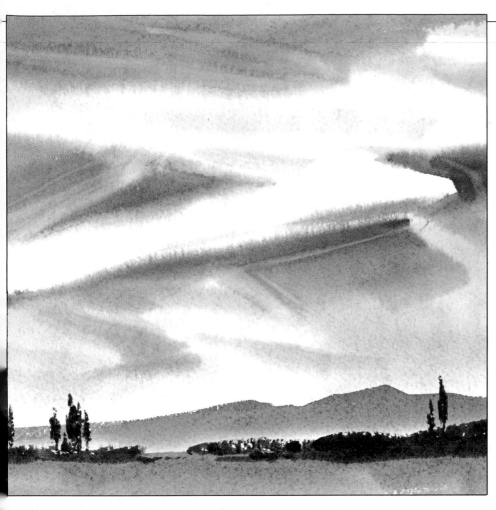

Mr. Szabo painted these layered *cirrus clouds,* left, with raw sienna and Antwerp blue in two applications. The white cloud exposed the lighter layers, which were painted smaller to show perspective. The hill was painted next with burnt sienna and French ultramarine; then the tall poplars were added. He finished with the foreground of raw sienna and Antwerp blue.

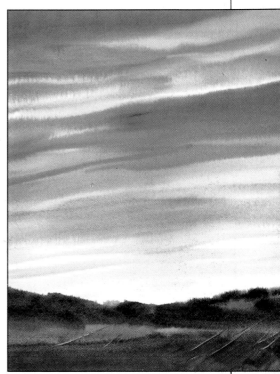

To paint these *strato-cumulus* clouds above, Mr. Szabo quickly applied varied brushstrokes of Antwerp blue, French ultramrine, raw sienna, and brown madder onto a wet background. He used a 1 inch flat brush, making sure that the brushstrokes were far enough apart so that they wouldn't blend completely.

To capture the *windswept clouds* at left he started with French ultramarine, burnt sienna, and raw sienna on wet paper, leaving out some clear white shapes. At the lower side of the sky he added a little cerulean blue. When this wash was damp, he rolled and lifted out the color with a wide, thirsty brush. This was followed by painting the dark hills, using burnt sienna, Antwerp blue, and raw sienna.

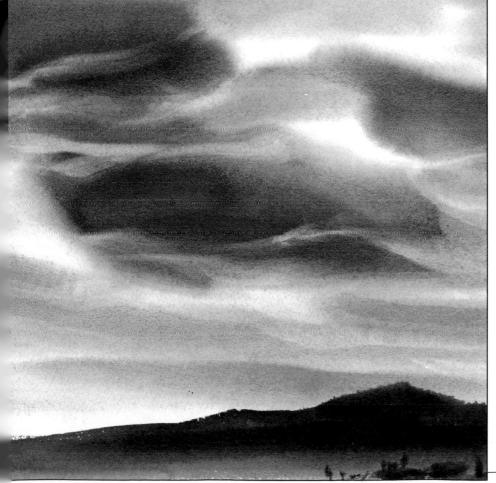

Creating Atmosphere

Sunset on a Clear Day. (Right) The artist wet-blended alizarin crimson, cadmium yellow deep, French ultramarine, and brown madder into the sunset sky. After it dried, he added the distant hill with a medium-strong mix of brown madder and Winsor blue. Mr. Szabo finished the painting by knifing in the tree and drybrushing in the grass with a darker value.

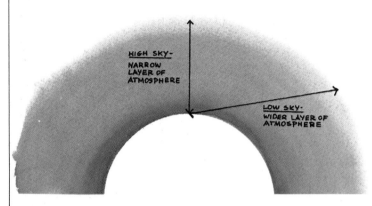

HIGH SKY-
NARROW
LAYER OF
ATMOSPHERE

LOW SKY-
WIDER LAYER OF
ATMOSPHERE

Atmosphere. In this diagram Mr. Szabo shows the different thicknesses of the atmosphere as a result of the curvature of the earth's surface. The thickness of the vapor varies with the angle of one's vision.

Earth and Sky. (Below) To harmonize the sky and the ground, Mr. Szabo first used four blues: cerulean blue, Antwerp blue, French ultramarine, and Winsor blue, which he applied in heavy brushstrokes onto the wet paper, keeping the colors darker at the top and lighter near the horizon. The brushstrokes remained visible, creating a variety of softly blending textures. For the colors on the ground, he used raw sienna, French ultramarine, and Antwerp blue.

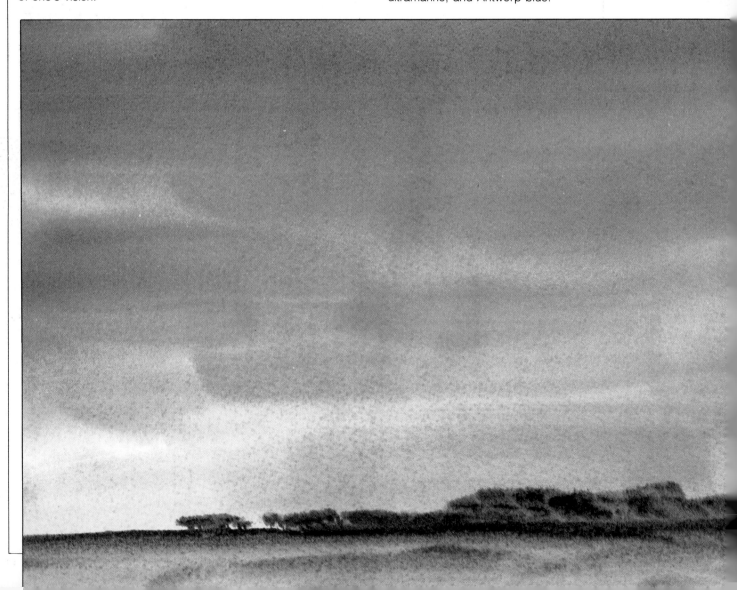

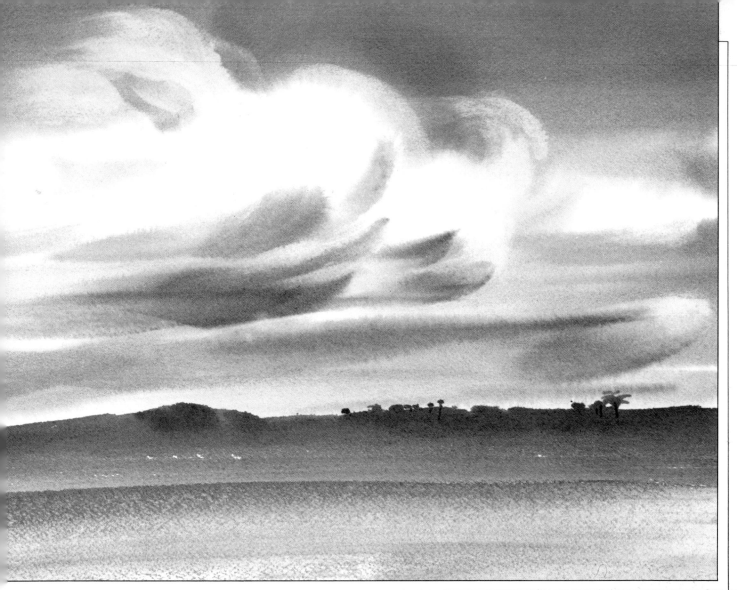

Windswept Cumulus Clouds. (Above) A mixture of French ultramarine and Antwerp blue was used around the top of the clouds on wet paper. In the lower part of the sky, Mr. Szabo also added cerulean blue and raw sienna. He lifted out the windswept cloud tails with a damp, thirsty brush. With a gray wash of burnt sienna and French ultramarine, he painted the shaded bottoms of the clouds.

Cumulus Clouds. (Above) First the artist wet the paper, then brushed on Antwerp blue and burnt sienna around the white cloud shapes. Using a flat, thirsty brush, he dampened and softened the inner edges of the larger cloud and lifted out the other cloud from the background. Quickly he added a little gray-brown to the cloud bases.

Cumulus Clouds. In this second example, Mr. Szabo painted around the cumulus clouds. First he put the blue wash around the white space on wet paper without lifting the edges of his brush. After the wash dried, he glazed on the grayer blue for the lower cloud and lost the upper edges.

Painting Streaky Clouds

1. Since streaky clouds don't have any definable shape, a preliminary brush drawing seemed pointless, so the artist began by scrubbing in the dark tone of the upper sky. He then drew a few lines to indicate where the streaks would go and where the forms of the landscape below would be.

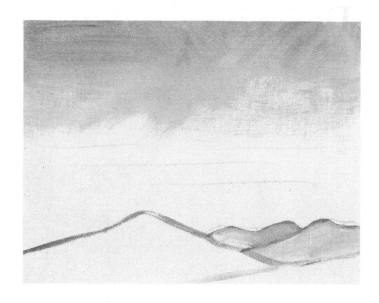

2. Because he knew that he must relate the sky tone to the underlying landscape, the artist blocked in the tones of the mountains. Then he began to brush in the general texture and movement of the sky with ragged, horizontal strokes. The general tone of the sky then began to emerge, though still without detail. At the end of this stage the entire canvas was covered with wet color into which the final details would be painted.

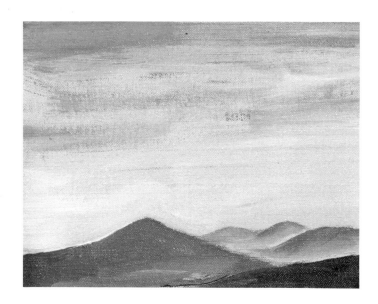

3. Into the wet sky tone the artist then painted horizontal strokes and small dabs, some light and some dark, which partially mixed with the underlying color. Because they were painted wet-in-wet, the streaks became part of the sky tone rather than seeming to lie on top of it. The dark streaks he painted were thin and fluid, the lighter touches somewhat thicker. Mr. Cherepov accentuated the luminosity of the sky by lightening the tone along the horizon.

Designing the Sky

1. Although the brushstrokes are rough, the shapes of the clouds have been clearly defined. Equally important, the negative spaces between the clouds also have been carefully observed, since these spaces must be just as interesting as the clouds themselves. The darkest notes of the landscape have been blocked in as well. When the artist painted the sky, he related the sky colors to these darks.

2. Mr. Cherepov blocked in the tones of the sky before he began work on the clouds. The original brushlines then began to disappear and the sky emerged as a design of flat dark and light shapes. At this stage, the artist wasn't rendering clouds but simply defining the design of the sky, which is just as critical as painting the clouds convincingly. The tone of the water was then blocked in.

3. The shadowy undersides and lighted tops of the clouds were painted in with bold strokes. The lights and shadows weren't carefully blended; instead, the strokes were allowed to remain separate and to blend in the viewer's eye. Note how the tones of the water reflect the tones of the sky and clouds.

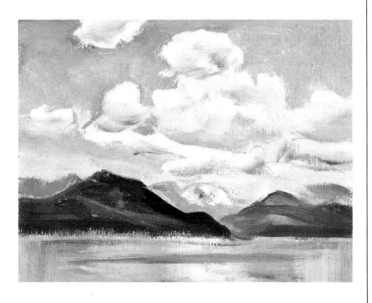

Painting Storm Clouds

1. Like an overcast sky, a stormy sky is often a mass of darks with no clearly defined edges to the clouds. Here the artist's preliminary drawing simply divided the sky into areas that would roughly correspond to the tones, but he made no attempt to record precise cloud shapes. Next he blocked in the tones which would obliterate the lines.

2. Working with large, sweeping strokes, the artist quickly covered the entire sky with wet color. He made no attempt to blend his tones evenly, but allowed the action of the brush to fuse the colors almost by accident. The sweeps of the brush captured the tones as well as the violent movement of the clouds being pushed by the wind. Since the light and shade of the sky seemed inseparable from the landscape beneath, he brushed in the values of the landscape. Although there appeared to be very little light in the sky, the artist made the blurred cloud masses lightest at the top and darkest along the bottom, suggesting an unseen light source which also illuminated the houses, trees, and road below.

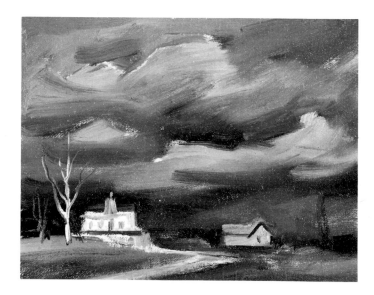

3. Working mainly with diagonal and horizontal strokes that followed the movement of the clouds, the artist refined the shapes in the sky, defining the light and dark shapes more precisely and suggesting that a few of the clouds did actually have edges. The brushstrokes are still apparent; he didn't smooth them out but decided to retain their lively texture. He concentrated darks at the horizon to dramatize the eerie lighting on the landscape below. In this step the artist also darkened the lights and introduced many more middletones so that the entire sky would be in a lower key.

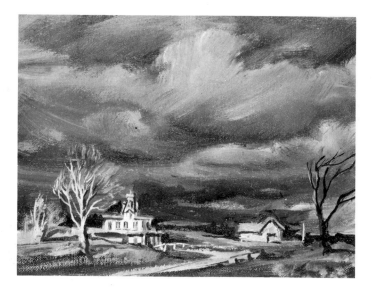

Using an Overcast Sky

1. Before starting this painting, Mr. Cherepov put a gray tone over his white canvas which he felt would add to the overall gray quality of the light. The artist then began to block in the soft gray shapes that would fill the sky, leaving a strip of light at the horizon. (In an overcast sky, the cloud masses often merge into irregular patches of gray, with an occasional break where the sunlight shines through.)

2. Next, the major cloud masses were covered with color, leaving a few breaks in the sky where the canvas remained relatively bare. The artist then blocked in the broad tones of the landscape to establish the overall value scheme of the painting.

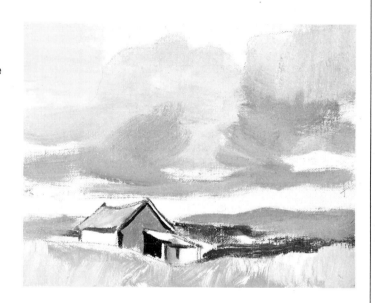

3. The artist completed the sky by merging the cloud masses and minimizing their edges. Patches of light between the clouds were painted in thick color, as was the strip of light at the horizon. The cloud shapes delineated in steps 1 and 2 have all but disappeared; what remains instead is a simple patchwork of light, halftone, and shadow. Not every overcast sky has a sunlit break at the bottom, but it is a powerful compositional device; it dramatizes the darkness of the sky and draws the viewer's attention to the horizon.

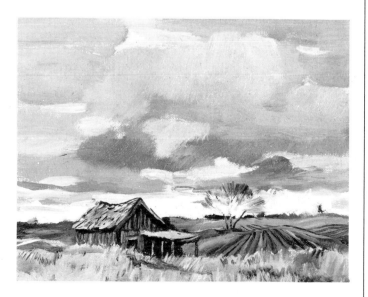

Bright Water Reflections Under a Threatening Sky

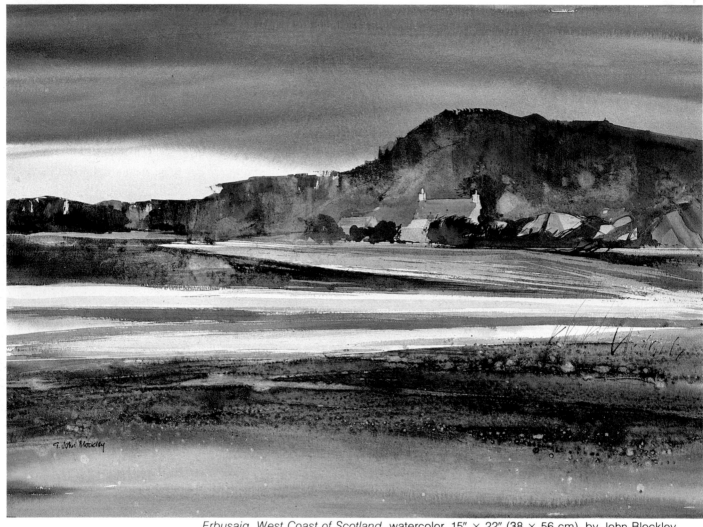

Erbusaig, West Coast of Scotland, watercolor, 15″ × 22″ (38 × 56 cm), by John Blockley

In rain-threatening conditions or after a rainstorm, the ocean sometimes reflects an exaggerated light. At such times, the sharp-edged land is accompanied by a gentle, brooding sky with a soft light pushing up over the horizon above a muddy, seaweed-tinted coast. Such was the case here. Mr. Blockley planned the strong light on the strip of land and water to be the center of interest in this painting. From the beginning, he kept the lightest tones there by masking the strip first before painting the sky and foreground wet-into-wet. Later, on dry paper, he painted the strip of land with long, horizontal strokes of diluted colors that reflected the surrounding scene—the red, blues, and browns of the moun-

tains and earth, and the gray and pearly yellow of the sky. Since he aimed for a somber but contemplative mood, he selected interesting, but not intense, colors. The soft, enveloping sky and strong horizontals express a tranquil mood, while the hard-edged, drybrushed mountains and highlighted land have a more active quality.

Mr. Blockley often uses the device of starting a movement away from one point of interest and then, with a sharply pointed turn, he brings the movement back toward the interest. Here, the middleground strip of water tapers and points the eye toward the right of the painting. Then the light strip of land behind it reverses the direction and points toward the soft light in the

sky. The clouds and bushes also suggest a zigzagging movement. The hard edge of the water and the abrupt reversal are designed to force attention and jerk the eye toward the contrasting softness of the sky.

When clouds are low over the coast and heavy with rain, the light at the horizon is often intense and pearl-colored. Here, top left, the softness of the sky is emphasized by the crisp, boldly painted mountains. Mr. Blockley painted the sky wet-into-wet, but painted the mountains after the paper was dry, which allowed him to reproduce their hard edges. In this painting, the light of the sky complements the brighter lights on the land.

Texture gives an area its special character, while also supporting the general mood of the painting. Here, the textures in the foreground are mostly soft and blended, and the colors are muted. Mr. Blockley painted the mud wet-into-wet with horizontal strokes, using a mixture of phthalo blue and burnt umber to give a hint of dank seaweed. To suggest the moist earth, he stippled the wet wash in parts with thick paint from the handle of a brush. To suggest stones, he blotted out small, soft-edged shapes and used a pen to draw a few sharp-edged weeds sticking up. The weeds provide some vertical movement and direct the eye to the water above. He kept the foreground textures secondary to the main interest of the painting by letting the forms there blend gently together.

A Misty Dawn Sky

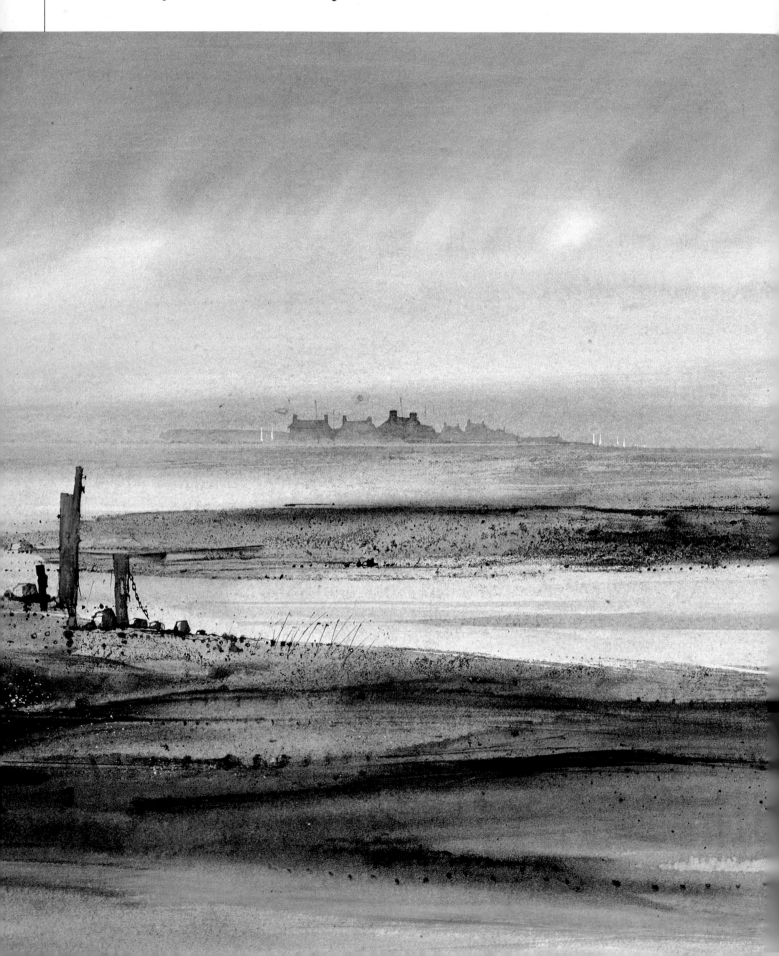

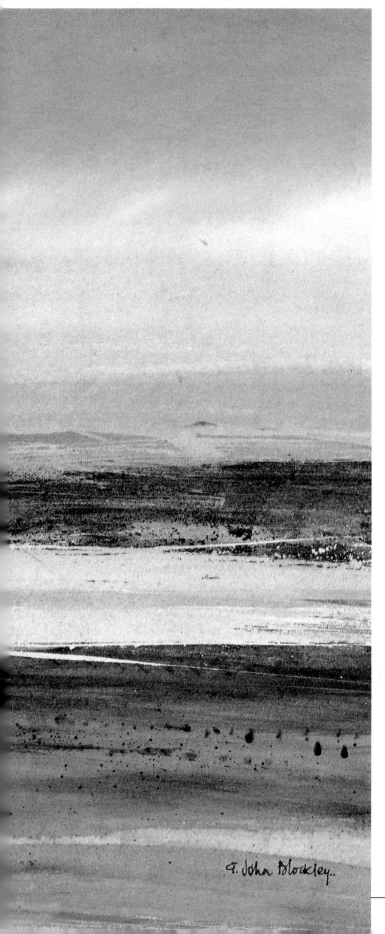

Mr. Blockley's main objective here was to capture the tranquility and subtle lighting he saw on the coast at dawn one day. The sea had retreated and the wet ground reflected the sky, shining a dull gray that was almost silver in places as mud became water and water became mud. The roofs of a distant farm were silhouetted against the sky, but the buildings' bases merged into the early morning mist. When he returned to the studio to paint, his only reference, besides his memory, was an outline of the rooftops on the back of an envelope—there wasn't anything else to draw on!

He had a strong impression of the mud engraved with lines of silverly light, and he wanted to recreate that effect. So he deliberately chose a smooth-surfaced watercolor paper and planned to use a 1-inch-wide housepainter's brush (and Payne's gray and raw sienna) to paint the mud. He knew that the stiff bristles would slide across the hard, smooth surface and splay open slightly to leave narrow lines of paper barely visible. When planning the painting, he also remembered that the tide had left behind a strip of water, very light and crisp edged, that provided a positive statement within the overall softness of the scene, so he masked that shape from the start.

Mr. Blockley also dotted paint into the wet foreground wash with the end of a brush handle to create tracks of soft-edged spots. Then he dampened the sky with clean water and gently brushed it with diagonal strokes to give the effect of light breaking over the horizon. When the paper was dry, he rubbed the masking fluid away and tinted the stripe of water with a pale mixture of cadmium red and Payne's gray. He painted the farm buildings and posts in neutral tones because he wanted to keep them unobtrusive and secondary.

Coastal Farm, Early Morning, watercolor, 13½″ × 18½″ (34 × 47 cm), by John Blockley

Handling a Subtle Sky

The sky dominates this painting—its gentle forms and warmth establish the character of the scene. The artist kept the horizon low to give a sense of vast space. Since the sky forms such a large portion of the picture, he had to concentrate on keeping it interesting by varying his painting techniques. For a soft texture, like that of the clouds, he used a traditional wet-into-wet technique, but left a few sharp edges to provide a focus.

He painted the sky and most of the immediate foreground with yellow ochre subdued with a hint of Payne's gray. Then he added a little burnt umber to give the sky some earthly warmth. Mr. Blockley also added hints of other colors to attract interest and suggest refracted light. He painted the farm buildings quickly and sketchily with crisp edges so they would stand out against the soft treatment elsewhere. For the dark tones of the shore and buildings, he mixed burnt umber and Payne's gray. To give movement to the scene, he drew dark lines across the foreground mud, indicating furrows.

The detail and bright colors in the immediate foreground heighten the feeling of deep space, and the strip of pale cobalt blue water provides a foil to the browns and grays of the landscape. The reeds are tall compared to the farm buildings; their relative size and angle reveal the distance from the foreground to the shore. The wispy, curving diagonals of the reeds also relieve the severity of the horizontals in the scene. The artist painted the reeds with Chinese white, made into a cream color with a little yellow ochre. He used that warm, delicate color to connect all the areas of the composition and harmonize the scene.

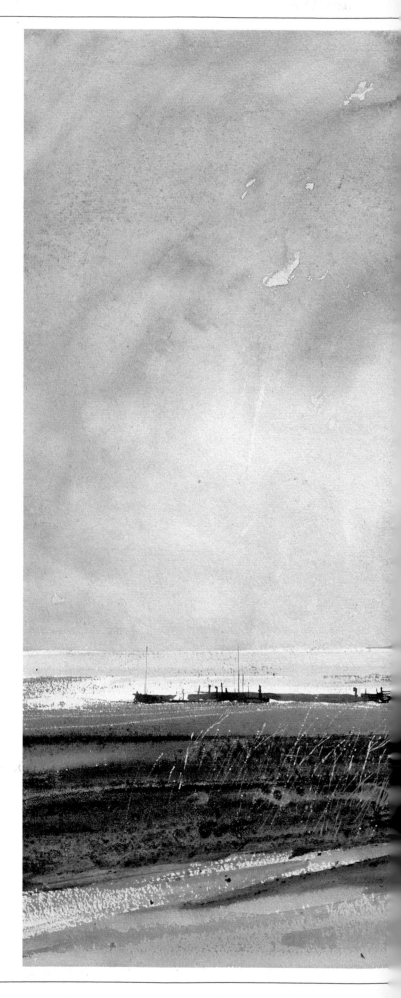

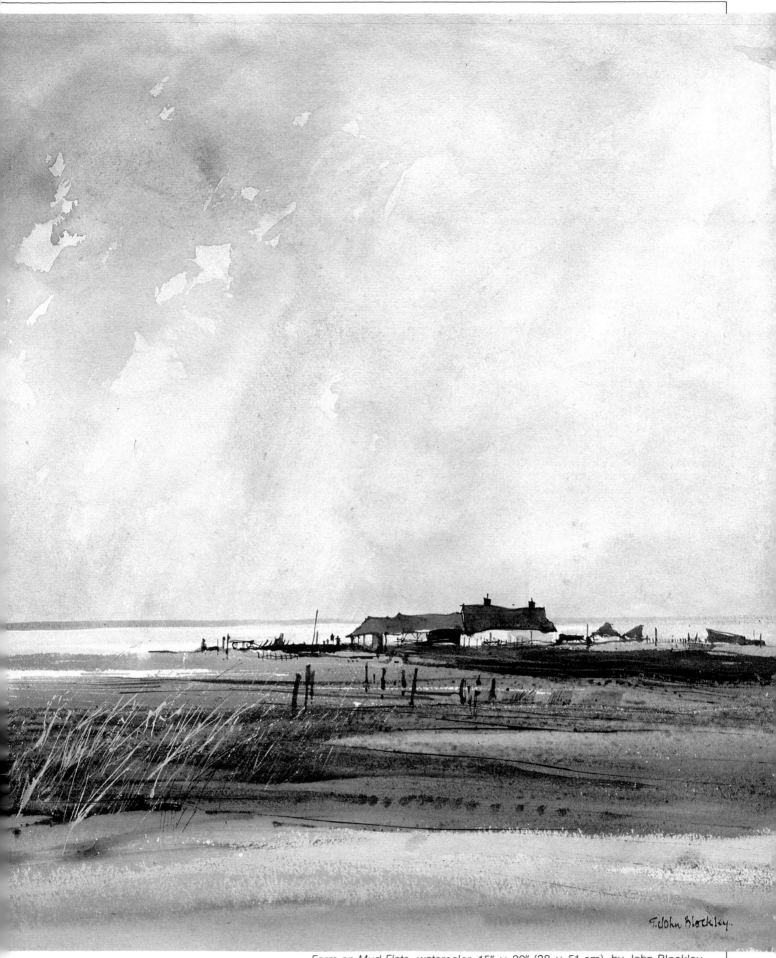

Farm on Mud Flats, watercolor, 15″ × 20″ (38 × 51 cm), by John Blockley

WATER

Breaking surf: cerulean blue, Antwerp blue,
a touch of sepia. Waves. Painting water in a
gray light. Reflections in a still pool. Low
tide. Lakes and boats. This section of the
book explores the different ways water moves
and how artists paint it. What colors are
selected? When is a wash best? When is it
good to lift out the light? To put it in? What
color is the sky's reflection? Watch the
techniques used by painters undaunted by the
rush of a brook and the complicated
reflections of trees and rocks and skies. See
how your techniques can be improved;
follow the steps.

Waves

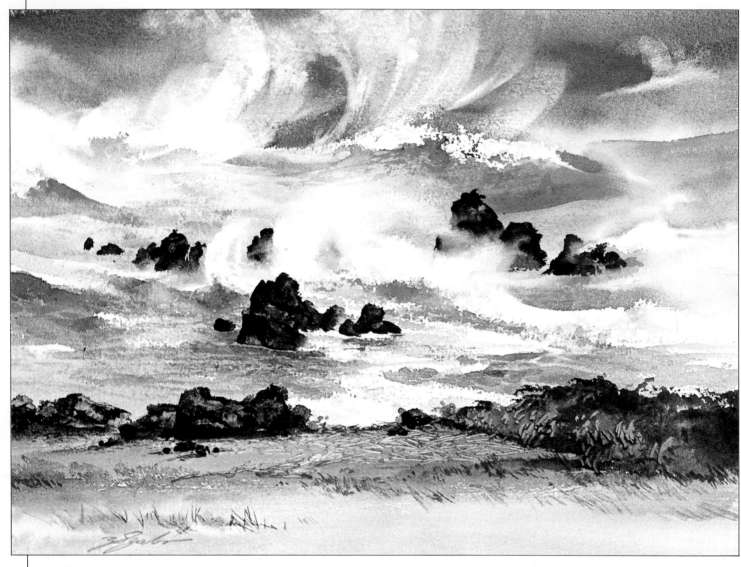

Breaking Surf. (Above) As the white surf broke into bubbles and the waves calmed down near shore, Mr. Szabo drybrush glazed on several layers of cerulean blue and Antwerp blue, with a touch of sepia, in light washes and dragged the brush back and forth on its side on the dry paper. He did not use the tip here.

Study of a Tubelike Wave. (Below left) Mr. Szabo added a quick touch of dark to the underside of the wave and another to the top edge of the white area. For this he mixed French ultramarine, Antwerp blue, raw sienna, and sepia.

Choppy Surf. (Below right) To create this turmoil, he used Antwerp blue, sap green, and warm sepia. First he established the water's values with blending washes; then he sprinkled droplets of water into the drying washes for texture. Afterward, using a soft, damp brush, he wiped out the diamond-shaped reflections at the lower left, making sure that the shapes connected in perspective, like a honeycomb.

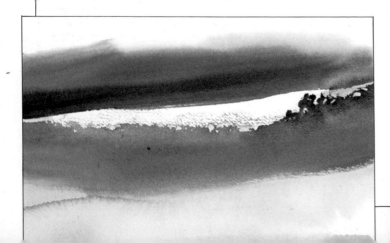

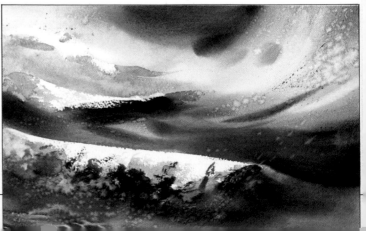

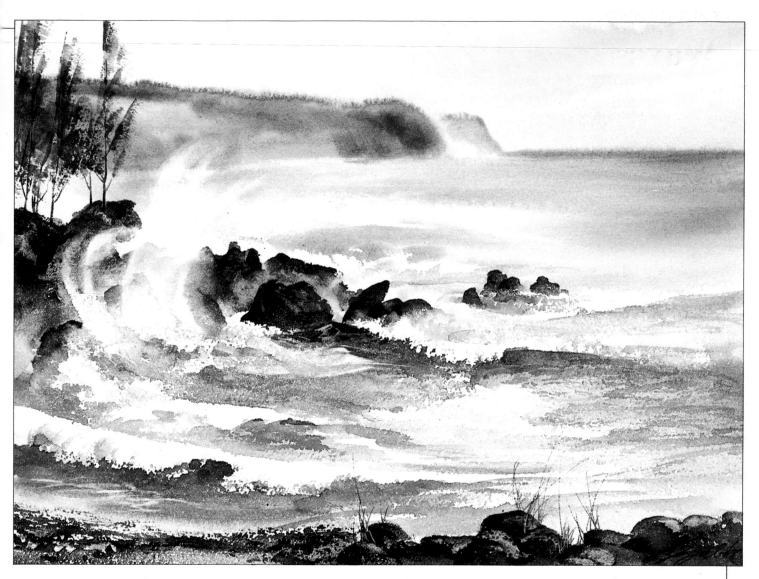

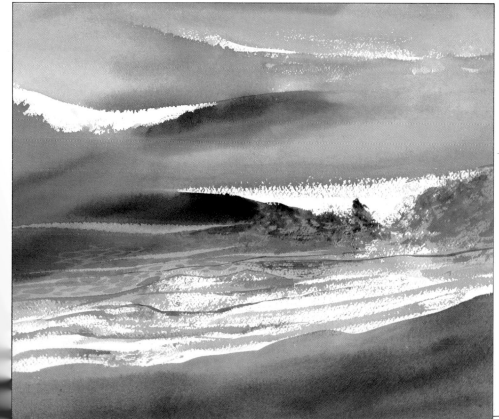

Waves Against Rocks. (Above) Mr. Szabo painted the rocks behind the spray with a medium-strength mix of sepia and charcoal gray. After it dried he wet and scrubbed the spray with a bristle brush and blotted up the loose paint several times. He drybrushed on the dark definition on the other rocks but avoided the spray area, thereby exaggerating the contrast.

Waves Against the Shore. (Left) For the water Szabo used Winsor blue, cerulean blue, and new gamboge on dry paper. He left the surf heads white and used a knife to lift a few foreground waves into a lighter value. For the breaking, foamy waves he put a light color in his brush and pushed the drybrush strokes against the ferrule of the flatly held brush in a zigzag pattern, imitating the churning waves. For the sand, he used raw sienna, burnt sienna, and French ultramarine in a single blend and let the colors separate in granules.

Designing into Accidental Forms

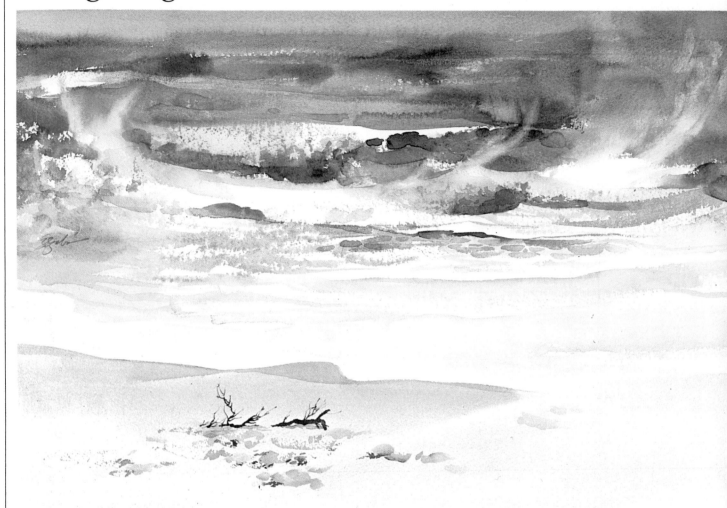

Emerald Bath, watercolor, 15″ × 22″ (38 × 56 cm), by Zoltan Szabo

This watercolor is the result of designing into accidental forms. Szabo painted the scene in glaring sunlight on the white sand beaches of the Gulf of Mexico in Pensacola, Florida. The accidental wet-in-wet effects occurred when he painted several large, rich brushfuls of varied blues onto the dry paper so fast that they flowed together.

As accidental white shapes were formed, he kept them intact, and they later became white surf. He even intensified their contrast with the blue waves by painting a darker brushful of color next to them. Mr. Szabo advanced the wash from the top downward using lighter color and more and more white space between drybrush strokes. The behavior of the breaking waves showed the extremely white foam as pure sparkle where it touched the sand. To exaggerate the purity of the blue waves, he contrasted it with the soft wash of burnt sienna and French ultramarine for the sandy beach.

The scattered twigs and footprints supplied foreground interest. The artist painted the branches with a palette knife and modeled the sand with lost-and-found edges. He added a touch of the warm sandy color onto the thin layer of foamy water to give a hint of refraction for better color unity. With a touch of aureolin yellow added to the waves, he introduced a color accent of luminous green.

Mr. Szabo blotted out the soft spray of the crashing surf with a tissue immediately after wetting the dry surface with clean water. After adding a few touches of clarifying shapes in the waves, the painting was completed.

PALETTE
Antwerp Blue
French Ultramarine
Manganese Blue
Burnt Sienna
Aureolin Yellow

Breaking Waves. Here a detail of the left center of the painting illustrates how Mr. Szabo drybrushed on the greens and blues of the deeper water. But where the water neared the sandy shore, the artist grayed his washes. He used manganese blue in the mixture because he knew it would granulate and separate from the other colors, adding a pattern of its own to complement the lacy drybrush effect. A strong separating wash is good for the foreground but would be wrong in a more distant location.

Crashing Surf Spray. This detail isolates the top right of the painting and focuses on the artist's treatment of the ocean spray. Warmer green colors again appear closer than the cooler blue ones. To exaggerate the soft, misty ocean spray, the artist painted drybrush touches of beading droplets next to it. To create the spray, he scrubbed the dry paint hard with a bristle brush. After he loosened the pigment, he lifted it off with vigorous pressure into a bunched-up tissue. He repeated this two or three times until the blotted value was just right.

Rapids

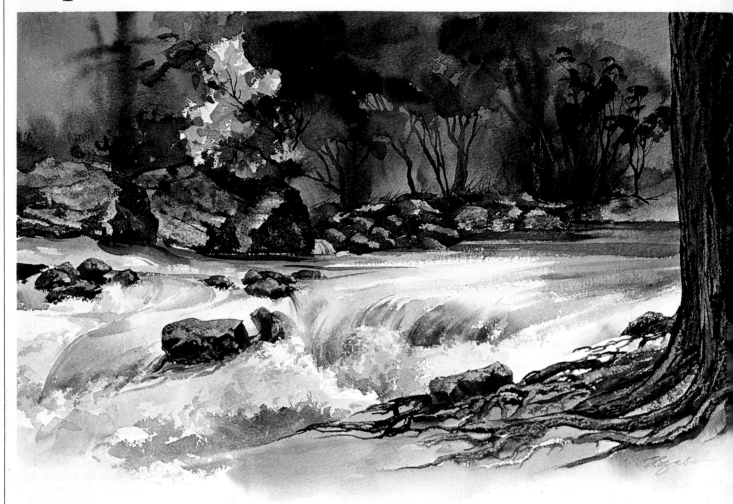

Rapids Serenade, watercolor, 15″ × 22″ (38 × 56 cm), by Zoltan Szabo

The artist started this composition of rapids in Gruen, Texas, with a bright, yellow-green tree. To accentuate the freshness of the spring foliage against the deeply shaded, somber forest, he chose aureolin yellow because it is subtle in hue, very transparent, and could be mixed lightly into the water, further diluting the color without dominating the wash. He painted in and knifed out the boulders, simplifying their shapes.

Sepia and Prussian blue were too cold for the large rocks, so he glazed a light wash of burnt sienna over the knifed-out light shapes. He combined sepia and Prussian blue for the dark forest, washing them on to dry paper and later modeling the wash with darker glazes. Next Mr. Szabo painted the rushing water and its active bubbles with several light drybrush glazes of aureolin yellow, Prussian blue, sepia, and burnt sienna in varying combina-

tions. Into these forms he sprinkled smaller boulders with aureolin yellow, Prussian blue, and sepia, and knifed out their light sides.

He used sepia and Prussian blue for the old cypress trunk and its exposed roots. He then knifed out the bark texture from the wet paint and structured the roots with the knife as well. To complete the painting, the artist added final details on the branches and directional washes in the water.

PALETTE
Aureolin Yellow
Burnt Sienna
Prussian Blue
Sepia

Flowing Water and Distant Forest.
Here the top right of the painting opposite is shown in detail. The combination of textures is important in this area. The artist started painting the misty forest with a series of wet-in-wet blended washes. He knifed out the light rocks and, with less pressure, the textured light tree.

After the paint dried, he glazed on the closer, darker trees. The fine clutter of twigs and weeds supplies additional interest above the rocks. For the horizontal drybrush glazes that represent the dark reflections in the rapids, Mr. Szabo mixed warmer colors to bring them closer in color perspective than the cool blue-gray forest beyond.

Foaming Waterfall. This detail is taken from the center of the artist's painting. Drybrush glazing cannot be rushed. To capture the luminous, transparent quality of water, the artist painted very light, well-diluted washes of color in several layers, waiting for each coat to dry before applying the next. The dark, solid shapes of the protruding rocks, painted with sepia and Prussian blue, contrast with the rushing water both in value and texture. The staining quality of sepia and Prussian blue are clearly evident where he has knifed out the light planes of the rocks. The underlying color looks light against the shaded edges, but dark and solid beside the white foaming water.

Still Water

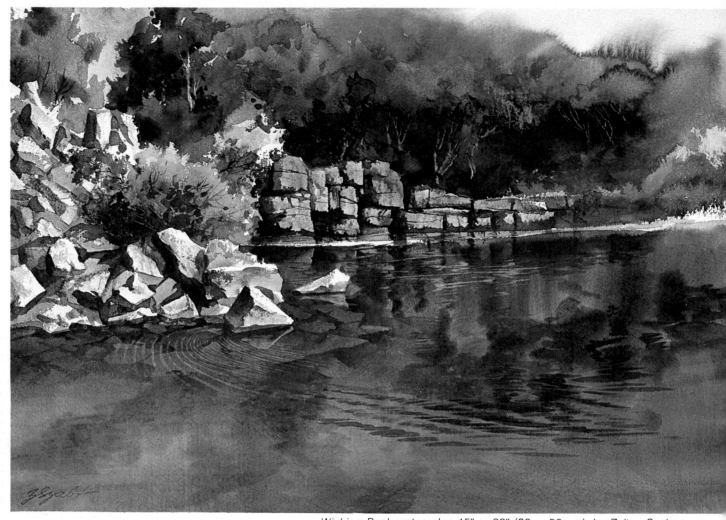

Wishing Pool, watercolor, 15″ × 22″ (38 × 56 cm), by Zoltan Szabo

This painting of a scenic area near St. Cloud, Minnesota, is a study of calm water, with its reflections and refractions. The artist started by glazing on the warm color of the rocks with burnt sienna and brown madder. He then knifed out the lighter textures while the paint was still damp, one rock at a time. His next step was to paint the forest. He wet-brushed the foliage onto dry paper but allowed these large brushstrokes to blend as they touched. New gamboge, Winsor blue, and burnt sienna mingle freely with an occasional backrun that defines the forest planes. He knifed out the light branches, then painted in the shrub on the left. For the water area, he painted the dominant color—sap green—and the soft reflections with all five colors on his palette, primarily emphasizing the sap green and new gamboge. When this wash dried, he glazed on the submerged rocks and the sharper, dark reflections, then added the blue cast shadows on the rocks. Finally, Mr. Szabo lifted out the light ripples and reflections with his brush; the sap green glow remained.

PALETTE
Brown Madder
Burnt Sienna
New Gamboge
Winsor Blue
Sap Green

Light Green Shrub and Rocks. This detail of Mr. Szabo's *Wishing Pool* focuses on the upper left portion of the work. Before painting this plump bush, he left the top edge as a jagged, lacy-white shape against the darker wash of the background forest, thus establishing a distinct edge between the two planes. The distant rocks were simplified with bold knife strokes, as were the line details on the cracks and the dark branches.

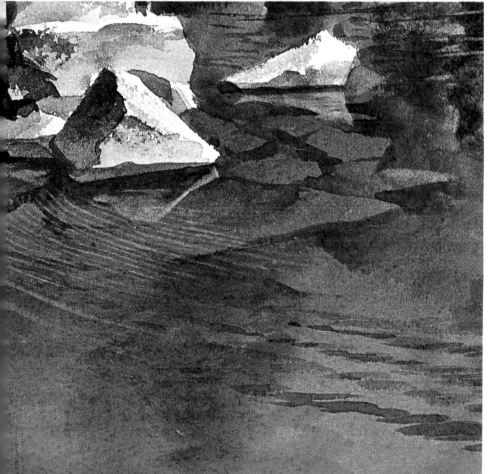

Submerged Rocks and Ripples. Here the detail illustrates the artist's delicate treatment of rocks, their reflections, and submerged rocks. The white sparkling sides of the rocks and their warm dry-brushed texture above the water level trap sunshine and contrast with the rich colors of the clear, smooth water: sap green, burnt sienna, and new gamboge. The artist glazed on the shaded edges of the submerged rocks with Winsor blue, burnt sienna, and brown madder. He wiped out the light-green reflections over the submerged rocks when the paper was dry.

Lakes

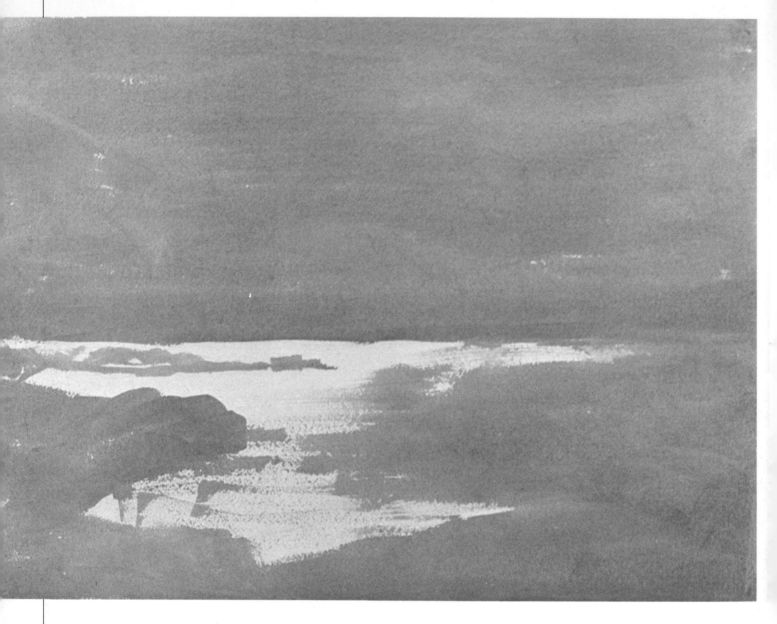

With a broad landscape such as this one, Mr. Pike always advises that the composition be carefully composed in a sketch so that the eye doesn't start to slide out of the frame at some point. The artist wants to give the *feeling* of a great expanse.

1. How does an artist like Mr. Pike gain the high, sparkling values of the lake? He puts a neutral gray wash over everything else in the painting. It takes experimentation to determine how light or dark that tone ought to be. But the idea is to make it dark enough so that

the patch of light really sings, yet the tone should be light enough so that the really dark darks will stand out later on. This trick—and it's a valuable one— may be used in any painting where the artist wants to emphasize the brilliance of one or more areas. When mixing grays, don't worry about how much of this color or how much of that color is in the mixture. Don't have any predetermined ideas about what colors are right. Just stir and slop around on the palette until you've got what you want. Those old "palette grays" have a way of happening by themselves.

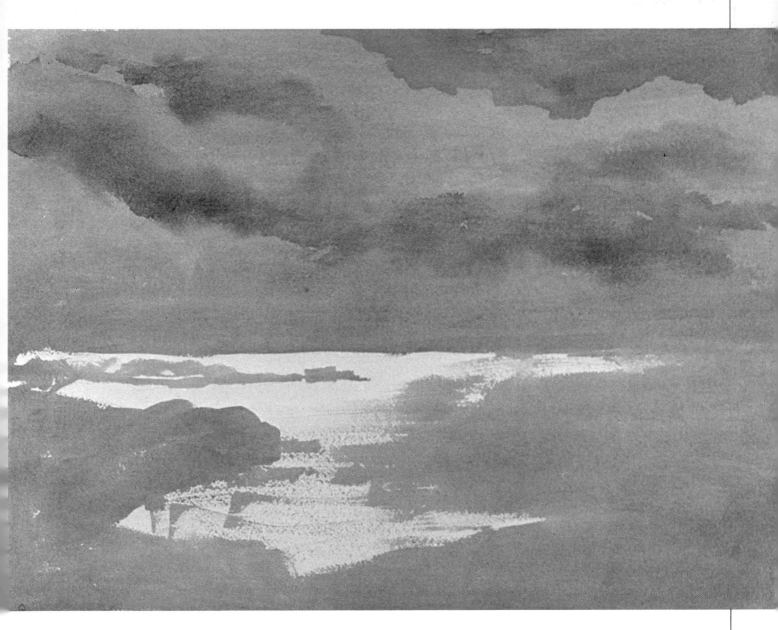

2. When the first big, neutral gray wash was dry, the artist rewet some of the upper area and modeled the clouds with darker tones. Some of the edges became hard and others soft, depending upon whether the brush hit a dry area or a wet one. The topmost cloud shape in the upper right has a hard edge, so it's obviously painted on a dry part of the paper. The artist put off touching the patch of white on the water.

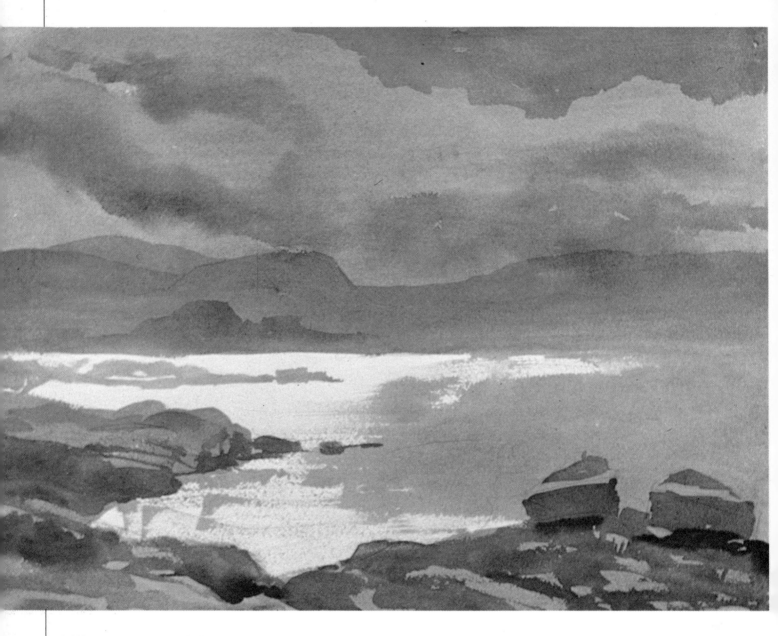

3. When step 2 dried, Mr. Pike painted in the farthest of the distant hills, let that dry, and then painted the nearer hills right on top. Then he started to identify some of the darker forms in the middleground and foreground. He put some flat gray tones over these shapes first. Then, when this dried, he went back with some darker tones to suggest shadows. He added two beached boats in the lower right to give scale. Then he started more modeling on the rocks and put shadows under the boats.

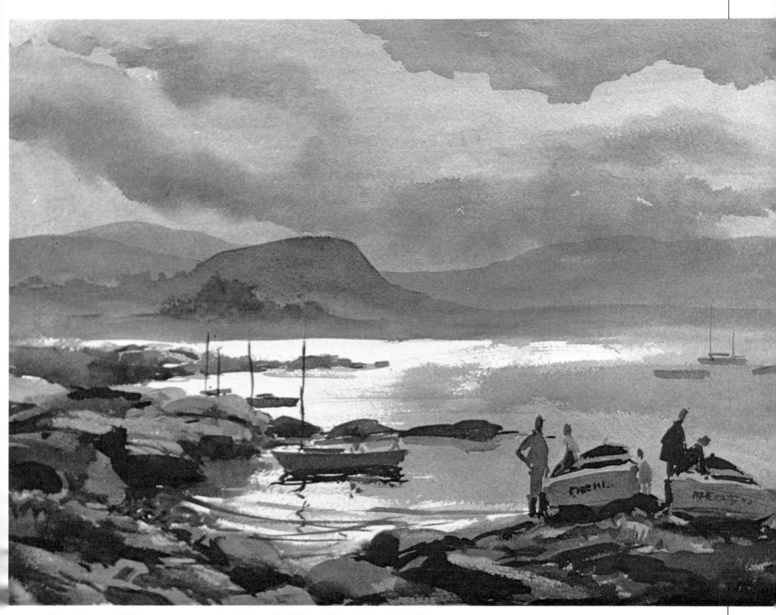

The Lakes of Killarney, watercolor, 22″ × 30″ (56 × 76 cm), by John Pike.
Collection Albert Ondush

4. Next Mr. Pike darkened the big hill just left of center, and when that dried, he put some rough strokes at the foot of that hill to convert the dark shape—painted in step 3—to a more irregular, tree-covered shape. Then he worked on the small craft moored in the water, the reflections and the ripples in the cove. To suit the weather, he worked mainly in grays: blue-grays, brown-grays, whatever. He added more detail to the boats in the right foreground, along with the figures—he likes a world that's peopled. All this was done very rapidly. He added strong shadows to the rocks and some curving lines for ripples at the edge of the water. But he resisted the temptation to do any more work on that brilliant patch of light, which remained just as he left it in step 1. When the watercolor was finished, he noticed that for all his planning the viewer's eye would fall off the right middle of the painting if he didn't add the three distant boats above the figures, so he did.

Reflections

1. Although the subject of this painting is a landscape rather than a small detail of nature, it's a study of a body of water that contains interesting reflections. The artist began by painting the object that would be reflected: the trees were painted with a flat wash covered with darker strokes of drybrush. The artist then shifted the band of sky from dark to light. And the band of shadow on the snow he made with a single, broad stroke on wet paper. He used new gamboge, burnt sienna, and Antwerp blue on the trees, adding a little French ultramarine for the sky and the snow shadow.

2. Moving into the jagged patch of water, he painted the darkest values of the reflection on damp paper to create soft edges. Note that the reflections contain the same colors as the trees above, but with more blue and burnt sienna. The ground cover, just beneath the trees, was painted with drybrush touches of new gamboge, burnt sienna, raw sienna, and Antwerp blue, with bright notes of new gamboge for the early flowers. For the pebbly ground, Mr. Szabo's colors were burnt sienna, brown madder, and French ultramarine. To indicate scale and also provide some relief from the bare, harsh snow, he painted a few trees at the far edge of the water.

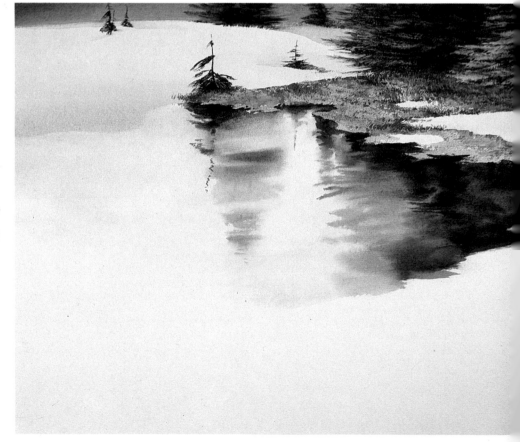

3. Turning his attention to the foreground, he painted texture and value at the same time. The colors are the same as the pebbly ground in the previous step—burnt sienna, brown madder, and French ultramarine—but they're more varied in value to dramatize the negative shapes at the edge of the water. The artist added some grassy clutter in the foreground to indicate perspective. The foreground brushwork was kept quite loose, with a bit of spatter for pebbles.

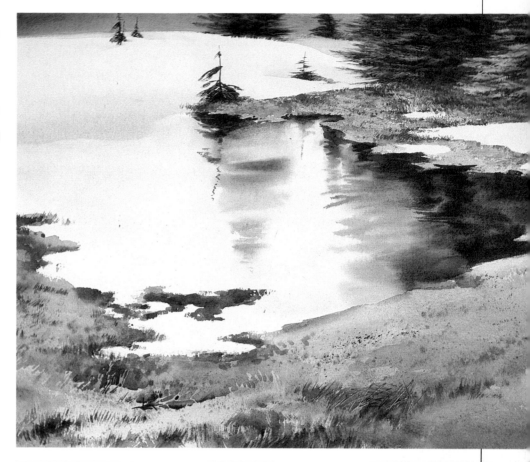

4. Going gently over the foreground shapes, Mr. Szabo darkened them to frame the water a little more boldly. Up to this stage the pale water was bare paper, but here he painted a very light value over the water at the near shore. To suggest wet sparkle, he left white, shiny edges around some of the dark shapes in the water. Finally he accented some of the weeds and twigs up front.

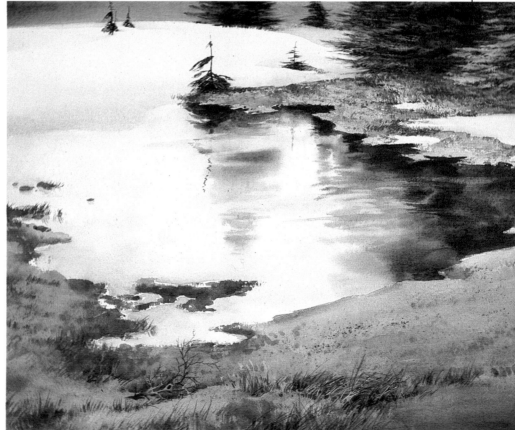

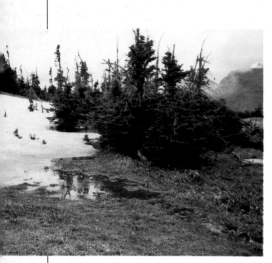

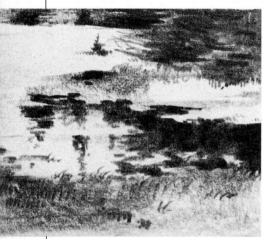

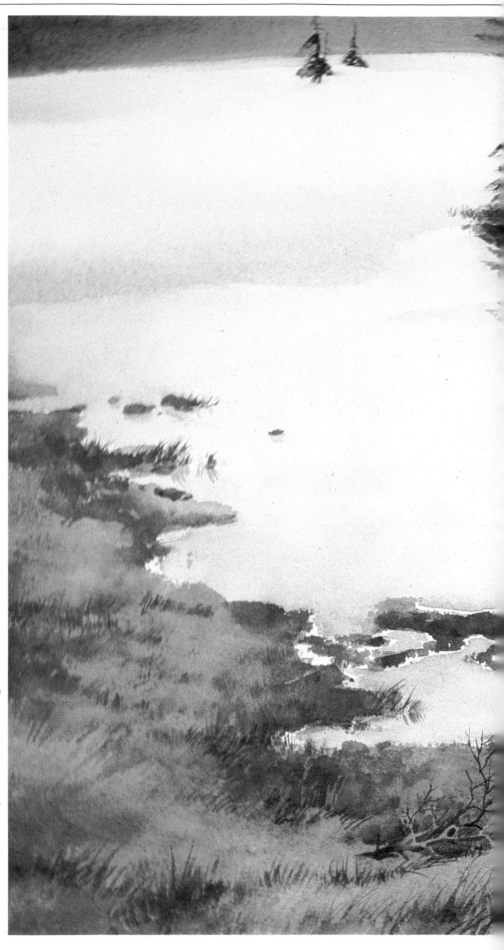

Photograph. This color snapshot gave the artist some idea of the colors and served as a reference for the shape of the shoreline. But, like most photographs, it was not much help in designing the painting.

Pencil Sketch. Here the artist established values; he showed the darks of the trees and their darker reflections. He indicated the placement of the small trees against the snow, but he did not show the interesting shape of the water framed by the foreground shore, so important in the final work.

Finished Painting. It is really the shape of the inlet, with its interesting shoreline, that is the subject here. What makes the picture is the interplay between the hard-edged, jagged shape of the water and the soft-edged reflections within it.

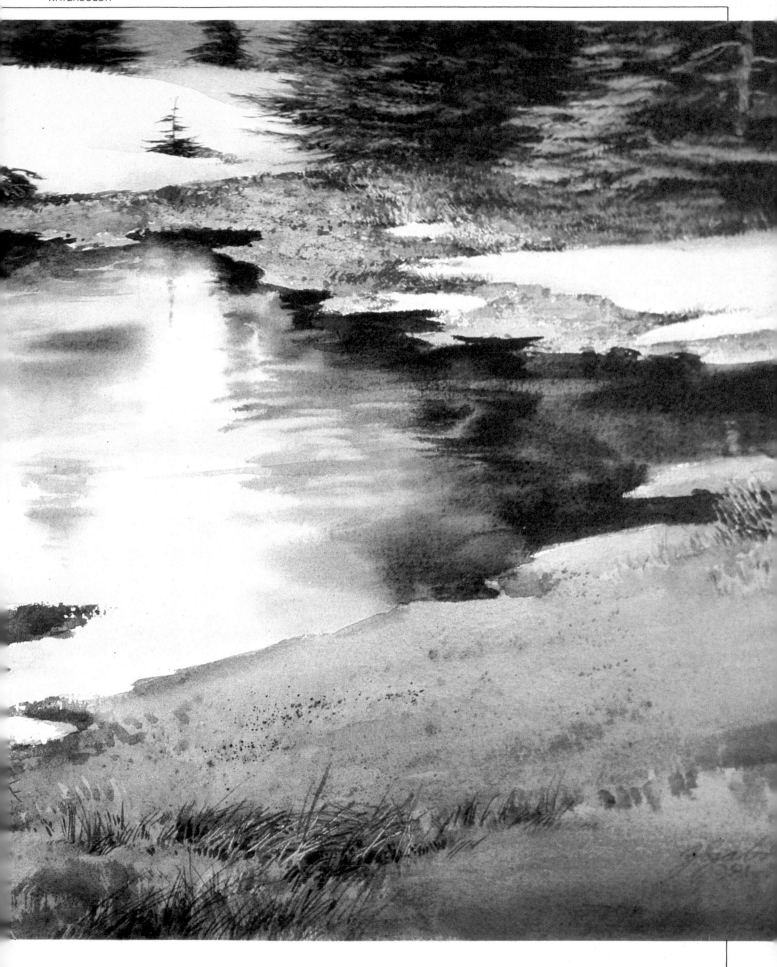

Streams

1. In this study the artist focused on the patterns of moving water, with most of the detail in the right foreground. He began by masking out the fallen tree in the deep part of the waterfall, at the center of the picture. Wetting the top two-thirds of the painting with clear water, he freely brushed in cerulean blue, Antwerp blue, burnt sienna, and new gamboge in various mixtures, letting the colors mingle. As the color began to dry, he painted a few strokes of clear water where the light branches showed against the darker background at the right. He also placed a few darks on the dry paper to give harder edges where the foam would be.

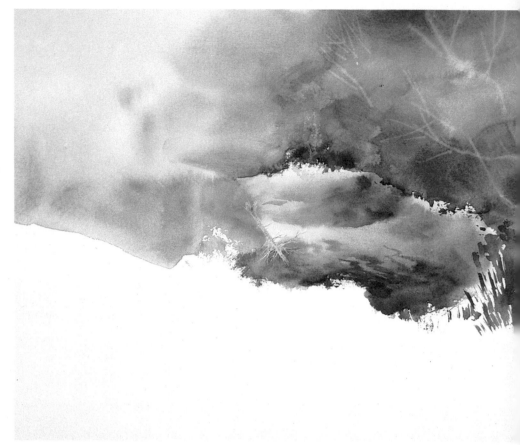

2. The artist improvised a few rocks on the left side where he needed stronger darks. Over the flat, basic washes of the rocks, he added textural strokes with cerulean blue, new gamboge, and burnt sienna, with some backruns to look like algae. He started to build up the darks in the distance with the same mixtures that appear in step 1. To define the trees at the right, he began to paint the darks between the branches. (If one decides to paint a tree in this way, the background color must be light enough so that the branches look light when the darks are placed around them.) Where the shallow water rushed over the warm bed of the stream in the foreground, Mr. Szabo painted fast strokes of warm color: lots of burnt sienna, plus new gamboge and Antwerp blue. Notice how he worked around the light shape of the shrub in the lower right.

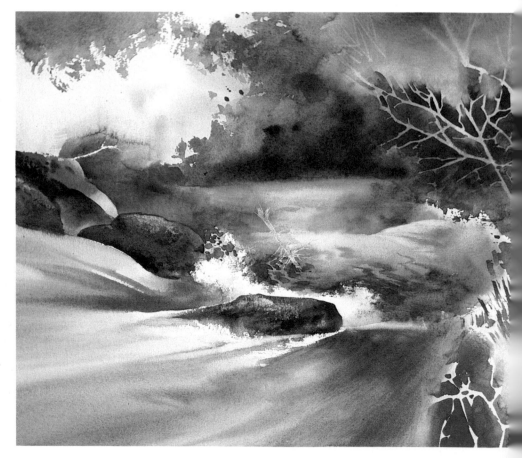

3. At this stage he concentrated his attention around the center of interest. He removed the liquid latex he had used to mask the fallen tree and then modeled the tree with halftones and shadows. Moving around the tree, he painted the cool ripples in the distant water and the warm ripples in the foreground water. He put more darks in the upper right to define more branches and then added more branches (both dark and light) in the upper left, surrounding the warm shape that would soon be transformed into foliage. In steps 2 and 3, he gradually lifted out the light in the water and built up the detail to suggest foam.

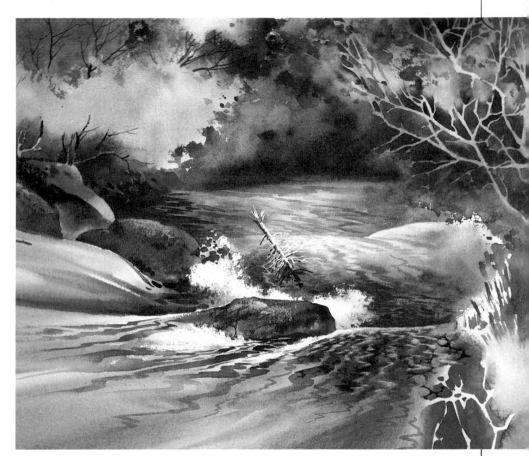

4. The intricate foreground detail was saved for the last stage, as usual. Many touches of warm color—mainly burnt sienna, sepia, new gamboge, and some ultramarine blue—represent the foliage and branches of the low shrub. The artist brought these colors up into the big tree at the upper right to suggest clusters of foliage; he then moved across the picture to add these colors to the light-struck foliage in the upper left. He warmed and darkened the upper left with another glaze of burnt sienna, adding more dark branches. Finally he used a wet bristle brush to lift off a few highlights on the ripples in the foreground and middleground.

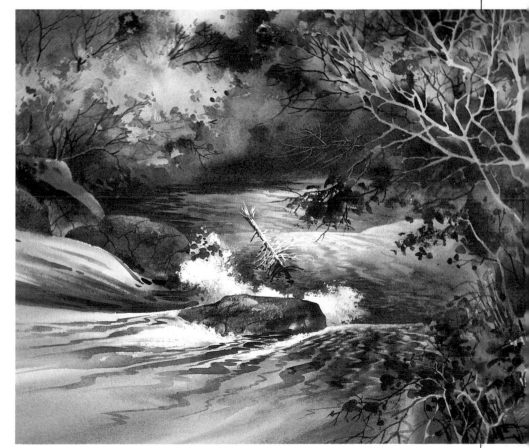

Betty M. Wilson

Tidal Pools

1. In this study of the abstract shapes in a tidal pool the artist wet all but the left center portion of the paper, where he wanted a few sharp edges to survive. Then he brushed the wet surface with raw sienna, burnt sienna, sepia, and French ultramarine. These pigments tend to separate, producing the sandy texture that he wanted. He left bare paper for the bright reflections. For the distant strip of landscape at the top he used raw sienna and ultramarine blue, out of which he knifed some bleached-out driftwood.

2. The dark edges of the pool emerged as he painted the reflections with a 1-inch flat sable brush that carried burnt sienna and French ultramarine. While this wash was wet, he darkened the value drastically with a firm bristle brush richly loaded with sepia, Antwerp blue, and burnt sienna. At the center of the dark reflection, the artist added vertical strokes interrupted by horizontal strokes to represent ripples. With a small sable brush, he depicted the contrasts and details of the distant driftwood.

 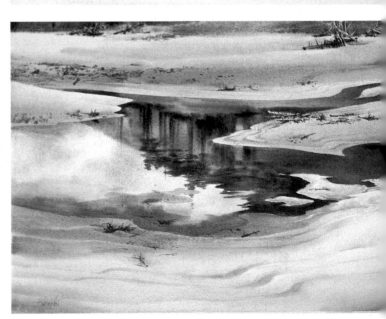

Tidal Mirage, watercolor, 15″ × 22″ (38 × 56 cm), by Zoltan Szabo

3. With long, curving strokes, Mr. Szabo painted the rippling design on the foreground sand, letting these strokes blur slightly into one another. He darkened the edge of the pool and on the sand beyond the pool, he added soft shadows with dark strokes, blurring the edges with a damp brush. Wetting the pool with clear water, he dropped in a few blue touches to suggest the reflected color of the sky. When step 3 dried, he went over the painting to scrub out some lights among the sand and to brighten the cloud reflections in the pool.

4. To add textural contrast, he painted some shoreline debris with small, dark, casual touches. He then went around the edges of the pool with slightly darker washes to accentuate the contrasts. At the forward edge, he painted a light wash of Antwerp blue and sepia where the sand was dark and wet. He then strengthened the cool tones of the sky reflections in the pool. Finally, he added a few inconspicuous darks in the lower left-hand corner and the strip of shadow just below the grass at the top of the painting.

Detail. In this section of the finished painting, reproduced close to lifesize, the varied brushwork is visible. In the immediate foreground, note the curving strokes that suggest the rippling pattern in the sand, created by alternating strokes of dark and pale color that blend softly together, with the lights lifted out. In the pool one can see a wash of medium value into which the artist has brushed darker strokes: long verticals that are interrupted by short horizontals, indicating the movement of the water rippled by the wind.

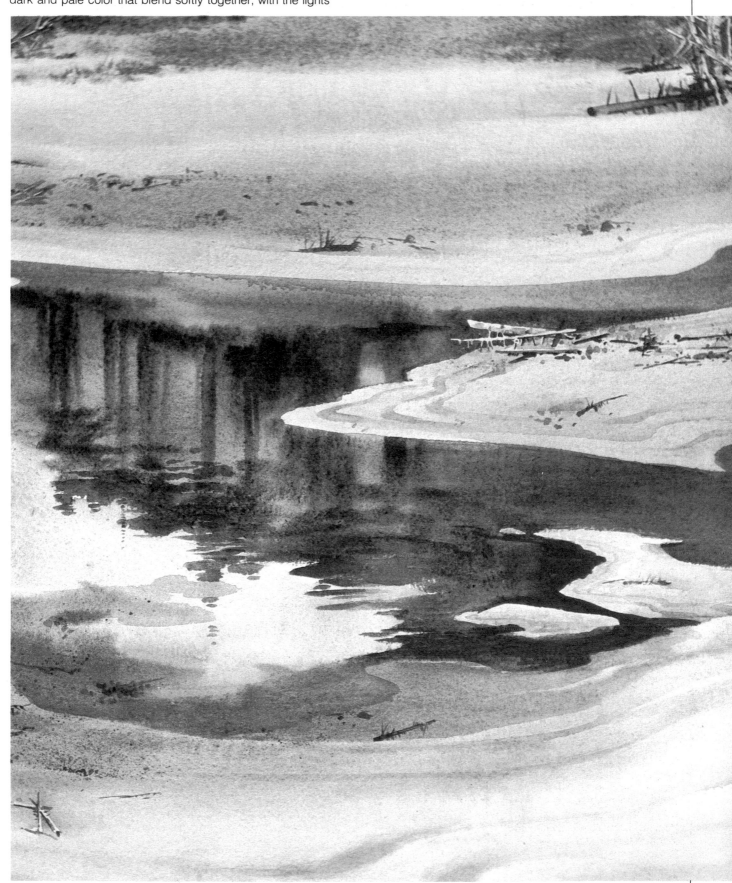

White Water

1. One of the most difficult things to paint is the pattern of white water as a stream tumbles swiftly over rocks. Here Mr. Szabo decided to wet the paper and use a 2-inch soft, flat brush to establish a loose, abstract base for the composition. He worked with a six-color palette: cadmium orange, brown madder, new gamboge, sepia, cobalt blue, and Winsor blue. All but sepia appear in this first step, which is dominated by cerulean blue to unify all the other colors. The first strokes blended softly on the wet paper. As the paper became somewhat drier—although it was still wet—the artist used more paint and less water in his brush to get sharper definition. These more distinct strokes show in the upper right and left corners.

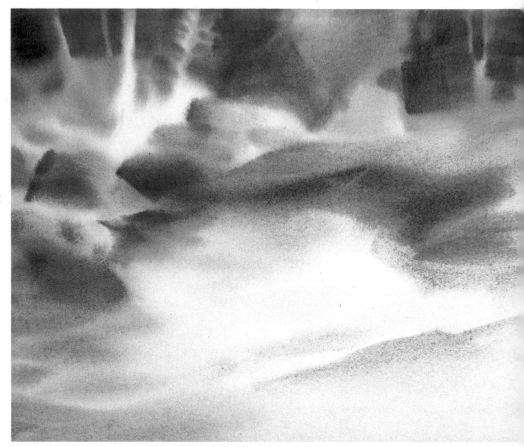

2. In the upper left-hand corner, he built up a combination of positive and negative shapes, carefully designing darker strokes to reveal the lighter shapes. He kept his darks transparent and many of the shapes lost edges where the wet strokes faded away. The light areas were filled with the soft, blurred color used in step 1, strengthened by new touches of warm and cool color on the trunks and rocks. The dark shapes were painted with Winsor blue and a touch of new gamboge. (The color that looks like burnt sienna is really new gamboge and brown madder.) In the upper right, he added a few cool, dark strokes that anchor the negative shapes of the trees to the ground.

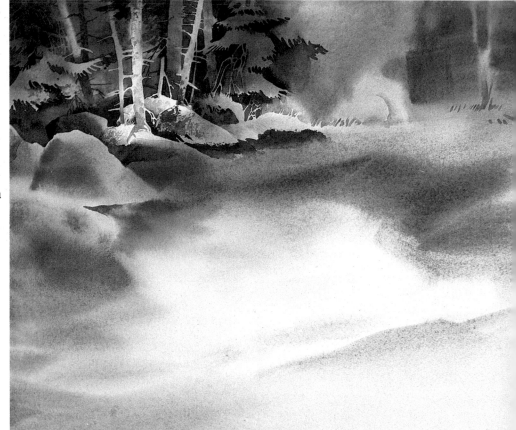

3. Moving down from the background trees, he worked on the reflections in the water. The ripples, reflecting the darker values of the shoreline, are Winsor blue, cerulean blue, and new gamboge. He worked these darks around the rocks, sharpening their edges. He then brought the tone of the water further down to suggest the texture and detail that surrounded the foam, which then took on a more distinct shape. He preserved the glowing color on the dry part of the rocks, but darkened the submerged portions so that they would look wet. The texture on the rocks is a combination of casual drybrush and spatter.

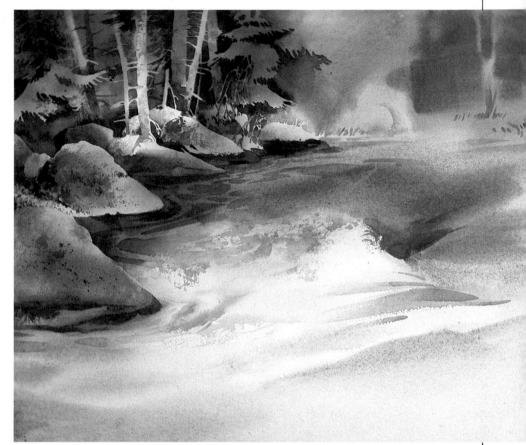

4. For the wet darks of the submerged rocks, Mr. Szabo mixed sepia and Winsor blue. He lifted out a few lights in the water by scrubbing gently and blotting. A few more trees were painted in the background, where a pale, rather ghostly rock was isolated by surrounding it with a darker wash. Next to the splashing wave, the artist placed some stronger darks to give greater contrast. Last came the cracks in the rocks, some drybrushed and spattered texture, and a bit more modeling to strengthen the shadows.

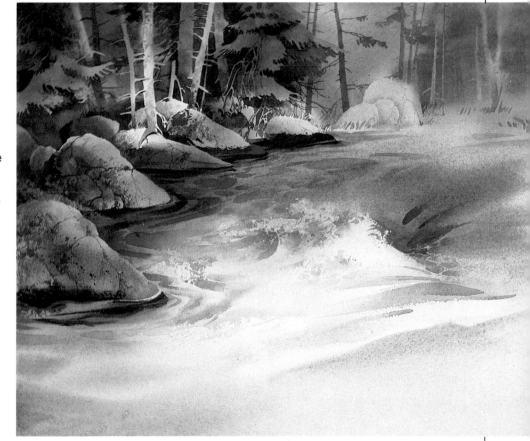

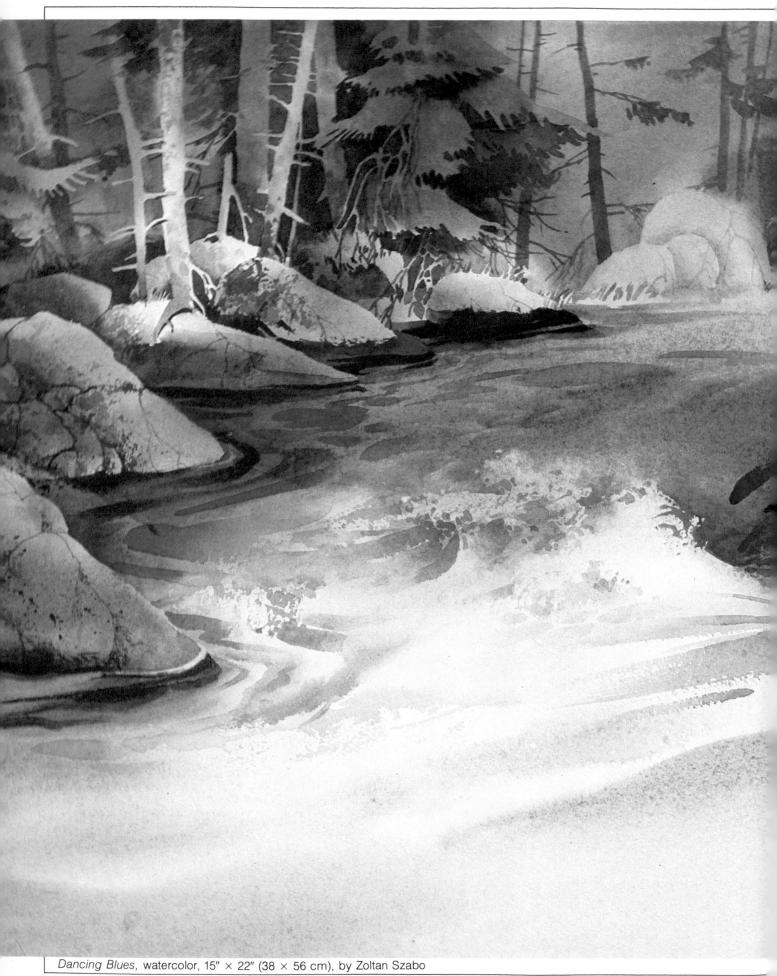

Dancing Blues, watercolor, 15″ × 22″ (38 × 56 cm), by Zoltan Szabo

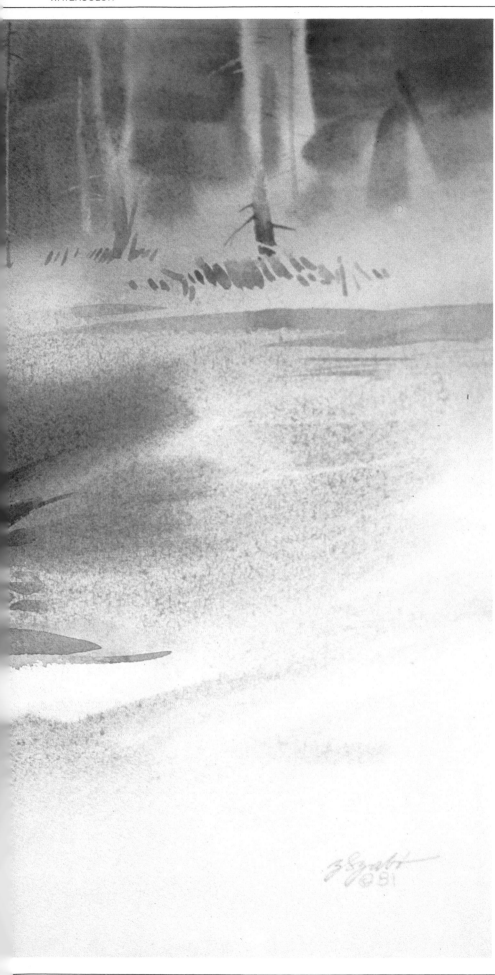

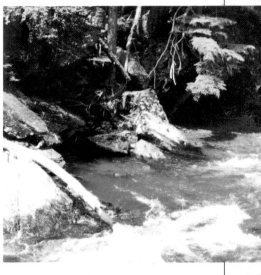

Photograph. This snapshot recorded some helpful details, particularly the action of the water. When water is moving this fast, it is helpful to have a photograph freeze the action.

Pencil Sketch. The artist used the sketch to work out the basic composition and the distribution of values. Here he determined the location of the main shapes and the most important lights and darks.

Finished Painting. To dramatize the white water, the artist surrounded it with the darks of the trees and rocks, as well as the dark reflections. The movement of the water was captured by smooth, transparent strokes with lost edges, and rough, drybrush strokes. Where the water moved quickly, the strokes were painted quickly. Where the beads of water seem to stop in midair, he applied drybrush very gently. Because there's very little variation in the color of the water, this area of the painting depends upon lively brushwork and control of values. At first glance, the water may seem to consist mainly of white paper, but there are just a few pure whites; most of the water is covered with delicate tones.

TREES

Trees. Deciduous trees. Sunlit leaves. Trees draped in snow. Broken trees. Trees without leaves. Artists Zoltan Szabo, George Cherepov, and Albert Handell give step-by-step accounts of trees they have painted. Mr. Handell uses plenty of turpentine to make his sketches on the canvas. He likes the accidents that the loose, runny paint can make. He likes to build up color in layers. Mr. Szabo sometimes uses photographs as reminders, as places to go from. Sometimes he will make a pencil sketch. Sometimes he'll make an abstract impression on wet paper with his colors. Mr. Cherepov will draw on his canvas and with each successive step obliterate his drawing, allowing his painting to emerge How would you do it?

Deciduous Trees

1. The first drawing established the leafy mass as one big shape and suggested a couple of large sky holes. Although these brushlines would soon be gone, the contours were carefully observed.

2. The artist mixed a middletone, lighter than the shadows and darker than the lights, which he brushed across the entire tree shape. This middletone defined not only the leafy mass, but also the negative shapes where the sky shone through.

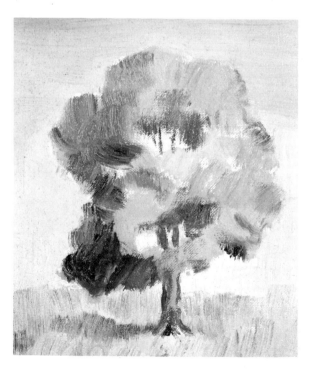

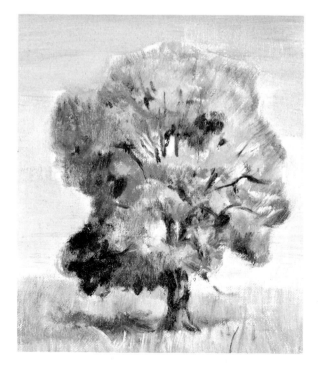

3. Next the painter blocked in the shadows that made the tree appear three-dimensional. He also brushed in the sky tone, which merged softly with the foliage, and the ground color. Notice the soft transition between the tree and the grass.

4. Until this last step, the artist worked with big brushes. Here he selected smaller brushes to pick out the lights, extend the middletones into the darks, suggest leafy texture and to add details such as branches.

Flowering Trees

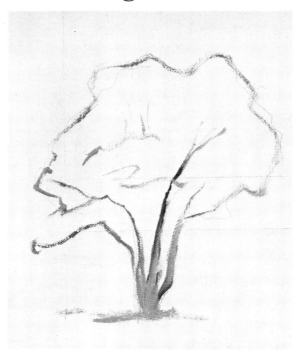

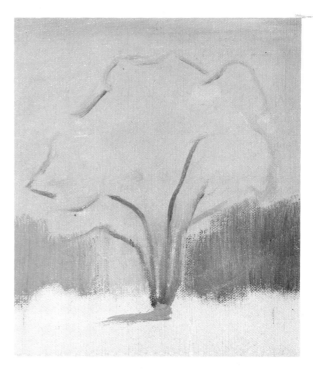

1. The artist made quick brushlines to suggest the silhouette of the tree, blocked in the middletones of the trunk, and suggested a cast shadow that anchored the trunk to the ground.

2. Next, the artist brought the sky tone down over the original brushlines and added some darker tones at the horizon to suggest distant trees. This sky tone partly obliterated the original drawing of the tree, so he quickly redrew some of these guidelines.

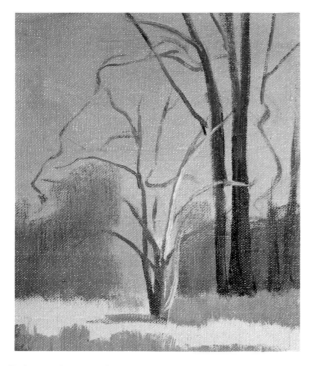

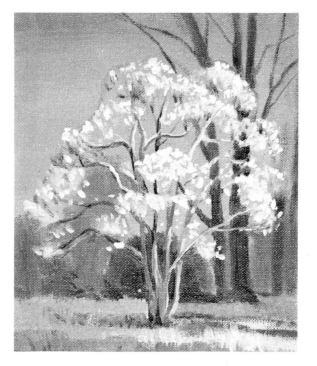

3. Before going any further with the main tree, the artist completed most of the background, adding distant trunks and more ground color. Then he began again on the trunk of the flowering tree, defining lights and darks more precisely.

4. Foliage, flowers, and the complete pattern of branches were saved for the final stage. They were painted into the wet background tones, each stroke melting into the color beneath. Thus the tree became part of the total atmosphere.

Sunlit Leaves

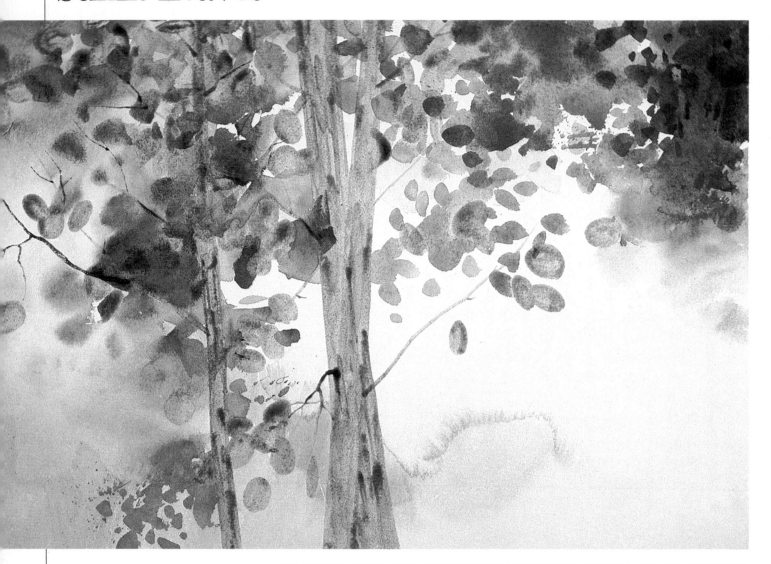

1. The artist used liquid latex to mask out the lightest or brightest areas in the painting. Then he was able to work freely, painting in the slightly darker yellows, browns, and greens. His palette for this painting was new gamboge, raw sienna, burnt sienna, sepia, Antwerp blue, and French ultramarine. New gamboge dominates this first step, staining the paper with its delicate, warm tone.

Detail. The cool tone of the masking fluid is visible; it protects the clearly defined shapes of the brightest leaves and the trunks. Over and around the dried liquid latex, the artist brushed warm strokes that contain various mixtures of new gamboge, raw sienna, burnt sienna, sepia, and an occasional touch of blue. Some of the wet strokes held their distinct shapes, while others blurred softly.

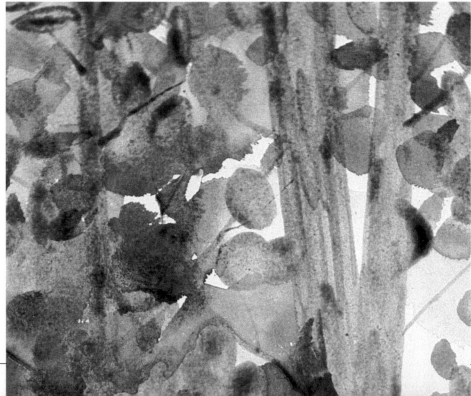

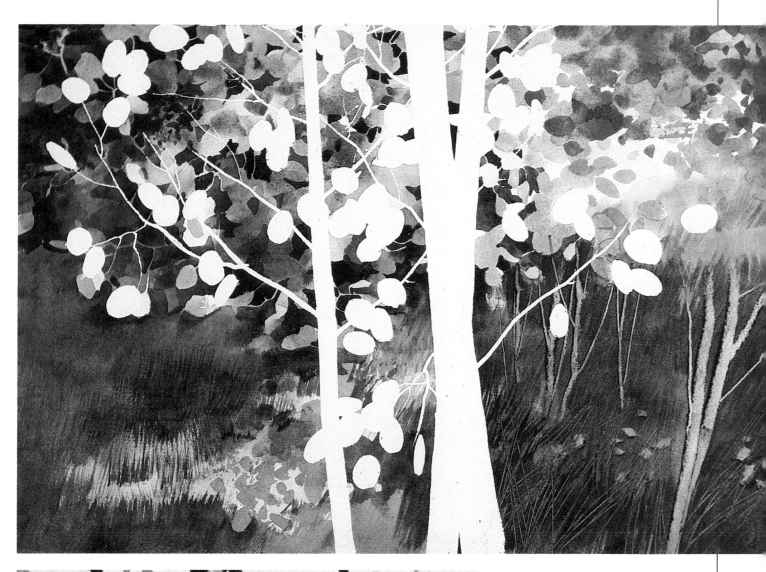

2. When step 1 was dry, the artist deepened the values of the dark forest behind and between the leaves. Then he painted the broad tones of the undergrowth (in the lower half of the picture) with a bristle brush. In the lower right, he knifed out the trunks of the younger trees. Then he lifted out the light lines of the grass with the handle of a nail clipper. (All this was done while the color on the paper was damp.) These dark tones are mixtures of Antwerp blue, burnt sienna, and new gamboge. When the colors of step 2 dried, the artist peeled off the Maskoid by sticking masking tape on top of it and pulling it away gently. Underneath the trunks and the brightest leaves were pure white.

Detail. Compare this to the detail on the facing page. See how the artist has gone back into the warm tones of the leaves with sharp touches of cooler, darker color, giving more precise, leafy shapes at this second stage.

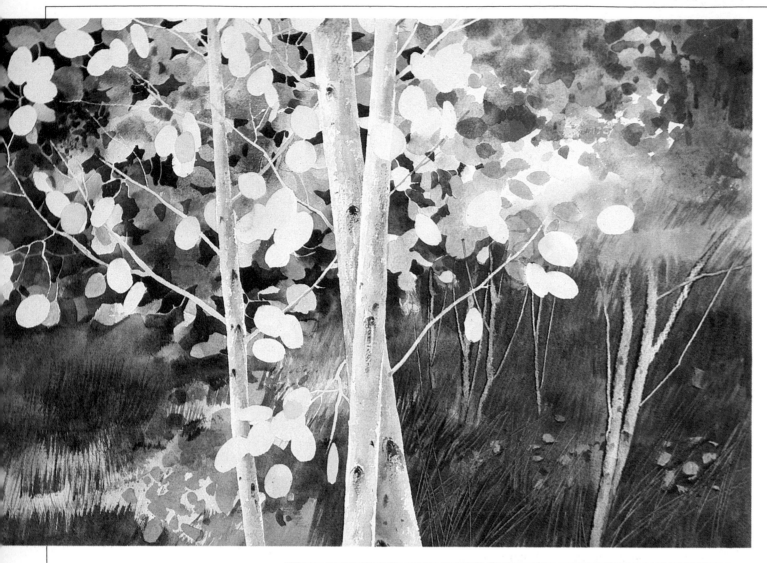

3. With pale, transparent washes dominated by new gamboge, he glazed the round shapes to look like the leaves on young aspens. For the trunks and limbs, he mixed burnt sienna, Antwerp blue, and sepia in varied combinations. To suggest the texture as well as the color of the trunks, he worked with loose, scrubby strokes, followed by drybrush touches. To relieve the density of the leafy detail, he allowed a bit of pale sky to show through at the right of the trunks.

Detail. The painting is close to its final stage, but the dense, colorful leaves shown here are essentially a pattern of lights, middletones, and darks, without any detail within the leafy shapes. This pattern, carefully planned and executed by the artist, actually tells the story without any need for detail.

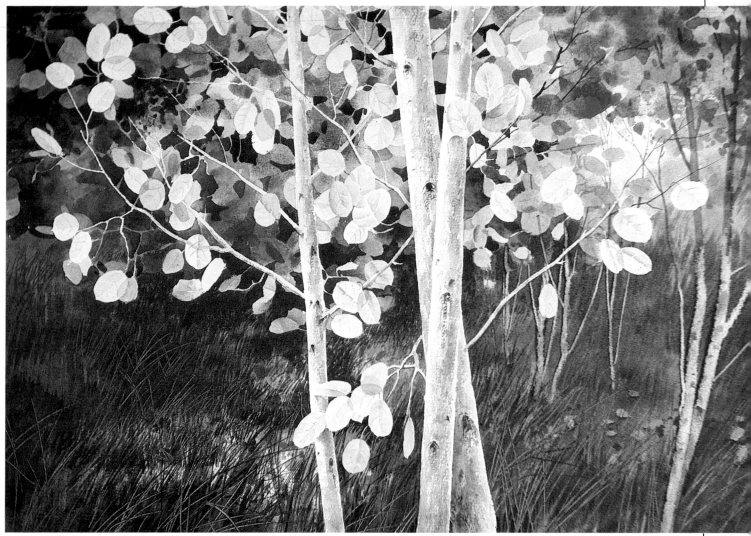

Recycled Gold, watercolor, 15″ × 22″ (38 × 56 cm), by Zoltan Szabo

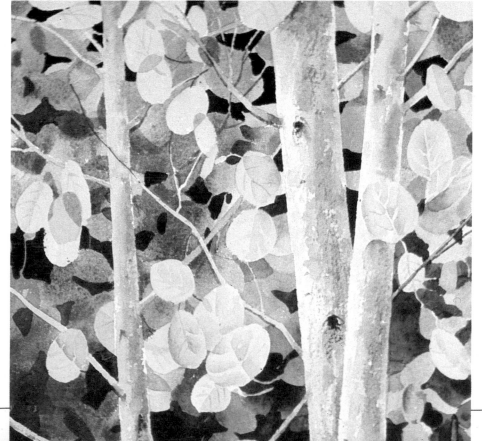

4. At this stage Mr. Szabo developed the internal details of the leafy shapes at the top of the picture, suggesting veins within the leaves, as well as subtle planes of light and shadow, both within the leaves and where the shapes overlap one another. The grass and weeds came to life when he added dark, slender strokes and then scratched away the lighter lines. He added more dark trees in the upper right-hand corner and darkened the upper branches of the slender trees at the right. Notice how his drybrush strokes blended the grass softly into the ground cover. In the lower left the shadowy grass was darkened to dramatize and balance the lights that dominate the upper part of the picture.

Detail. One can see here that the flat shapes at the top of the picture are transformed into realistic leaves by selective touches of detail. The artist didn't paint every vein on every leaf, but added details to a handful of leaves. To create a more three-dimensional feeling, he also added shadow shapes where leaves overlap.

Selecting and Recording a Subject

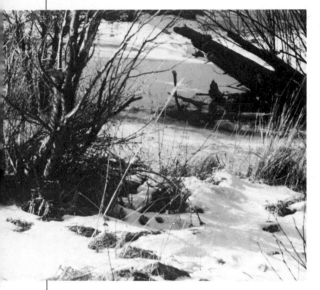

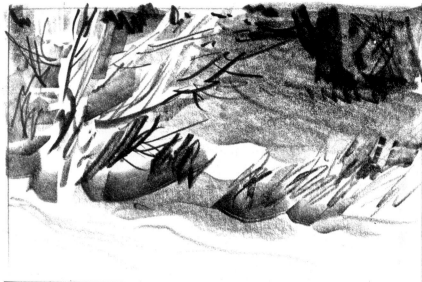

Photograph. The snapshot depicted an area swimming in sunlight and also full of complicated shadows. There was too much detail in the photo, but the artist knew that he could simplify the subject and eliminate a lot of detail in the finished painting.

Pencil Sketch. In the sketch he simplified his subject considerably. He selected one large shadow shape and placed his light on the snow and on the shrub. This served to link the picture together. He used fewer darks, carefully located to provide accents. Note how he eliminated foreground detail in particular. He also reduced the size of the large fallen tree in the upper right.

Finished Painting. The artist put the drama of the picture in the closeup view of the brilliant, sunlit shapes of the trunks and branches, contrasting with the shadows at the base of the trees and beyond. He minimized the darks in the background even more than he did in his pencil sketch.

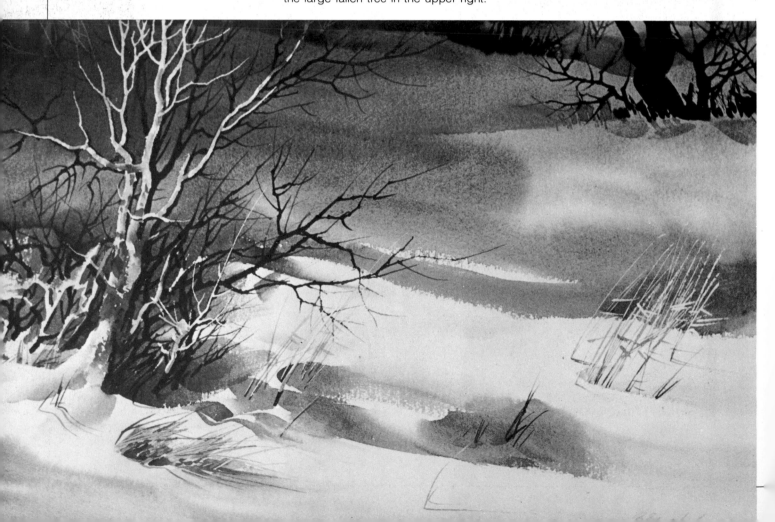

Using Photographs as Reminders

Photograph. The snapshot appears unpromising, but amid the confusion of crisscrossing branches the artist saw a bold, potentially interesting compositional idea. The snapshot lacks the large shapes that give readable strength to the painting, but the subject had the right feeling for the artist.

Finished Painting. One can see that the artist simplified the background, uniting the values and shapes and allowing them to melt far away into the dreamy distance. He concentrated all the rich texture and detail on the mossy trunk and branches and deleted most of the branches that appear in the photo. Comparing the painting with the photograph, one can recognize a few shapes, such as the trunk, the main branches, and the mass of snow. But the final painting is successful because he used the photo as a point of departure, not as something to copy.

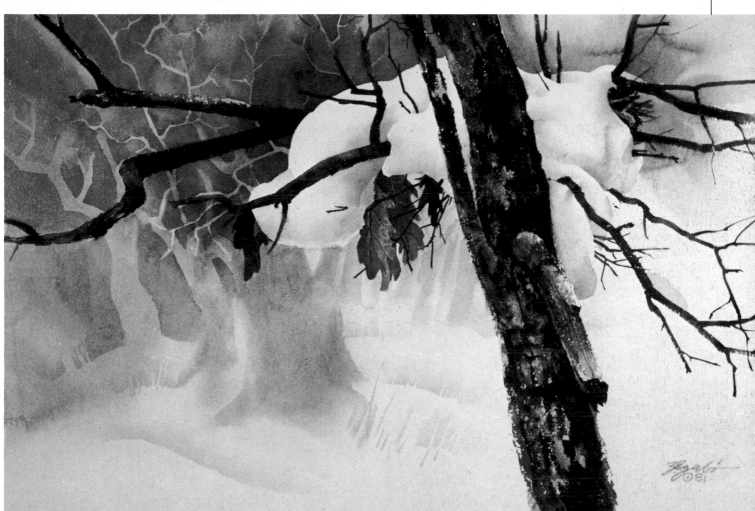

Snow Nest, watercolor, 15″ × 22″ (38 × 56 cm), by Zoltan Szabo

Integrated Friends, watercolor, 15″ × 22″
(38 × 56 cm), by Zoltan Szabo

Using Oil Almost Like Watercolor

1. Using raw umber diluted with lots of turpentine, Mr. Handell drew in the tree and decided its placement on the light gray-toned surface. He eliminated the details and kept the values simple as he washed in the general tone of the trunk. He then established some of the shadow areas, working to get the shapes the tree made and as much of the rhythm as possible.

2. Mr. Handell washed in the background lightly, diluting the raw umber with much turpentine to give the sensation of a dense forest. The mixture has a tendency to run, but that does not bother him. He likes the lovely accidents that can occur when this is allowed to happen. Continuing to build and feel his way around the picture, Mr. Handell reinforced the darks of the tree, still not getting involved with details at this point.

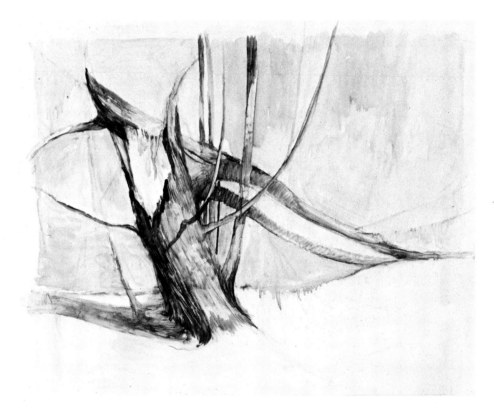

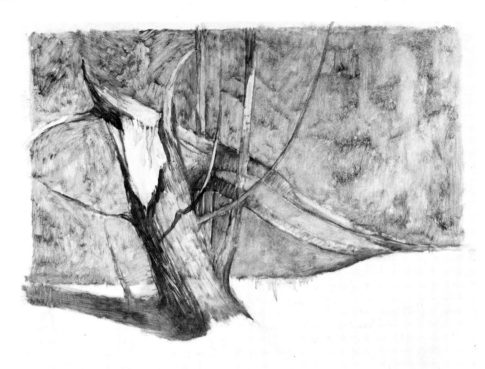

3. He made the background richer and darker here, using less turpentine and more raw umber. Again, he simplified the values, contrasting the darker background with the lighter areas of bark. Once these two areas related tonally, he reintensified the cast shadows on the snow. He established a few more lighter and darker values in the tree but basically kept the work loose and simple. At this point, the picture was in a transitional stage. The basis was developed solidly; he was ready to add the fine details and finishing touches to the painting.

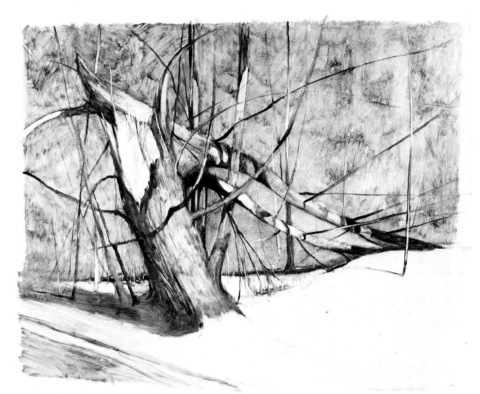

The Fallen Tree, oil, 24″ × 30″ (61 × 76 cm), by Albert Handell. Private collection

4. In this final stage Mr. Handell concentrated on the details of the branches and shadows they cast. He worked with less turpentine while painting the sharp, delicate forms of the dark branches. To create the lighter areas, for example, to indicate thin branches against the dark, dry background, he dipped a clean brush into turpentine and without paint drew a line with the brush into the dark area. Then, wrapping a clean rag around his finger, he blotted the area. Delicate wispy lines remained. In the finished painting one can see the two different ways he applied the oil paint transparently. In the early stage he applied it thinly, with a great deal of turpentine, so it is very watery, almost like watercolor. Then later, when he painted the darker tones, he scrubbed the paint on, without medium. This paint was also transparent but thicker.

Snow, Weeds, and Icicles

1. Just before sunset, the sunlight was very warm, and the snow picked up this warm light, which bounced over every surface. The inspired artist painted this glow of direct and reflected light with a 2-inch flat, soft brush, richly loaded with French ultramarine in various combinations. He applied these colors on wet paper, allowing them to blend where the strokes touch. Thus, the first step was an abstract impression of warm and cool contrasts. Even the lightest areas of the paper contained a hint of color.

Detail. (Right) At first this section of the painting was just a big, sunny mass of color, reflecting the rosy hues of the sun as it approaches the horizon. Because the strokes were painted on wet paper, all the edges were soft and tended to flow together. However, the effect isn't as accidental as it looks. This shape has been precisely planned, and the colors are placed exactly where the artist wanted them, creating a solid, three-dimensional form with a highlight in the center.

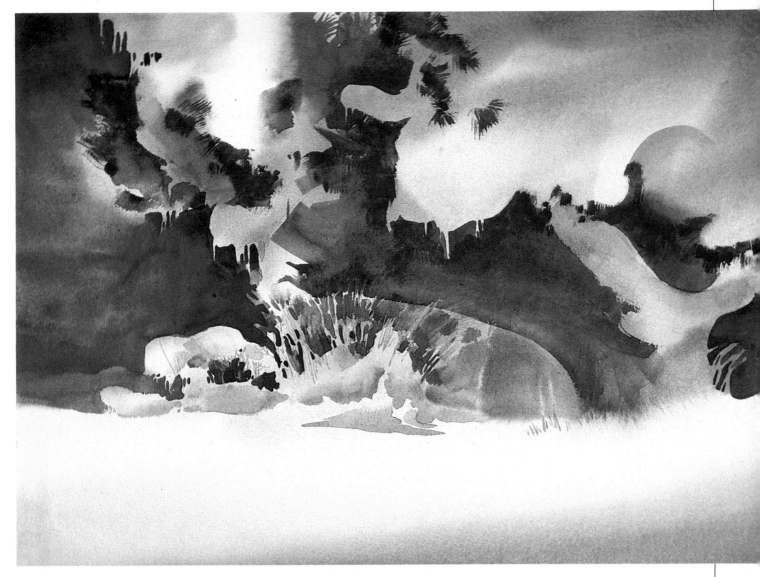

2. When step 1 was dry, Mr. Szabo masked out the fine, slender weeds in the bright light. This enabled him to brush the background color freely over them. He painted the cool background tone (Winsor blue, French ultramarine, and alizarin crimson) around the silhouette of the trunk with its big masses of snow, defining the horizon line at the same time. He worked around and over the weeds with smaller strokes of the same mixture. With burnt sienna and Winsor blue, he roughed in the shape of the tree trunk and silhouettes of some branches. These two dark tones, one cool and one warm, defined a lot of the pale, negative shapes such as the snow clumps, weeds, and icicles.

Detail. (Left) By working around that rosy, cloudlike shape in the upper left, he added the warm darks of the pine branches. In many places, Mr. Szabo worked with a split brush to suggest clusters of pine needles. Thus, the amorphous shape in step 1 began to look solid, with strong contrasts of light and dark. The brushwork was still broad and rough, but a clump of snow hanging amid the pine branches began to emerge.

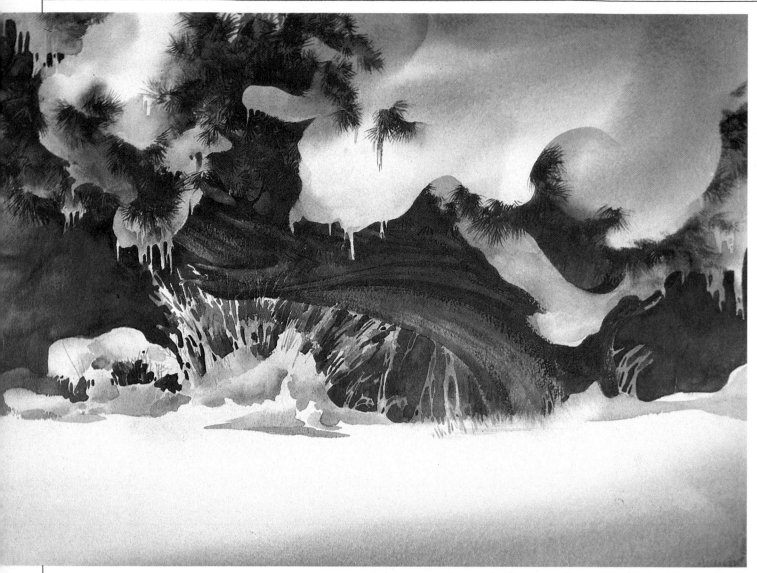

3. With sharp, tiny strokes, the artist developed the detail of the foliage, defining many more pine needles. This is particularly evident in the upper left and beneath the big clump of snow to the right. Working mainly with drybrush, he added texture to the thick trunk. Beneath the trunk, more darks were added to define additional weeds and to sharpen the lower edge of the old juniper. He placed a few cast shadows on the ground to the right and increased the modeling of the icicles to make them look more solid and less like cutouts.

Detail. (Right) Here one can see where he added more detail to the needles at the top. Dark drybrush strokes, following the curve of the tree shape, suggest the texture of the bark. He placed more darks among the weeds to suggest still more detail.

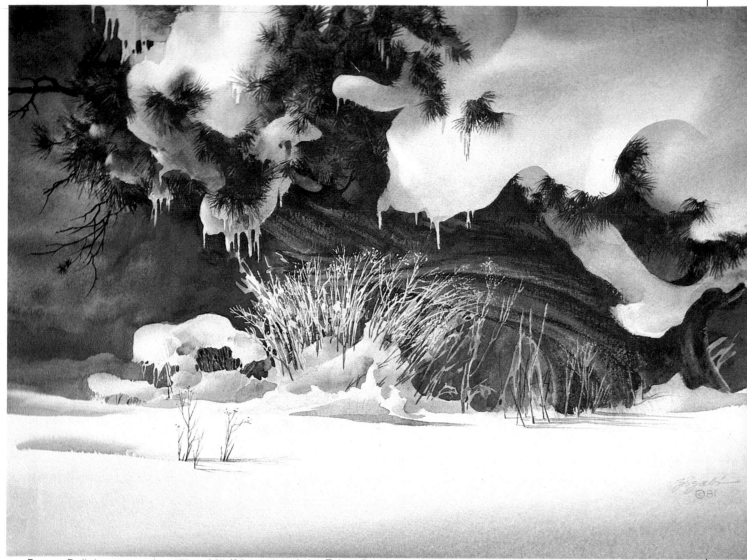

Frozen Delight, watercolor, 15″ × 22″ (38 × 56 cm), by Zoltan Szabo

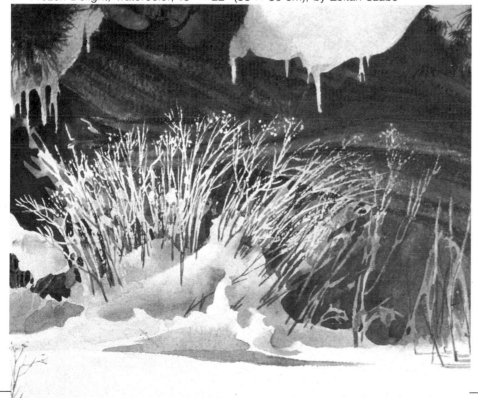

4. Here the artist altered the light on the trunk by scrubbing off dark color along the lower edge. This brightened the shape with the reflected light bouncing off the snow. He then lifted off the Maskoid to expose the light weeds and added dark weeds, thus anchoring the entire clump to the snow. (Note the warm tone of the pale weeds remains untouched and as he painted it in step 1.) Since the tree needed to rest more firmly on the ground, he widened the base, adding more darks and scratching out pale weeds. He brightened the lights on the snow by scrubbing and blotting and then painted dark, slim branches with sepia and Winsor blue. The foreground needed more action, so he added more weeds and their shadows.

Detail. (Left) With the latex peeled away, the frozen weeds reveal an extraordinary amount of detail. The original color, painted in step 1, shines through. Dark weeds mingle with the lighter ones. Note where he scrubbed away the dark underside of the trunk to suggest reflective light.

FLOWERS

Daisies bob in the fields. A lily floats on the water. Charles Reid keeps his eye on the shapes the lights and shadows make and warns against trying to depict each petal. Don't forget about all that bothersome area around the edges of the canvas, he adds. Mr. Reid works *all over* the canvas at once. Flowers can be the most beautiful and inspiring form to paint in all of the outdoors, and also the most trite if handled poorly. Watch how boldly Mr. Reid moves across his canvas. Study how Philip Jamison combines impressions of years into one painting. Watch Zoltan Szabo's masterful touch with lilacs, apple blossoms, and meadow flowers.

Flowering Tree Branch

1. After wetting the paper thoroughly, the artist painted the subdued background tone at the top of the picture with a mixture of cobalt blue and burnt sienna. Then he visualized the slightly shaded lower half of the flower cluster and painted this across the center of the picture with cobalt blue, alizarin crimson, and an occasional touch of Antwerp blue. For the green shapes of the leaves he used burnt sienna and Antwerp blue. As these washes started to lose their shine, he introduced touches of clear water. These last touches produced interesting backruns, shown in the detail at right. Where the undertone started to lose its shine, blossoms were suggested and the darker backruns indicated leaves. Sometimes called fans, such backruns are often dreaded by watercolorists. But when properly controlled, they add vitality and spontaneity.

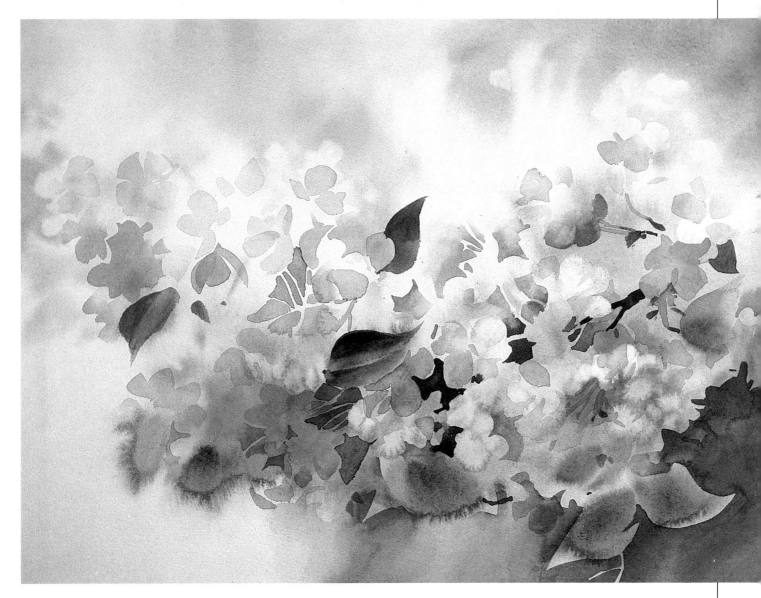

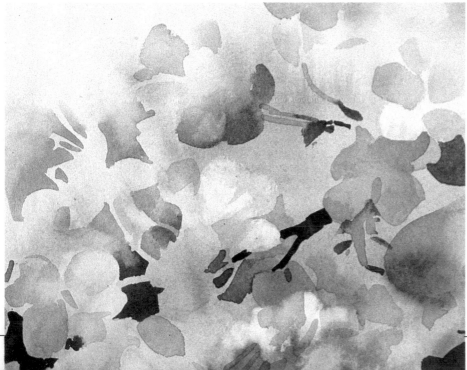

2. Although Mr. Szabo was guided by a pencil sketch, he did not follow it slavishly. He invented the shapes of the blossoms and leaves. The sharp (found) edges carried the design, while the soft (lost) edges blended and locked the shapes into a unified whole. Cobalt blue was used most often in these mixtures, combined with burnt sienna and/or new gamboge for the leaves, and blended with alizarin crimson and burnt sienna for the flowers. For the darkest touches he used a combination of the two mixtures, plus Antwerp blue. Mr. Szabo made sure that there were spots of clean paper showing to communicate freshness.

Detail. (Left) The blossoms and leaves, painted with hard edges, are placed among the soft-edged shapes of step 1. The brushwork is full of variety and surprises, conveying the freshness and profusion of the blossoms.

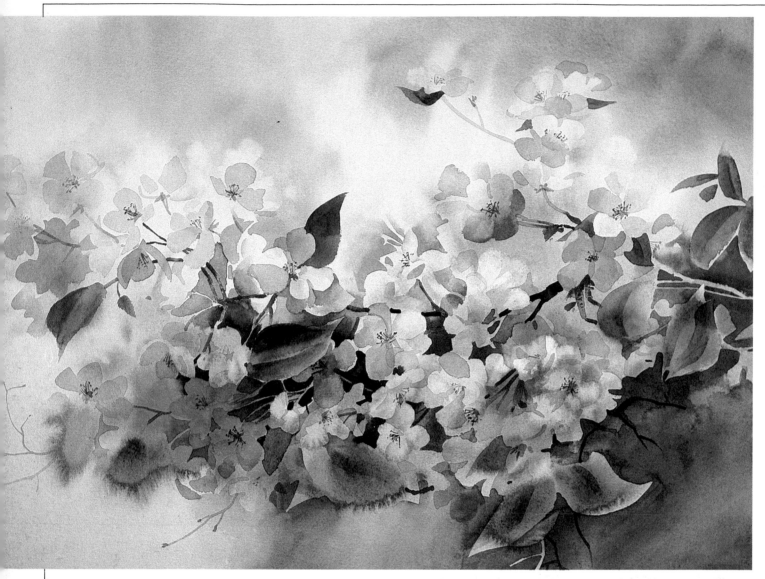

3. With the same mixtures that appeared in step 2, Mr. Szabo continued to clarify the shapes of the flowers and the background; more petals and the small details at the centers of the blossoms emerged. He also added more touches of darkness to indicate background tones behind the flowers. Small branches were then painted between the clusters of flowers, giving inner structure to the design. He then added more modeling to the leaves, suggesting the gradation of the light and shadow, but avoided detail that might compete with the blossoms.

Detail. (Right) Here one can see the three values: light, middletone, and dark. The lights are the patches of paper that carry the delicate wet-in-wet tones of step 1. The middletones are slightly darker mixtures that suggest the shadows on the blossoms. The darks suggest the shadowy background behind the flowers. Mr. Szabo added these touches sparingly, for variety, and to make the flowers come forward.

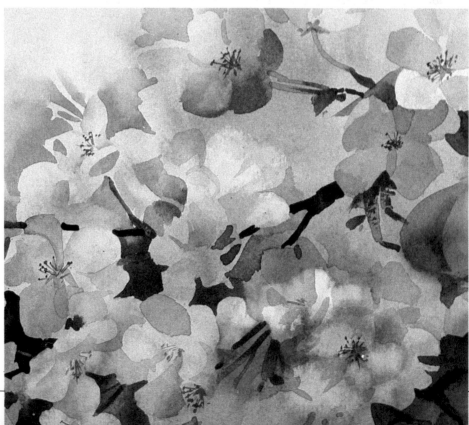

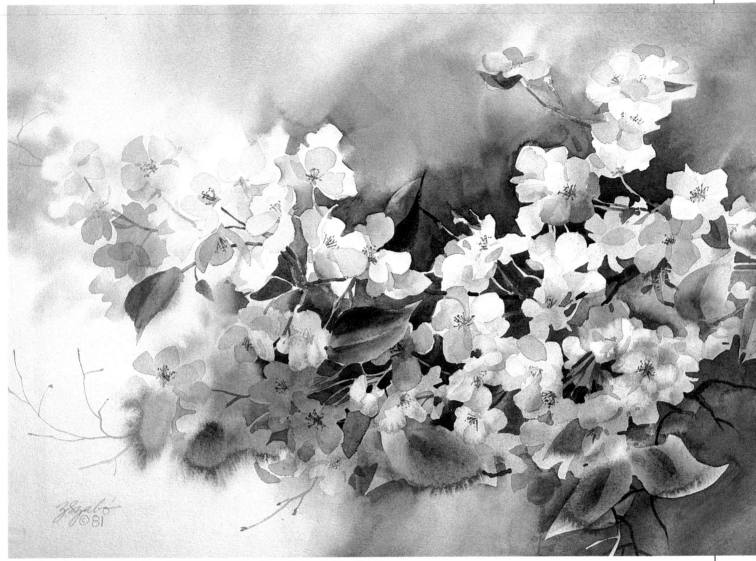

New Apples, watercolor, 15″ × 22″ (38 × 56 cm), by Zoltan Szabo

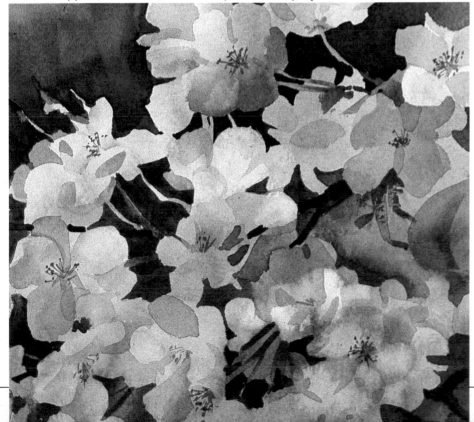

4. To dramatize the blossoms, the artist painted a dark background above them. This background mixture was darkest near the flowers and gradually lightened as his brush moved toward the top of the painting. Because of this contrast, the flowers became brighter and more luminous and the entire painting became more three-dimensional. Mr. Szabo carried some of this dark background mixture down into the gaps between the blossoms, defining the edges of some individual flowers. He also defined a few of the flowers more precisely.

Detail. (Left) The viewer's attention goes to the center of interest, where the contrast is strongest. Mr. Szabo introduced just enough darks among the flowers to heighten the contrast and define a few shapes more precisely, but the darks do not take over. The mass of blossoms is still dominated by lights and middletones.

Flowers and Grass

1. Here's another example of the selective use of the wet paper technique. The artist wet most of the paper, excluding the area just left of center, where he planned sharp contrast. In the wet areas, he mingled varied mixtures of six colors in his wash: new gamboge, alizarin crimson, burnt sienna, manganese blue, Antwerp blue, and French ultramarine. The whisker-like twigs were painted with a rigger. When the paper was surface dry, but not dry all the way through, he painted the light weeds into the dark background at the top. Mr. Szabo made a quick, graceful stroke of clear water, let the water sit for about three seconds, and then blotted off the wet line to remove some color.

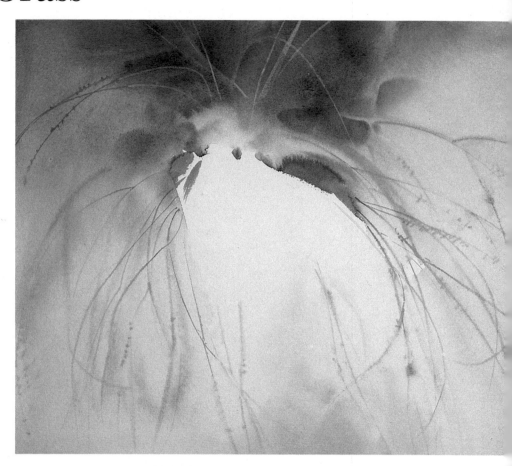

2. After letting the sheet dry thoroughly, he painted some very delicate floral shapes and a few more lacy stems, as well as the grassy texture of the little plateau where the flowers were growing. He used new gamboge and alizarin crimson for most of the flowers, and manganese blue, Antwerp blue, and burnt sienna for the grass. Where the dark lines of the hanging stems moved over the grass, he painted the dark grass color around the stems, which then became light-against-dark. It is easy to see now why he steered around that central patch of white paper in step 1; the white frames the hanging flowers.

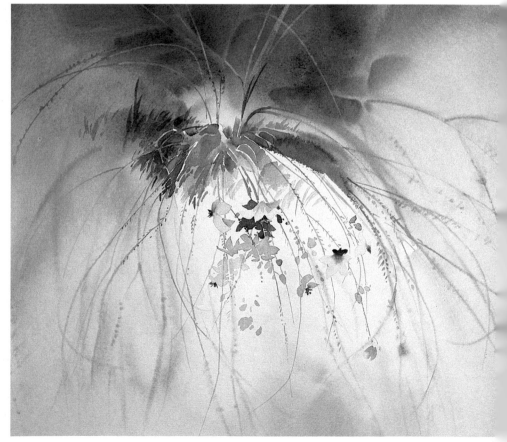

3. With the basic design of the center of interest, the artist began to make more value contrasts to draw attention to the flowers and grass. The flowers no longer have the flat poster-like quality because, with the sharp point of a small sable brush, he built up the darks behind the flowers. Then he worked upward into the grass itself, strengthening the darks and adding detail at the same time. Notice how Mr. Szabo executed very painstaking negative painting around the pale blades of grass above the flowers.

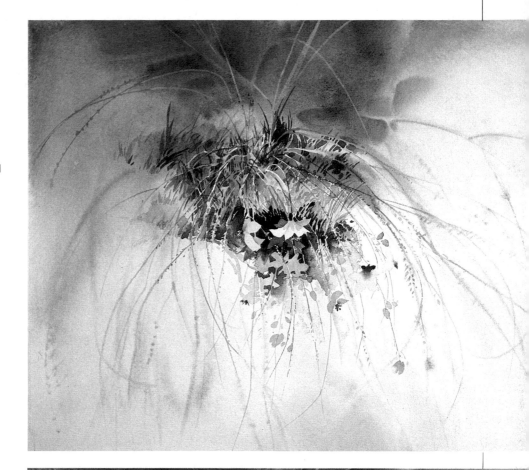

4. Rewetting the lower right and lower left portions of the paper, he spattered touches of blue-gray on the moist surface and then connected these spatters to a few more stems. These stems were painted on moist paper, so the lines became slightly softened. These last touches were subtle, but important, because they allowed his composition to fill the entire sheet, reaching out to all four sides. He didn't want the cluster of flowers and grasses to become an isolated vignette, nestling in one corner of the sheet. Rather, he wanted to create a pictorial design that used the entire rectangle.

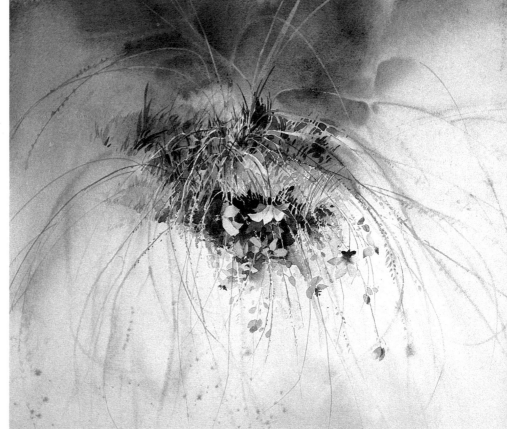

Lilacs in Bloom

1. The simplest way to protect a large mass of flowers is to paint the background around them. Here Mr. Szabo wet the paper partially, leaving a dry area for the lilacs. He painted the background with French ultramarine and burnt sienna, holding his flat nylon brush with its tip away from the edges of the flowers to create a loose, drybrushed feeling around them. The background foliage was painted on wet paper with new gamboge, burnt sienna, and French ultramarine.

2. On the dry paper, he painted the basic colors of the lilac clusters with French ultramarine and alizarin crimson. Then he dragged the side of a brush over the paper to get a lacy feeling that matched the ragged edges of the shapes. With a darker mixture of French ultramarine, new gamboge, and some raw sienna, he strengthened the foliage. To increase contrast and to suggest light branches against the darkness, he added more background tones around the flowers.

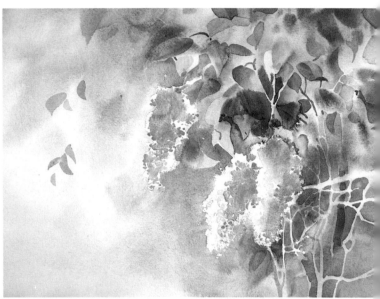

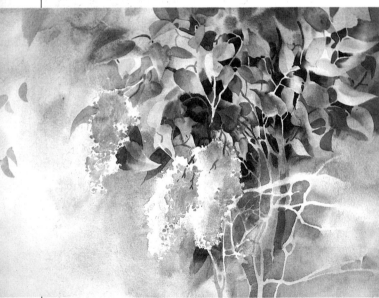

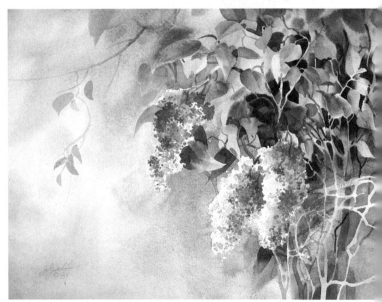

Spring Prelude, watercolor, 15″ × 22″ (38 × 56 cm), by Zoltan Szabo

3. With Winsor blue, alizarin crimson, and burnt sienna, the artist introduced more dark shapes, particularly in the background between the leaves. He also darkened the value of that area by adding darker leaves—a mixture of Winsor blue and burnt sienna. An exciting variety emerged in the foliage, created by the interplay of negative and positive shapes, cool and warm color, and light and dark values.

4. Next he added dark modeling to the lilacs to define individual flowers. He connected leaves and branches with dark strokes and also placed dark strokes among the lights to define the edges of pale branches. He darkened the lower left corner with a soft, subdued mixture of alizarin crimson, burnt sienna, and French ultramarine. As he moved this wash upward, he made it freer by adding more water. To complete the painting, he touched up some of the branches with burnt sienna.

In this closeup of the final work one can observe how the texture and detail of the lilacs were built up with small touches made by the tip of the brush. But these touches don't cover the entire flower; they're concentrated in the darker areas, where there are just enough strokes to convey the internal structure of the flowers without overdoing it. Notice how Mr. Szabo preserved the ragged, white edges of the flowers so that there would be a bright value contrast between the sunlit shapes and the shadowy background. The leaves in the upper right are also a good example of what he calls negative painting. (This is when he places lots of small, dark notes around lighter shapes to suggest sunlit leaves and branches that crisscross to produce a lovely, light-against-dark pattern.)

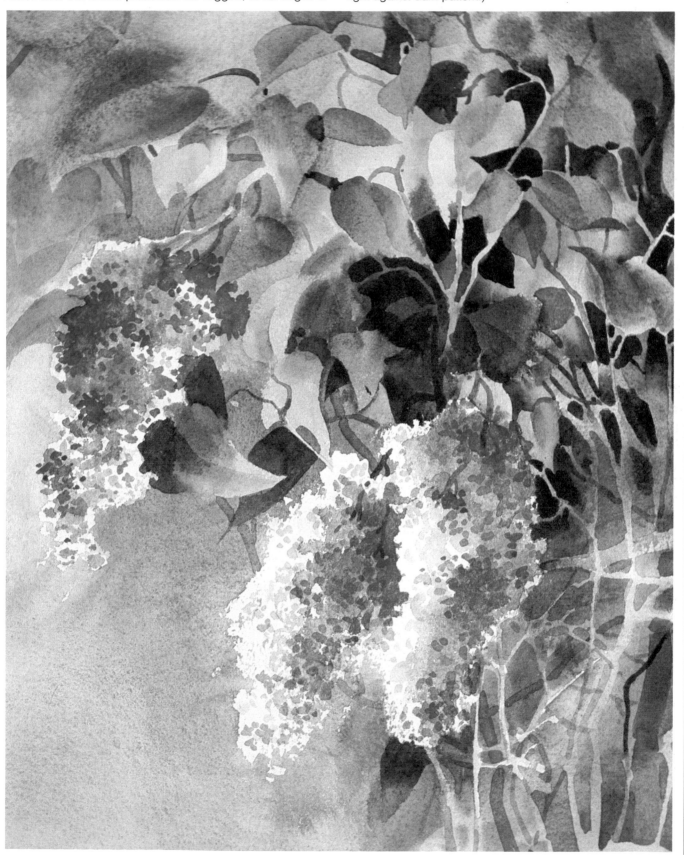

Grass, Weeds, and Flowers

Violets. Here Mr. Szabo masked out the violets and the dry grass with latex and washed dark green grass onto wet paper using burnt sienna, Hooker's green light, and Winsor blue. While this was still damp, he knifed out a few blades of grass and some leaves. Then he glazed the sharper, darker leaves onto the dry paper later. After removing the latex, he painted flowers and grass.

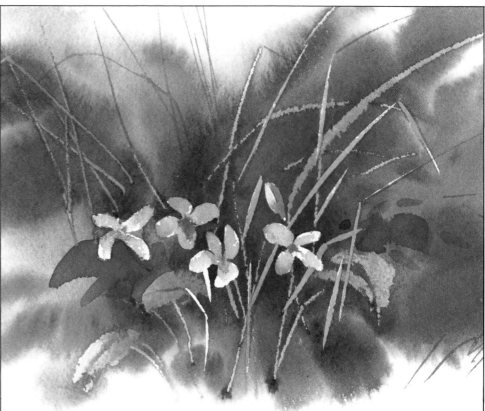

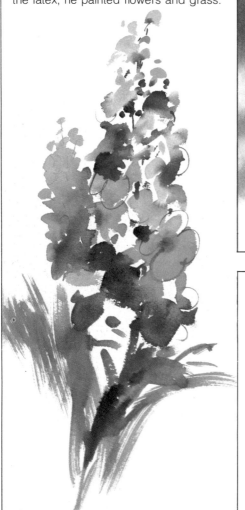

Flowers in Mass. (Above) This quick study of the color and values of a flower took about four minutes. The artist wet-blended French ultramarine, cerulean blue, cobalt blue, and Winsor blue, and added orange for stamens and sepia for the stem.

Flowering Bushes. Mr. Szabo painted this lilac bush as a single form with French ultramarine, Antwerp blue, alizarin crimson, aureolin yellow, and sepia. He knifed out some of the triangular leaves and a few light flowers and glazed on others. The lilacs at the outer edges are drybrushed on. Finally, he knifed on the dark branches.

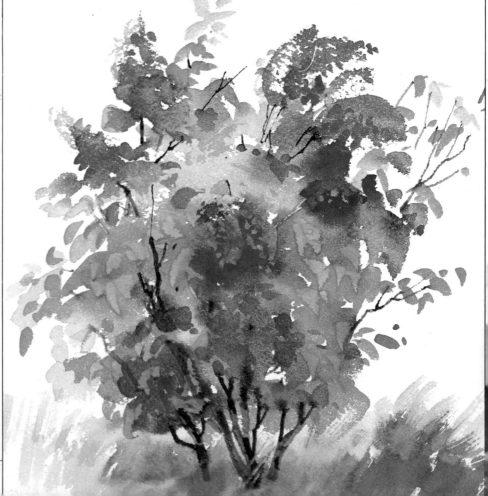

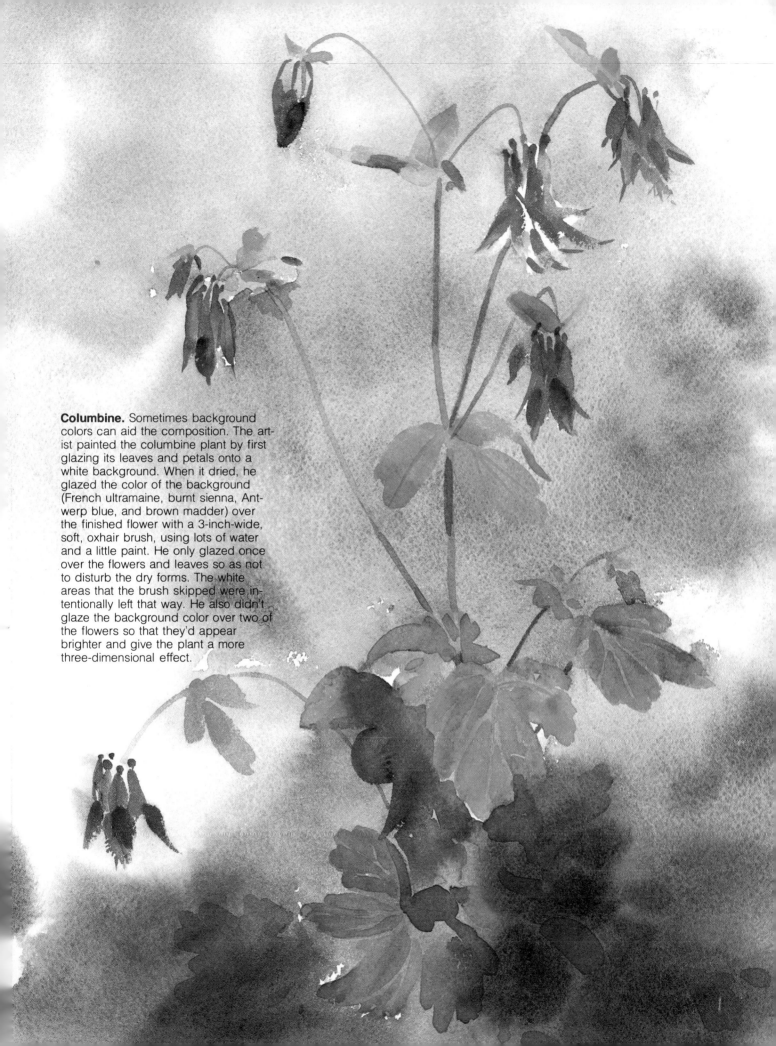

Columbine. Sometimes background colors can aid the composition. The artist painted the columbine plant by first glazing its leaves and petals onto a white background. When it dried, he glazed the color of the background (French ultramaine, burnt sienna, Antwerp blue, and brown madder) over the finished flower with a 3-inch-wide, soft, oxhair brush, using lots of water and a little paint. He only glazed once over the flowers and leaves so as not to disturb the dry forms. The white areas that the brush skipped were intentionally left that way. He also didn't glaze the background color over two of the flowers so that they'd appear brighter and give the plant a more three-dimensional effect.

Water Lilies

1. The artist began with a white canvas. (He often finds inspiration when the first strokes hit the pure white surface.) He sketched with a No. 9 round sable oil brush with viridian mixed with a lot of turpentine. He will often start a painting with umber or black or even red or blue. Sometimes the bright color makes one less timid with color, he feels. Note that the sketch includes some very light strokes, indicators of what will come. Mr. Reid advises never to think only of the subject, but always think of the background "and all that bothersome area around the edges of the canvas."

2. Next Mr. Reid blocked in the darks so that he could establish the light color of the blossom. He advises to always start with the middle or dark values in the first strokes. Note how he did not move his brush in just one direction. He moved it horizontally, diagonally, and vertically, all in quick succession. He rarely makes more than two or three strokes before changing direction.

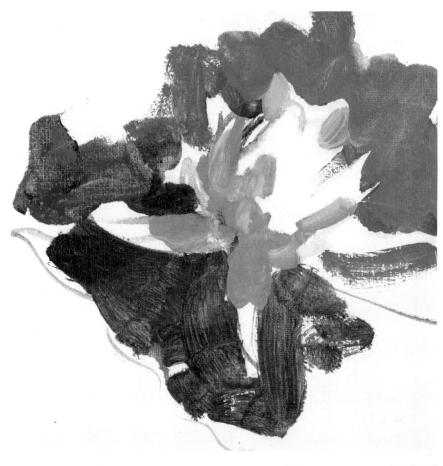

3. Mr. Reid keeps the whole picture going at the same time so that the background will be at the same stage of "finish" as the subject of his painting. The strong sunlight on the flower created a definite shadow shape which he used to give the painting foundation. He connected the shadow into one shape to obtain a large, simple, single-value shadow area. His shadow is broadly yet carefully painted. Note that he used the shadow shape to describe the structure of the form on which it lies.

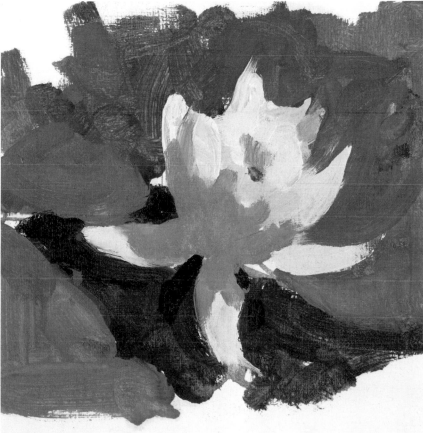

4. Next he began massing in his lights, and at the same time he tried to avoid destroying the simple shadow shape. He painted his lights right up to and into his darks. He also tried not to allow small dark values to get into his big light shapes nor lights to get into his big shadow shape.

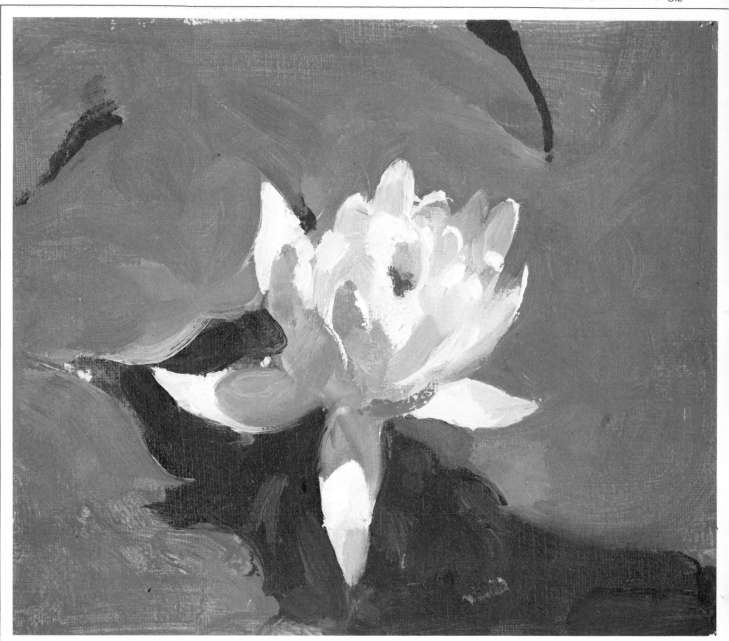

5. But in the final stage the artist did add some small shadows out in his big light area and some reflected light in his shadow. He advises never to allow reflected light to be as light as the main light. He was careful to maintain a dominant shadow area and a dominant light area and always kept in mind that he was painting a whole flower, not a bunch of individual petals.

Comparing Line and Tone

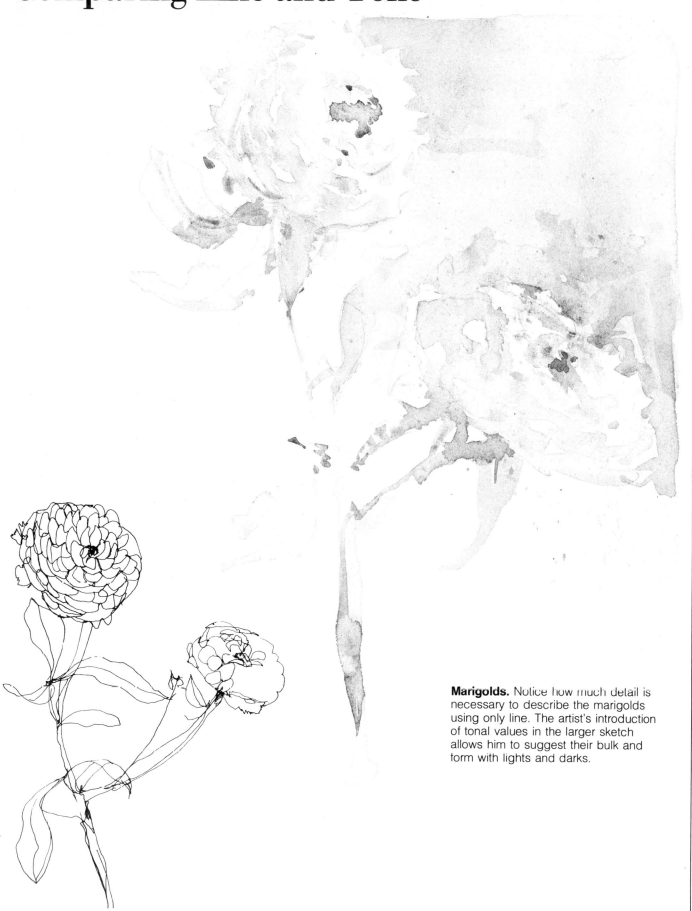

Marigolds. Notice how much detail is necessary to describe the marigolds using only line. The artist's introduction of tonal values in the larger sketch allows him to suggest their bulk and form with lights and darks.

Flowers in Profusion

1. In this small watercolor Mr. Jamison wanted to give his impression of the numerous fields of daisies encountered over the many summers he has spent in Maine. It was done entirely from memory; he wanted to focus on the flowers themselves, with no other elements, such as sky, trees, or water, in the painting. His first concern was to paint the field itself; the flowers would come later. After dampening the entire paper—a sheet of 140-pound semi-rough—with a photographic sponge, he worked wet-in-wet with yellow ochre, raw sienna, olive green, raw umber, and Vandyke brown in an attempt to create an overall impression of the grasses. He was primarily interested in color, but also in space—the receding horizontal plane of the field.

2. The process he followed here is almost an exact duplication of step 1. Again he worked wet-in-wet, using yellow ochre, raw sienna, olive green, raw umber, and Vandyke brown—and again, he almost completely covered the paper. He was still trying to capture the "feel" of the grasses by building up layers of washes. Here and there he left sharper edges where he didn't wish the colors to run together completely.

3. Using a mixture of his two greens (olive and viridian) and two browns (burnt sienna and Vandyke), he darkened a few areas in the foreground where he wished to center the interest. Next he "spotted-in" what would become the centers of daisies, using cadmium yellow laced with a little permanent white. He painted a few daisy petals in a warm Davy's gray to get a sense of where he would go in terms of establishing values, form, and the feeling of space. With a natural sponge, he suggested yellow pale and white. Here and there he brushed in grassy stems and leaves, occasionally splashing and spattering the paint where he thought things were getting too static.

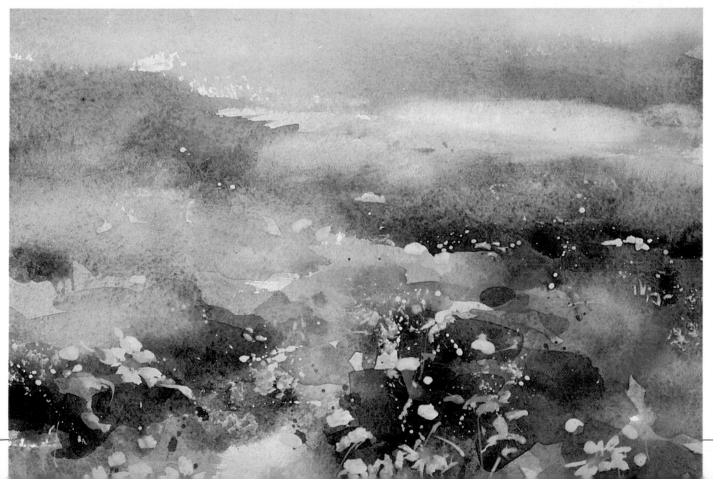

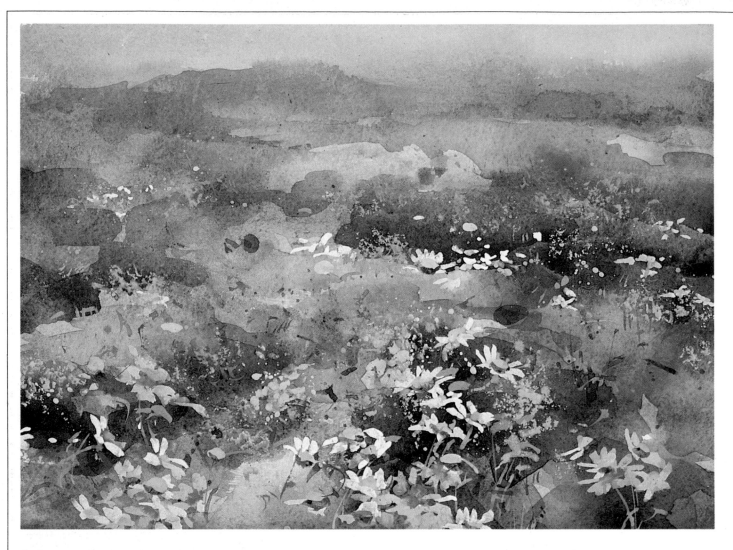

4. On the upper half of the paper he dropped burnt sienna and olive green into small wet washes, with a No. 4 sable brush, to give the field a little more solidity. He used burnt sienna and Vandyke brown here, partly to keep the green from becoming monotonous. He added more daisies and grasses as he felt his way along. He then gave form to the centers of the daisies by suggesting shaded areas with olive green and burnt sienna. The daisies he wished to bring forward were painted with permanent white almost straight from the tube; for those in shadow, he used permanent white toned down with Davy's gray.

5. In most of his paintings Mr. Jamison concentrates on the overall abstract pattern. Although that was also a concern here, his main interest was color—not only the color he actually saw in a field of daisies, but also the color with which he wanted to compose his painting. In other words, he wanted his watercolor to be a painting as opposed to a literal representation of a particular field. This is why he introduced the reds of the clover to complement the larger areas of green. To indicate the clover, he used several opaque combinations of alizarin crimson, cadmium red, Payne's gray, and permanent white. He refined the daisies further by adding more detail. To unify the entire composition, he lightened some of the darker values in the upper part of the painting with a damp natural sponge and, by smudging with the same sponge, blended together some of the adjacent areas.

6. Following his intuition, he put some washes of olive green and Vandyke brown over the lighter areas in the center of the paper. But once done he decided that this was really no improvement and sponged them right out again. Mr. Jamison will often add and subtract as he works in watercolor, and in many cases this procedure produces an end result quite different from his original idea. He completed this picture by going from area to area, placing more flower forms and refining them further until he was satisfied with the overall painting.

Field of Daisies, watercolor, 7½″ × 10½″ (19 × 27 cm), by Philip Jamison

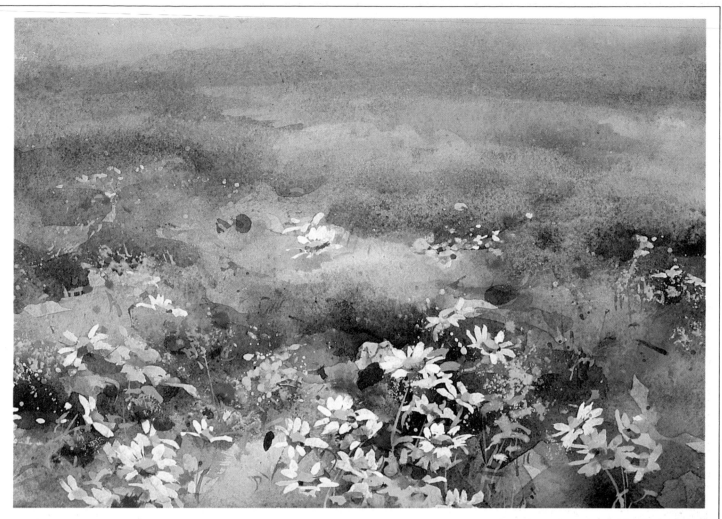

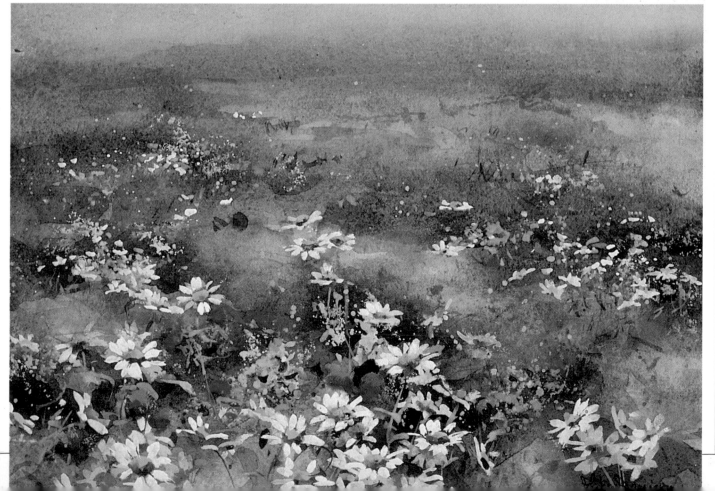

Containing Flowers

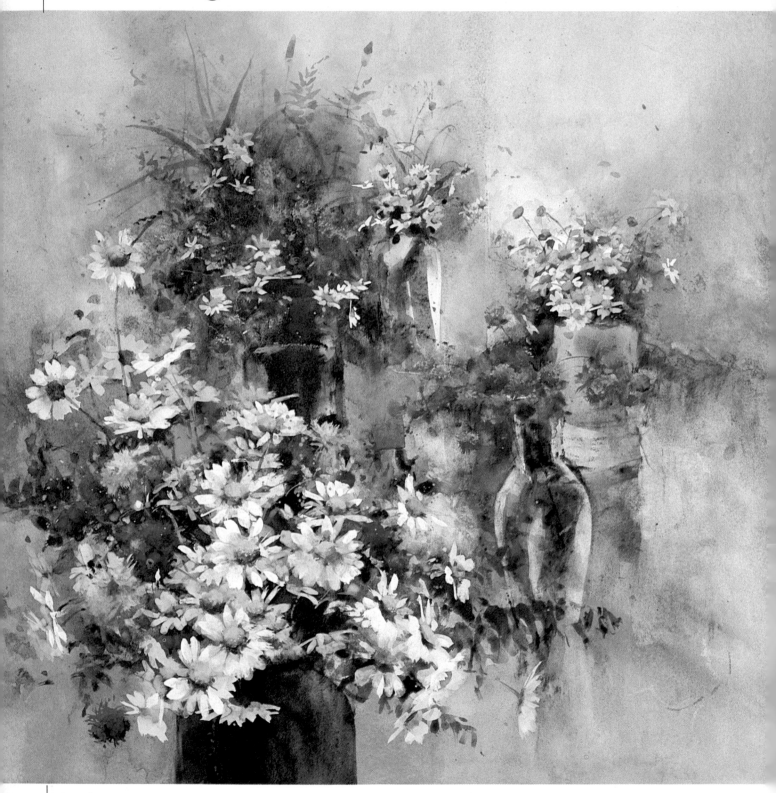

Last Summer, watercolor, 21″ × 29″ (53 × 74 cm), by Philip Jamison. Collection
New York Graphic Society

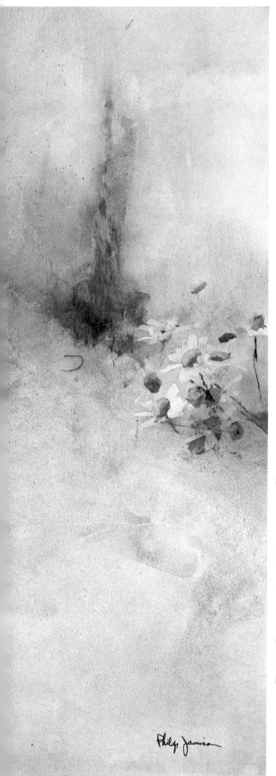

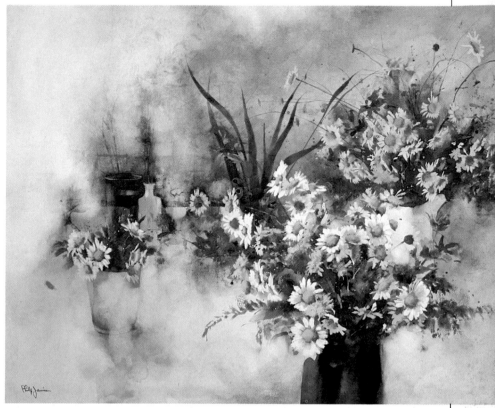

June Flowers, watercolor, 19¼″ × 29″ (49 × 74 cm), by Philip Jamison. Collection Mr. and Mrs. Earl H. Reese

Last Summer began as a very different concept from what appears here. Originally the artist planned and painted it as an interior view of his studio, with a number of vases of flowers scattered about. But the painting seemed much too confusing, so he proceeded to eliminate various elements. Almost everything suggesting a room vanished completely, including a window, a wall, and a table. Even some of the flowers disappeared in the process. The resulting painting, although far removed from his intial idea, proved to be much more gratifying and esthetically pleasing.

June Flowers is really an extension of some of Mr. Jamison's smaller flower paintings in which he is primarily interested in two things: the flowers themselves, and forming an esthetically pleasing arrangement in space with them. To do this he completely eliminated any suggestion of the room or surroundings and concentrated solely on the flowers.

Index